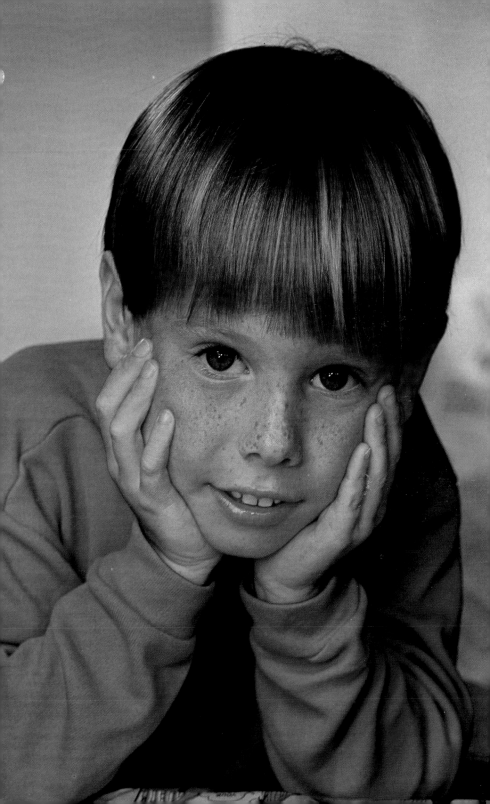

Adventures in Color-Slide Photography

CONTENTS

© Eastman Kodak Company, 1976
Standard Book Number: 0-87985-162-7
Library of Congress Catalog Number: 75-34515

PICTURE CREDITS
cover photograph, DENNIS HALLINAN
page 1, JOHN MECHLING
page 2-3, Mountain, RAY ATKESON
page 3, Bird, DR. W. TRIPP

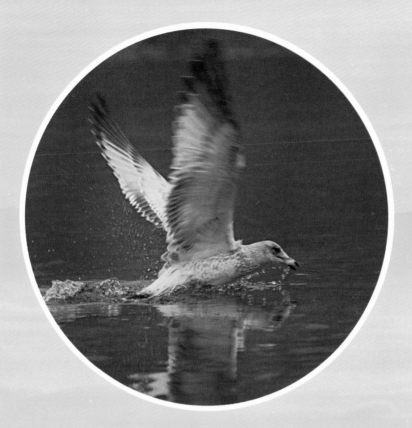

Color Slides Are Fun

When you load your camera with color film, you can explore a myriad of picture-taking possibilities in our very colorful world.

Some of our most enjoyable and picture-worthy experiences happen right around home. A new baby just coming home from the hospital, children cavorting under the Christmas tree, weddings, birthday parties, Thanksgiving dinner, and the kids building a snowman, raking leaves, or swimming in the backyard pool—these and many other happy memories live on through the magic of color slides.

In addition to photographing family activities, you may find enjoyment in creating color slides of beauty by making close-ups of flowers, photographing tabletop subjects, experimenting with montages, or designing your own colorful abstractions.

Away from home, more picture subjects await you. Trips to the beach; picnics; your favorite sport or hobby pastimes, such as boating and camping; vacations; ice shows; circuses; museum dioramas; school and church activities—the list is endless.

This book is intended to show you some ways of making your color slides better and to supply some ideas that will help you find new frontiers for your color-slide camera.

HANS WENDLER

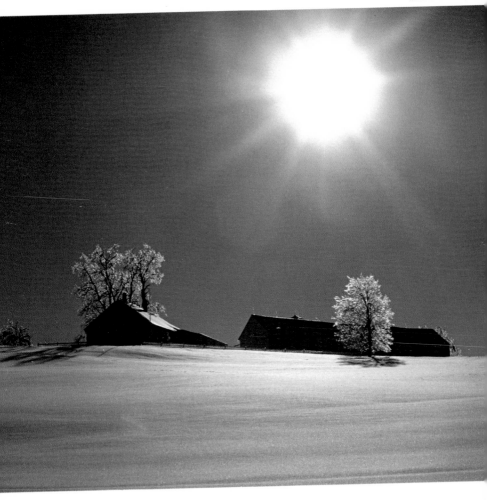

*The following pictures show the kinds of
slides you can take with the help
of the information provided in this book.*

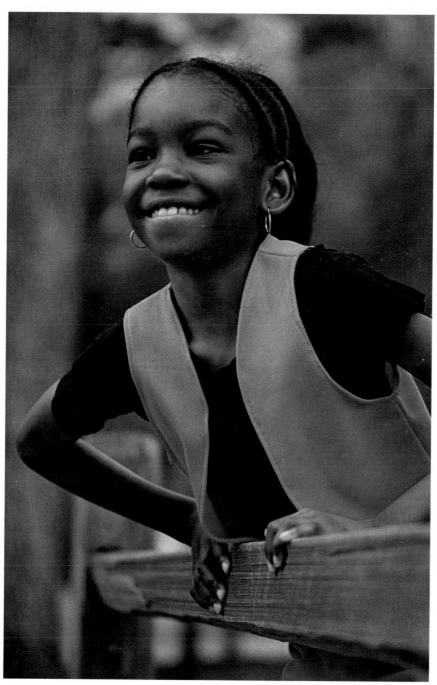

M. PETERSON

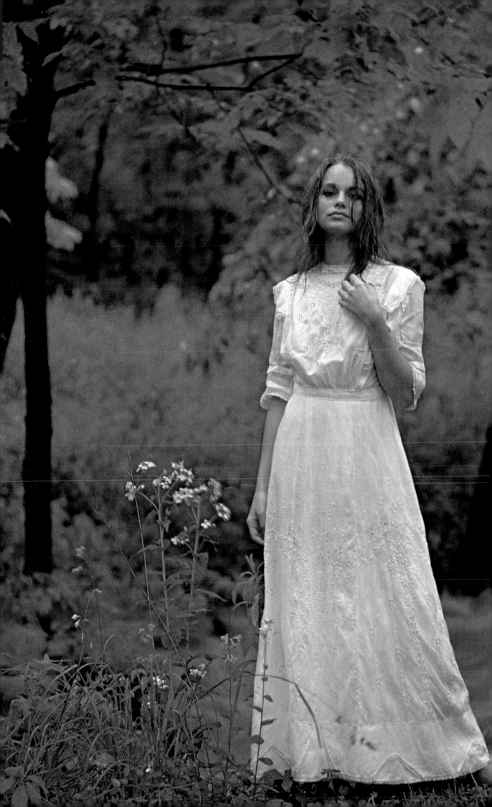

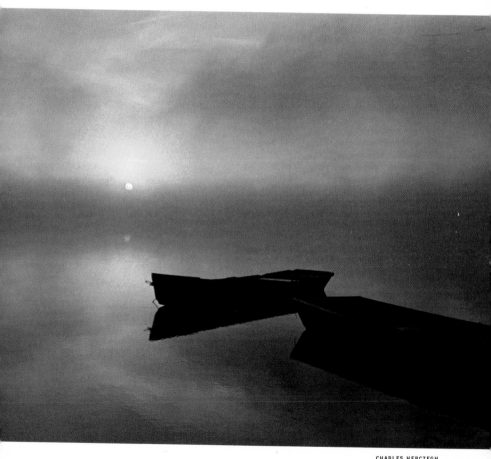

CHARLES HERCZEGH

photo page 8, BOBBY ADAMS
photo page 9, NORM KERR

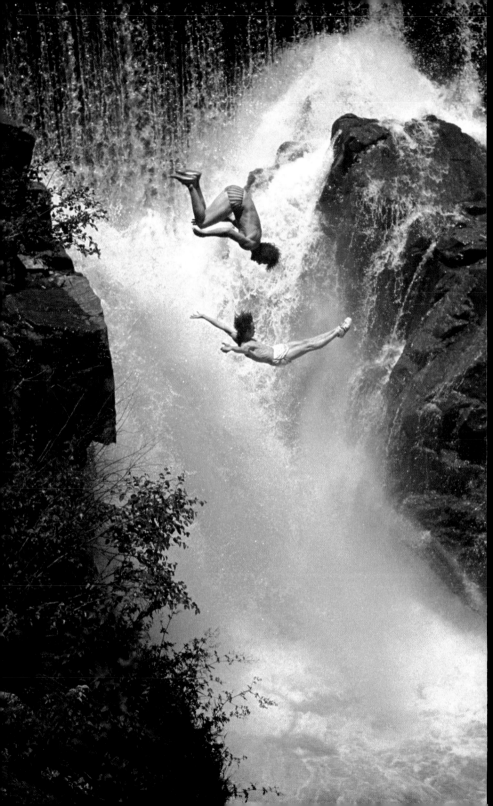

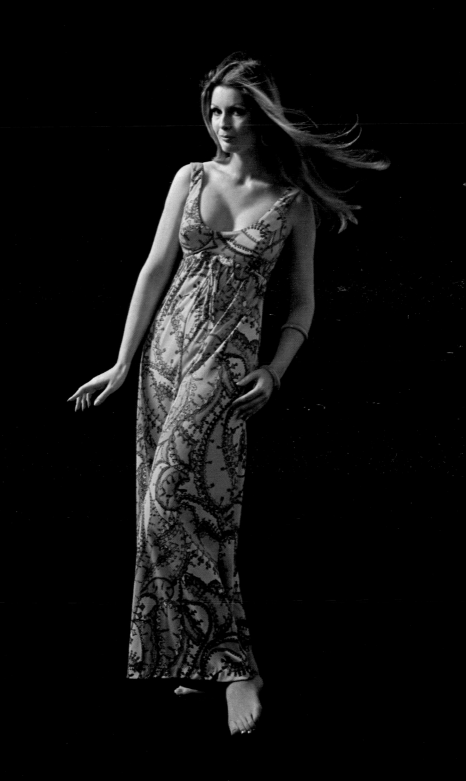

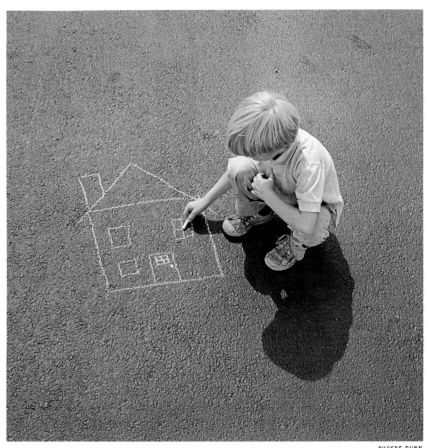

11

BARBARA JEAN

What Makes a Slide Good?

Pictures that are pleasing, pictures that appear in professional slide shows or in salons and draw gasps from the audience, all have in common the fact that they *do* something to the viewer. They have *impact*. Impact results when the subject itself is of popular interest, when you present it from a novel or an especially revealing viewpoint, when you catch the significant instant in a bit of action, and when you select a viewpoint that achieves strong masses and lines and a tasteful or dramatic bit of color.

In addition, good pictures must be of top-notch technical quality. This means they must have correct exposure and proper brightness range for good tone rendering, and must be in needle-sharp focus. Some pictures are intentionally blurred to create a particular impression or mood. If an unusual technique gives you the effect you want, go to it!

RONALD BLOOMQUIST

DR. DAVID MILLS

14

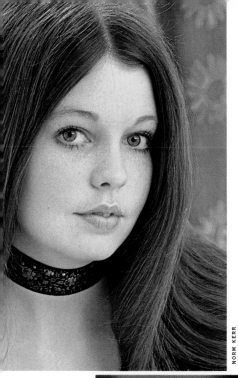

NORM KERR

Several factors make these pictures good. They have interest and impact because the subjects nearly fill the picture area; the pictures' meanings are clear; and the backgrounds are simple, not distracting.

W. PEDDISDIN

JOHN BICKEL

General Hints for Good Pictures

This is not an elementary picture-taking book; it assumes that you know a good deal about cameras and have made a few good pictures. What follows is a general review of some well-known but oft-forgotten tips that will help you improve your slides. They are summarized here in the space of a few pages to provide a handy reference guide and memory jogger.

Keep It Simple. Pictures that pack a lot of punch usually have a single idea, uncomplicated by extra details. You can keep it simple by making close-ups or choosing a simple, uncluttered background.

Move in Close. Moving in close is one of the easiest things you can do to give a picture impact. Pictures of people should almost always be close-ups in order to show the detail of your subjects' expressions. By taking this picture at a low angle, the photographer was able to use the blue sky for a plain yet colorful background.

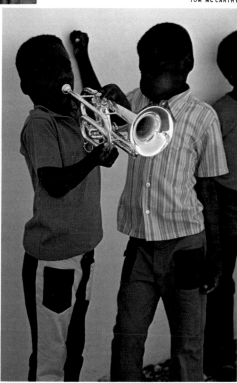

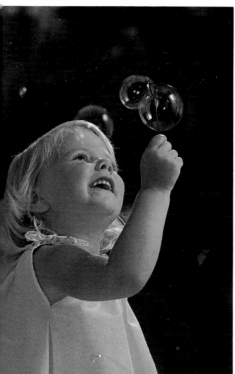

Keep Your Subjects Busy. People look relaxed and natural when they're busy doing something. If you can't catch your subject doing something, be ready to suggest some activity.

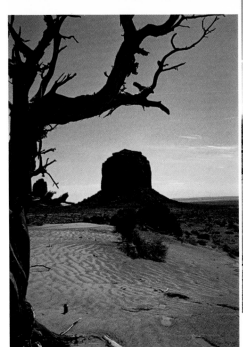
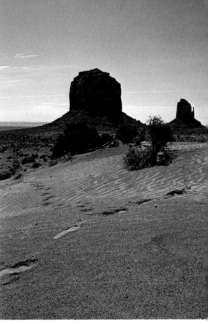

HERB JONES

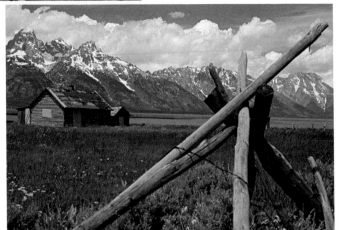

HERB JONES

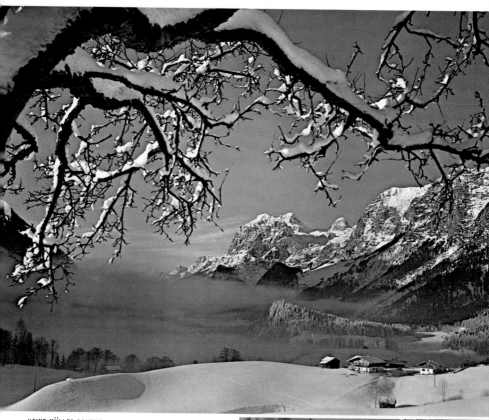

HEINZ MÜLLER-BRUNKE

Include Foreground in Scenic Pictures.
Including foreground objects in your scenic
slides will give your pictures a feeling of
depth and dimension. Sometimes you can
use objects in the foreground to put a frame
around your main subject. Compare the two
pictures made in Monument Valley, and note
how the tree frames the view and gives a
feeling of depth to the scene. When you want
to see detail in the foreground, make sure
it's in sharp focus.

EMIEL BLAAKMAN

19

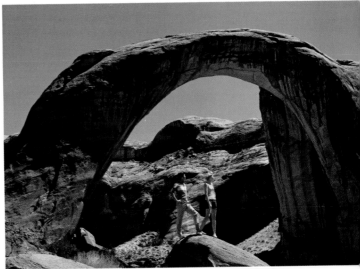

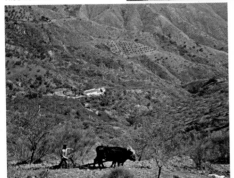

Use Figures in Your Pictures. Placing a few people in the foreground of a sweeping scenic panorama will add interest, balance, and perspective and give the viewer a feeling that he's a part of the scene.

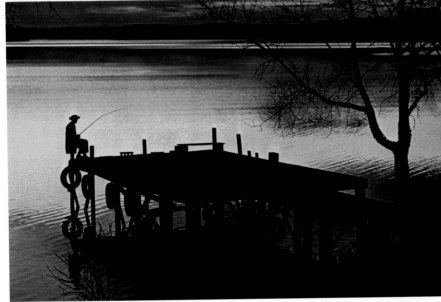

ALLAN HORVATH

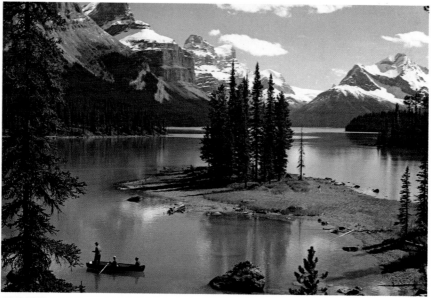

PETER GALES

21

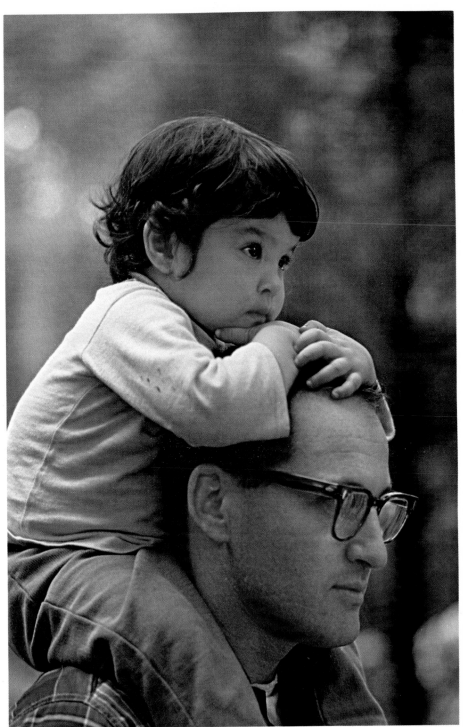

Watch the Background. A confusing, jumbled background can ruin an otherwise perfect picture. Make it a habit to look beyond the subject before releasing the shutter. Take the picture from a low viewpoint and let the sky be your background, or use a large lens opening to throw a busy background out of focus.

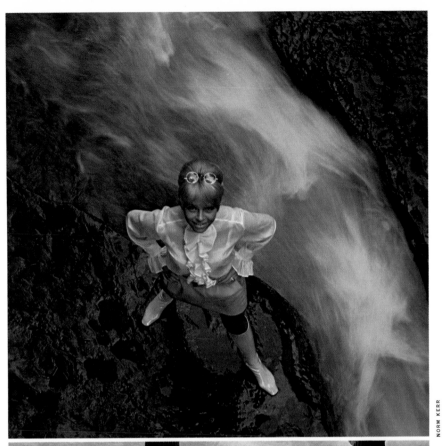

Think Before You Snap the Shutter. Decide
what you want your picture to say. Take
several pictures of the subject from different
angles. Use archways, leaves, or branches
as a frame for the picture. Even a much-
photographed spot can be given a unique
treatment by a photographer with
imagination.

HERB JONES

LEE HOWICK

25

NORM KERR

26

Put Variety into Your Pictures. Good picture subjects are all around you. Look for the unusual. Keep your eyes open for humor, offbeat color, night scenes, action, and patterns to add spice and variety to your slide collection.

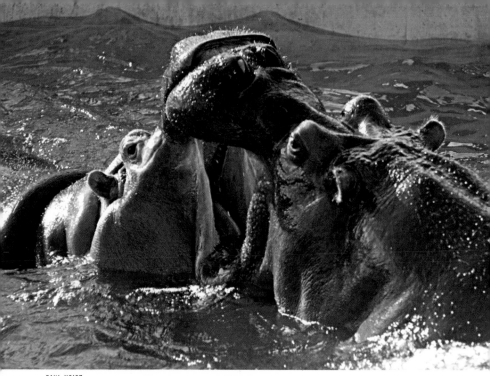

PAUL VOIGT

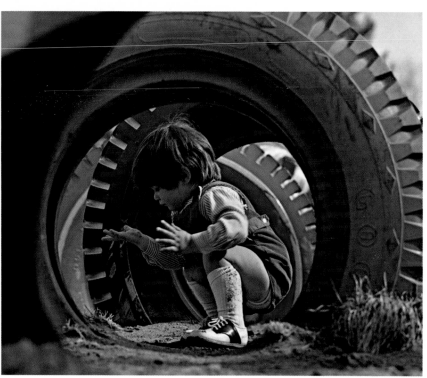

EMIEL BLAAKMAN

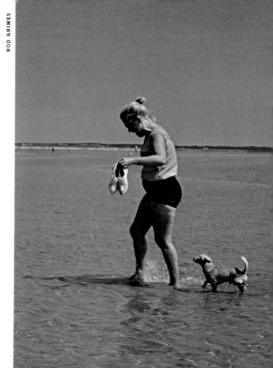

ROD GRIMES

Keep Your Camera Handy. You've probably often thought, "Wouldn't that make a good picture?" If you had your camera with you, you probably captured that good picture for your collection. So keep your camera handy to take advantage of the many picture-taking opportunities you'll find every day.

MRS. G. DOWNING

Let's Talk Tools

Once a person gets the photographic "bug," it's not long before his gadget bag starts to bulge like a camper's knapsack with tools and equipment to cover almost every possible situation. The intelligent use of these tools can spell the difference between good pictures and ordinary snapshots.

A STEADY CAMERA

Slight camera movement is a greater detriment to top-drawer slide quality than most people realize. To see if you're guilty of camera movement, perform the simple "mirror test" illustrated below. If you do have trouble holding your camera steady, there are several things you can do to remedy the situation. First, develop a firm grip, with the camera pressed flat against your cheek. Hold your breath when releasing the shutter, and s-q-u-e-e-z-e the shutter release; don't punch it. If you still have trouble, adopt a standard shutter speed of no slower than 1/125 second. For the ultimate in sharpness, you will find the use of a tripod helpful, even at common snapshot speeds. And when you want to use shutter speeds slower than 1/25 or 1/30 second, a tripod or other camera support is usually a necessity for sharp pictures. (See page 145 for more information.)

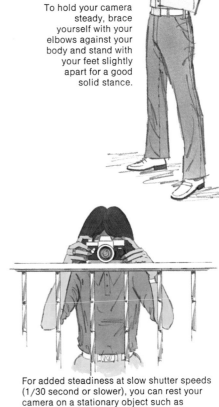

To hold your camera steady, brace yourself with your elbows against your body and stand with your feet slightly apart for a good solid stance.

For added steadiness at slow shutter speeds (1/30 second or slower), you can rest your camera on a stationary object such as a railing.

Direct a beam of light from a flashlight or projector at a small mirror taped to your camera so that a spot of light is reflected on a wall in front of you. Squeeze the shutter release gently. If the spot of light reflected from the mirror moves, the picture would have been blurred. Practice until you can hold your camera steady.

The photographer used a large lens opening to throw the background
out of focus and direct attention to the subject.

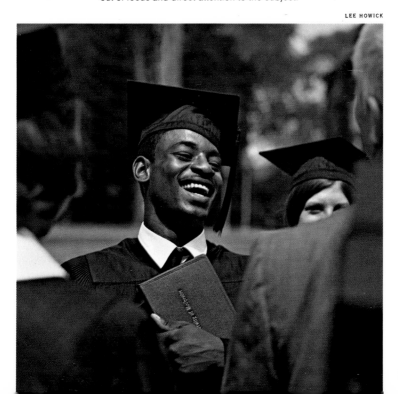

DEPTH OF FIELD

Depth of field is the distance range between the nearest and farthest points in a picture which are in acceptably sharp focus. By manipulating lens openings or focus settings and subject distances, you can increase or decrease depth of field. The focus setting on your camera, as well as the lens opening, controls depth of field. The closer the subject is to your camera and the closer the focus setting, the less depth of field you have at a particular lens opening. And the smaller the lens opening (the larger the f-number), the greater the depth of field at a certain distance.

Many adjustable cameras have built-in depth-of-field scales on their lens mounts. These handy scales indicate the near and far limits of sharp focus at any combination of lens opening and focus setting. Creative use of your depth-of-field scale will enhance your pictures. By controlling depth of field, you can emphasize or play down any part of the picture. For example, you can place great emphasis on foreground objects by having the background out of focus.

To get the most depth of field at any given lens opening, set the infinity mark of the camera's focusing scale opposite the far depth-of-field limit for that lens opening on the depth-of-field scale. This focuses the lens at the point that will give you the most depth of field for the lens opening you're using. If your camera doesn't have a depth-of-field scale, you'll find the Depth-of-Field Computer in the *KODAK Master Photoguide,* No. AR-21, $3.95 (available from your photo dealer), quite useful. Knowing how much depth of field you have helps you plan the picture before snapping the shutter.

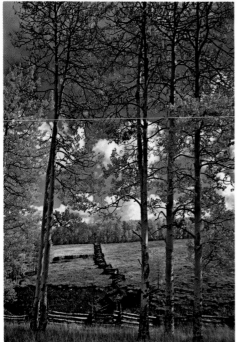

Both foreground and background had to be in sharp focus, so the photographer used a small lens opening for great depth of field.

ARTHUR UNDERWOOD

Photographed with a 500 mm lens on a 35 mm camera.

PETER GALES

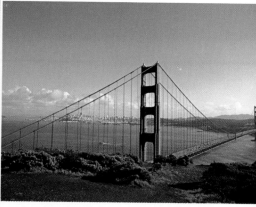

This picture was taken with a wide-angle (24 mm) lens.

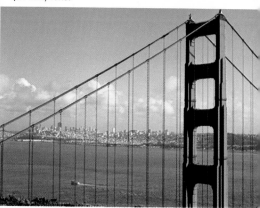

Photographed with a normal (50 mm) lens.

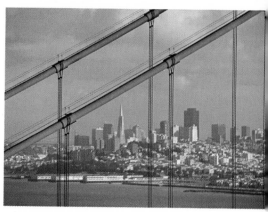

Photographed with a telephoto (135 mm) lens.

WIDE-ANGLE AND TELEPHOTO LENSES

Some cameras have interchangeable lens systems. With these cameras, you can use wide-angle, telephoto, or zoom lenses. Use a telephoto lens, a lens of longer-than-normal focal length, to make pictures taken of distant objects look like close-ups. Telephoto lenses are ideal in situations where you can't move in close. But they have comparatively little depth of field, so focus carefully when you use them. Depth of field is usually less with a telephoto lens than with a normal or a wide-angle lens because the image size is greater. All lenses, however, have equal depth of field when the image size is equal.

Telephoto lenses also increase the effect of subject and camera movement. You can minimize these effects by using the highest shutter speed that the lighting conditions will allow. It's also a good idea to use a tripod with a telephoto lens.

Telephoto lenses compress the apparent distances between objects, too.

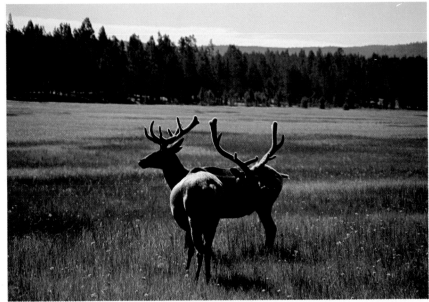

ROD GRIMES

DR. J. SPIES

A telephoto lens lets you get a larger image of wildlife subjects without the risk of scaring them away by approaching too closely.

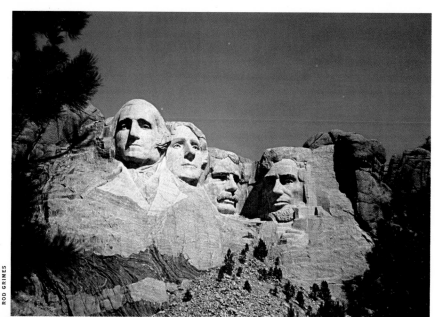

When you can't get close enough to your subjects, a telephoto lens will bring them up close.

A telephoto lens compresses the apparent distance between objects and creates an interesting perspective in this street scene.

A wide-angle lens is helpful in capturing panoramic scenic views. In this scene, the lens lets the photographer include the trees for framing.

With a wide-angle lens, try to avoid tilting your camera upward to photograph tall objects, because distortion is introduced. Parallel lines will begin to converge toward the top of your pictures.

Indoors, you often need help in including all of the scene in your pictures when you can't move back far enough. A wide-angle lens does the trick.

For example, a telephoto picture taken down a city street will make the buildings look squeezed together or closer to each other than they really are.

Use a wide-angle lens, a lens of shorter-than-normal focal length, when you want to "get all of the subject in." Wide-angle lenses are good for scenic pictures where you want to record as much of the landscape as possible. These lenses are also invaluable indoors when you want to include all of a subject and you can't move back any farther in the room. Wide-angle lenses have relatively great depth of field.

However, you do have to use wide-angle lenses with discretion because they can distort the subject. For ex-

36

ample, if you aim your camera upward to photograph tall buildings, the vertical lines will tend to converge toward the center of the picture—somewhat like the leaning tower of Pisa. Or if you take a close-up of a person, the part of the subject nearest to your camera will look large and out of proportion.

Zoom lenses are adjustable for focal length. You can set the lens at any focal length within the zoom range and use it just like a nonzoom lens with the particular focal length you have selected. For special blurred effects, you can zoom the lens while making an exposure; see page 316.

LENS ATTACHMENTS

There are two lens attachments that every serious photographer will want to have and use. These are a skylight filter and a polarizing screen. Occasionally you may have need, also, for light-conversion filters.

Skylight Filter

Pictures taken in the shade or on overcast days have a slight bluish cast. A skylight filter is a slightly "warm" filter which helps eliminate this bluishness and gives a more natural appearance to the scene. A skylight filter will absorb some of the ultraviolet radiation that causes the bluishness in photographs of distant scenes, too. A skylight filter is also useful for photographing cool-toned subjects, such as snow or water, in direct sunlight. An added bonus of this filter is that no increase in exposure is required.

Polarizing Screens

A polarizing screen looks like a gray filter, but it's really not a filter at all. It's a polarizing device that allows light vibrating in only one plane to pass through it. It is used over the camera lens in color photography to control sky brightness and to increase color saturation. A polarizing screen will also reduce reflections from bright, nonmetallic surfaces and will reduce haze when the camera lens axis is at right angles to the sun.

If you look through a polarizing screen at the part of a blue sky which is at right angles to the sun and then slowly rotate the screen, you will notice that the sky gets increasingly darker as the indicator handle rotates toward the direction of the sun. If you look through the polarizing screen at oblique reflections coming from shiny, nonmetallic surfaces such as glass, wood, water, and leaves, you will find that the reflections can be greatly reduced by rotating the polarizing screen to its most effective position. This not only eliminates glare but also has the effect of increasing color saturation. Specular highlights from colored objects, such as green foliage, yellow and red leaves, and flowers, are not colored at all but white. When a polarizing screen is used to reduce or eliminate such white highlights, you can see the true color of the subject; the whole picture shows a more pleasing saturation of color and appears "cleaner."

A polarizing screen is easy to use, because any effect you can see through the screen can be reproduced on the color film. An exposure increase of at least 1½ stops is required. Since the camera must point at right angles to the sun for a maximum dark-sky effect, the subject will necessarily be sidelighted. Sidelighted subjects (not including distant landscapes) require additional exposure even without a polarizing screen. As a result, an exposure increase of at least 2 stops is required when you photograph a sidelighted subject through a polarizing screen.

Photographed through a polarizing screen.

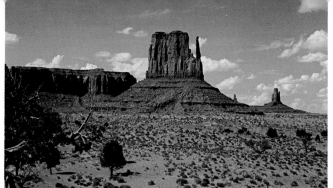

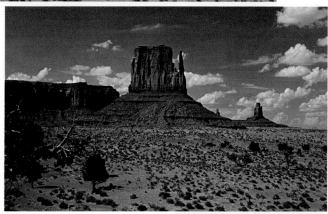

In the comparison slides on the right, the polarizing screen darkened the sky and increased color saturation.

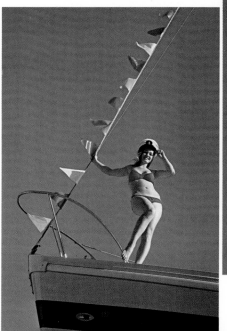

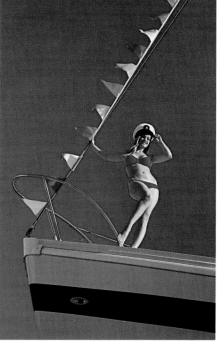

Without polarizing screen.

With polarizing screen.

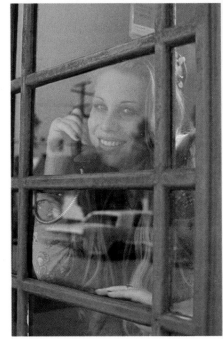

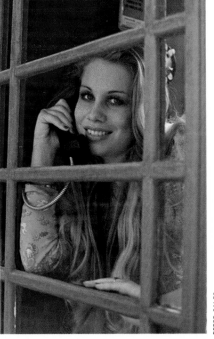

Without a polarizing screen over the camera lens, you may see distracting reflections when you photograph through glass.

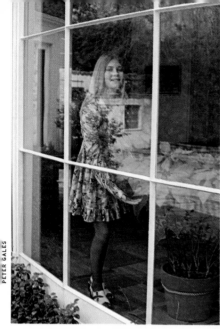

With a polarizing screen, the reflections are eliminated.

This comparison shows how a polarizing screen reduces reflections and makes colors appear deeper and more saturated.

Without polarizing screen.

With polarizing screen.

Conversion Filters

Color-slide films are balanced for specific light sources. Daylight films are balanced for daylight, blue flash, and electronic flash; Type A films for 3400 K photolamps; and tungsten films (formerly Type B) for 3200 K tungsten lamps. When you want to use these films with other light sources, you'll have to use a conversion filter to change the color quality of the light source to match the color quality of the light for which the film is balanced. For example, if you want to use KODAK EKTACHROME-X Film, which is balanced for daylight, with 3400 K photolamps, use a No. 80B blue filter over your camera lens.

Since these filters absorb light, your film will have a lower effective film speed (ASA) when used with a filter. The table on page 46 gives the proper conversion filter and film speed for Kodak color-slide films.

Generally, it's better to choose a color film designed for the light source you're using so that you won't have to use conversion filters.

EXPOSURE METERS AND AUTOMATIC CAMERAS

An exposure meter is an invaluable tool for any serious photographer. When lighting conditions are unusual —for example, late in the day, indoors, in the shade, at night, or on overcast days—*the eye is not a reliable exposure guide.* In such situations, an exposure meter that is correctly used is the best means for determining exposure.

Many modern cameras have built-in exposure meters. Automatic cameras have built-in meters that automatically set the lens opening or the shutter speed for proper exposure. Other cameras have meters that indicate the proper camera settings. Then you set the lens manually.

Orange color balance—the result of using a daylight color-slide film with 3400 K photolamps and no filter.

PETER GALES

Correct color balance—a No. 80B filter was used over the camera lens to convert the 3400 K lighting for use with daylight color film.

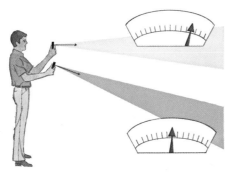

Some exposure meters give misleading readings if they are not pointed slightly downward in daylight. The manufacturer's instructions will tell you the proper way to use your meter.

The best way to get the most out of your exposure meter is to follow the instructions provided by the manufacturer. In addition, you always need to use your own common sense when you use the meter, because in some situations you may not be able to take the meter reading at face value. Many exposure meters, for example, give misleading readings if they are not pointed slightly downward in daylight. Any meter will give a reading that is too high if the sky is allowed to influence it on an overcast day. In fact, you should at least question any meter reading that calls for much less exposure (smaller lens openings or higher shutter speeds) than the exposure shown in the film instruction sheet for the same lighting conditions.

You need to be particularly cautious whenever you are photographing a light subject in dark surroundings or a dark subject in light surroundings. In such cases, you can get a more reliable exposure reading by moving up close to the main subject to make the reading. The effect of the surroundings will then be greatly reduced. If it's not possible or practical for you to get close to the subject, you might still be able to make a reading from a similar subject in similar lighting. With an automatic camera, move in close to your subject so that the subject fills the viewfinder.

Whether you use an automatic camera or a separate exposure meter, you'll find that exposure meters simplify picture-taking and are especially useful under unusual lighting conditions.

On overcast days, it's better to keep the sky out of your pictures. Tip the meter down when you take a reading, because the sky is much brighter than subjects on the ground, and the bright sky will fool your meter.

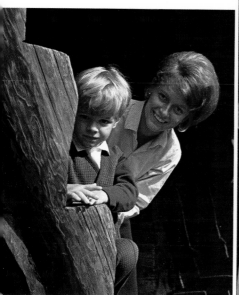

The great brightness differences between the subjects and the backgrounds make these pictures contrasty and can fool your exposure meter. Base your exposure on the most important part of the scene.

FILM SPEEDS—FOR USE WITH EXPOSURE METERS OR AUTOMATIC CAMERAS

The film speeds listed in the following table and published in film instruction sheets are numbers that show the sensitivity of the films to light. The higher the number, the more sensitive, or "faster," the film. You set this number on exposure meters and on some automatic cameras. On other automatic cameras, such as KODAK INSTAMATIC® Cameras, the film speed is set automatically by a notch in the film cartridge when you load the camera.

There's nothing magic about these numbers, and you should feel free to adjust them to get the results you want. If your slides are consistently too dark, use a slightly lower film-speed setting. If your pictures are consistently lighter than you like them, try using a slightly higher number than the published one. For example,

the speed of KODACHROME 25 Film (Daylight) is ASA 25. For darker slides, set your meter or automatic camera at 32 or 40. If you want your slides lighter, try 20 or 16. You can adjust the speed of any film this way (provided the speed is not automatically set by the cartridge) in order to produce the slide density you prefer.

When you use a filter that requires an exposure increase, just set the *speed of the film with the filter* on the film-speed dial of your camera or exposure meter. If your camera has a built-in exposure meter which makes the reading through a filter used over the lens, you should set the built-in meter for the *speed of the film without a filter.* However, since manufacturers' instructions for this type of camera vary depending on the camera and the color of the filter, be sure to read the instructions in your camera manual for exposure with filters.

FILM SPEEDS FOR *KODAK* FILMS

KODAK Color Film	Balanced for	Film Speed and Filter		
		Daylight	Photolamps (3400 K)	Tungsten (3200 K)
KODACHROME 25 (Daylight)	Daylight, Blue Flash, or Electronic Flash	ASA 25 No filter	ASA 8 No. 80B	ASA 6 No. 80A
KODACHROME 64 (Daylight) EKTACHROME-X		ASA 64 No filter	ASA 20 No. 80B	ASA 16 No. 80A
High Speed EKTACHROME (Daylight)		ASA 160 No filter	ASA 50 No. 80B	ASA 40 No. 80A
		ASA 400* No filter	ASA 125* No. 80B	ASA 100* No. 80A
KODACOLOR II†		ASA 80 No filter	ASA 25 No. 80B	ASA 20 No. 80A
KODACHROME II Professional (Type A)	Photolamps (3400 K)	ASA 25 No. 85	ASA 40 No filter	ASA 32 No. 82A
High Speed EKTACHROME (Tungsten)	Tungsten (3200 K) or Existing Tungsten Light	ASA 80 No. 85B	ASA 100 No. 81A	ASA 125 No filter
		ASA 200* No. 85B	ASA 250* No. 81A	ASA 320* No filter

*With EKTACHROME Film Special Processing, 135 or 120 size; see page 110.
†This film is for color prints, but you can have color slides made from the negatives. See page 333.

DAYLIGHT EXPOSURE TABLES—DETERMINING EXPOSURE WITHOUT AN EXPOSURE METER

Daylight exposure tables that are printed in film instruction sheets will give reliable exposure settings for most of your outdoor picture-taking situations. The exposure settings depend on the sun and sky conditions, the direction of the light, and the na-

DAYLIGHT EXPOSURES—*KODACHROME 64* FILM				
Shutter Speed 1/125 Second				
Bright or Hazy Sun on Light Sand or Snow	**Bright or Hazy Sun (Distinct Shadows)**	**Cloudy Bright (No Shadows)**	**Heavy Overcast**	**Open Shade†**
f/16	f/11*	f/5.6	f/4	f/4
*f/5.6 at 1/125 second for backlighted close-up subjects. †Subject shaded from the sun but lighted by a large area of sky.				

ture of the subject and its surroundings. The table above is from an instruction sheet for KODACHROME 64 Film (Daylight). The tables work because the conditions you are most likely to encounter are grouped into a few easily recognized situations.

Here's a good rule to remember in case you misplace the film instruction sheet and you don't have an exposure meter: The basic exposure for

For example, with KODACHROME 64 Film, ASA 64, the exposure is 1/60 second (round 64 to 60) at f/16 or 1/125 second at f/11. The exposures for the other daylight conditions are 1, 2, or 3 stops away from the basic sunlight exposure as described in the following discussion. If you memorize these rules, you can determine daylight exposures without a reference, if necessary.

$$\text{FRONTLIGHTED AVERAGE SUBJECTS IN BRIGHT OR HAZY SUN (DISTINCT SHADOWS)} \quad \text{is} \quad \frac{1}{\text{FILM SPEED}} \quad \text{SECOND at } f/16$$

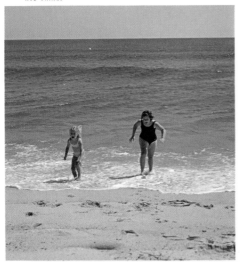

Bright or Hazy Sun on Light Sand or Snow

When the surroundings are very bright —as when the sun is shining on a *light*-sand beach, on water, or on snow—they reflect more light. In such situations, use an exposure 1 stop less than the exposure for an average subject.

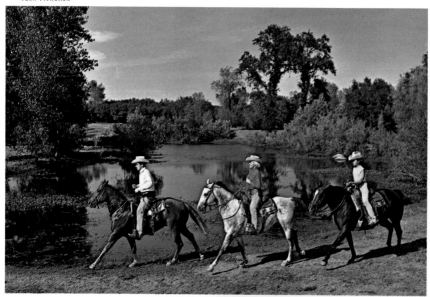

Bright or Hazy Sun— Frontlighting

This is the most usual, or basic, condition for outdoor picture-taking. Fortunately, sunlight is quite constant from 2 hours or so after sunrise to about 2 hours before sunset, so you can use the same exposure during most of the day. The sky condition may vary from a clear blue to a definite haze or scattered clouds, as long as the sun is strong enough to cast distinct shadows.

49

DON BUCK

Bright or Hazy Sun—Sidelighting and Backlighting

When the sun is at the side or back of the subject, the side toward the camera is in shade. This makes little difference with distant subjects, such as scenic views, but with close-ups more exposure is needed. For sidelighting, give 1 full stop more than for a frontlighted subject; for backlighting, give 2 stops more.

TONY PETROCELLI

50

Cloudy Bright

When the sun is obscured by light clouds so that it doesn't cast shadows, you will usually get a good picture with an exposure of 2 stops more than that for the basic sunlight condition. The sky may be completely overcast, or there may be scattered clouds. You cannot see the sun's disk, but you can tell where it is by a local bright area in the clouds.

Heavy Overcast

When the sky is completely overcast and there is no bright area to show the position of the sun, use an exposure meter if you have one. If not— and if there are no extremely dark areas in the sky which indicate an approaching storm—you can generally get acceptable pictures with an exposure of 3 stops more than that for basic sunlight conditions.

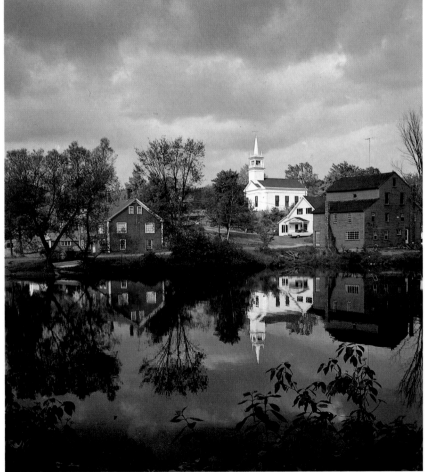

ESTHER HENDERSON

Open Shade

Open shade is the lighting condition in which your subject is shaded from the sun by a large nearby object that is not overhanging the subject. The illumination comes from a large area of open sky overhead and in front of the subject. Open shade usually requires an exposure increase of 3 stops over that for sunlight conditions. Here again, it is desirable to use an exposure meter, because conditions can vary widely.

53

When there is very little difference in brightness between the darkest and lightest areas in a scene, you have a good bit of exposure latitude.

This is an average subject with a normal brightness range. Exposure can vary by ½ stop in either direction without a severe loss in quality.

EXPOSURE LATITUDE

Color-slide (reversal) films do not have the great exposure latitude of negative films. It's important that your exposure be correct so that your slides will be of high quality. For subjects of average contrast, you can vary the exposure about ½ stop on either side of the "ideal" exposure without a severe loss of quality. The actual exposure latitude a photographer has in making transparencies depends on a number of things. When the brightness range of the subject is short, for example, and the lightest and darkest objects in the scene do not differ greatly in brightness, there is increased exposure latitude. This is frequently the case in aerial photography, where the subject is usually a uniformly lighted, uniformly reflective surface having a short brightness range. In such a case, exposure can vary about 1 stop in either direction from the "correct" exposure and still produce acceptable slides.

In the case of a very contrasty scene which includes both dense shadows and brilliant highlights, no single exposure will be correct for everything in the picture, so you must expose for the most important part of the scene.

TAKE CARE OF YOUR FILM

Color film has two enemies—heat and high humidity. Protect your film from these villains by storing it in a cool, dry place. The glove compartment, trunk, and rear window of a car in the sun are hot places. So when you travel, store your film on the car floor, away from the area of the hot exhaust muffler and out of direct sunlight. Also avoid storing your film or slides in damp basements or hot attics. Unprocessed film that has been stored in hot, damp places will often appear greenish, and colors will be degraded. Some antimildew agents and moth-balls can ruin film, so store your film away from these items, too.

Under normal temperature conditions (below 75°F [24°C]), Kodak amateur films do not require refrigeration. Always expose the film before the expiration date and have it processed promptly.

Exposure to excessive doses of x-rays will spoil unprocessed film by fogging it. Carry-on luggage of airline passengers is subject to inspection by x-ray devices. However, these are low-dosage devices, and unprocessed film carried by most passengers will not show visible effects from the x-rays even after two or three inspections. If you don't want to have your films subjected to x-ray inspections, you can request a hand inspection by security officials.

If you're going to mail packages containing unprocessed films from one country to another, you should label the package **"Undeveloped Photographic Film. Please Do Not X-Ray."** Film processing mailers that are provided by processors and are clearly marked as film usually are not x-rayed.

Now that we've discussed some basic techniques, it's time to take a close look at some of the special "tricks of the trade" that help to create exciting, eye-catching, prizewinning slides.

Watch the Light Outdoors

The light around us is constantly changing in color, direction, and intensity. The perceptive color photographer will plan in advance to make these variations work to his advantage. Here are some of the situations that you will meet and some pointers on how to handle them.

BRIGHT SUN

A majority of the color slides made are taken on clear, bright days. Sunny-day color picture-taking has many advantages: Colors are brilliant, exposure is simplified for most subjects to the extent that simple exposure guides will give all the information you need, and you can use smaller lens openings or higher shutter speeds than on any other kind of day.

At the same time, brilliant sun can produce problems, such as harsh, black shadows and strong, contrasty lighting. This is a difficulty, especially in pictures of people, because the relatively short scale of the photographic process can't successfully record bright highlights and dark shadow areas in the same scene. If you expose for the highlights, the shadows tend to appear unnaturally dark; if you expose for the shadows, the highlights become washed-out and colorless. Since neither alternative is pleasant, you should use some method to reduce lighting contrast by making the shadows lighter.

Fill-in flash eliminates harsh shadows and produces pleasing lighting. The camera was set for an average *frontlighted* subject in sunlight.

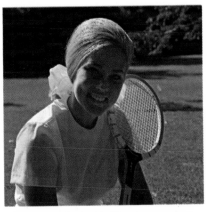

Without fill-in flash and with no exposure compensation, the shadow side of the face is much too dark.

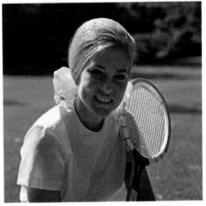

Fill-in flash was not used, but more exposure was given to obtain more detail in the face. This picture is better than the one in the middle, but not as good as the one made with fill-in flash.

PETE CULROSS

56

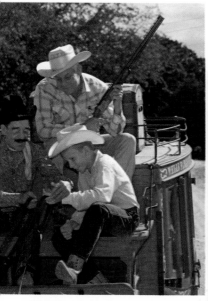

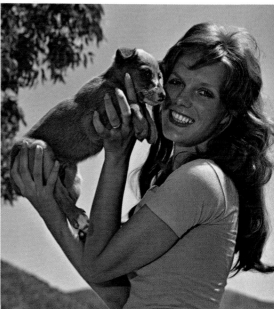

Fill-in flash helps you obtain pleasing expressions in pictures of people because your subjects don't have to squint into the sun.

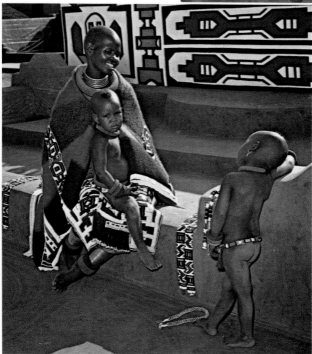

FILL-IN FLASH

One method for lightening shadows and reducing lighting contrast is to use fill-in flash in bright sunlight. Fill-in flash also eliminates the squinting problem that arises when the sun shines in people's faces. Place your subject with the sun at his back or side. Then fill in the shadows with the light from a blue flashbulb or an electronic flash unit. To preserve the natural sunlight effect, the light from the flash should lighten the shadows, not eliminate them.

Set your camera for an average *frontlighted* subject in sunlight. Keep your subject within the distance range listed in the appropriate table on page 60 for your flashbulb, reflector, and shutter speed, and take the picture with flash.

With a camera synchronized for normal flash pictures at 1/30 second, or with any camera set at "X" synchronization, you can take fill-in flash pictures at either 1/30 or 1/60 second with flashbulbs or flashcubes. For cameras with "M" synchronization, you can use any shutter speed for fill-in flash with flashbulbs (except with M2B flashbulbs). If you have an electronic flash unit, you can use any shutter speed with a camera with a leaf-type shutter and "X" synchronization. Your camera manual will tell you whether your camera has "X" or "M" synchronization.

If your camera has a focal-plane shutter, you can use focal-plane flashbulbs with "FP" sync at any shutter speed or electronic flash with "X" sync at the shutter speed recommended in your camera manual. You may be able to use conventional-type flashbulbs and flashcubes with your focal-plane camera, too, depending on the camera manufacturer's instructions. See your camera manual.

Fill-in flash.

No fill-in flash was used and no exposure compensation was made for backlighting.

58

No fill-in flash was used. Exposure was increased by 1½ stops from a normal frontlighted exposure.

Fill-in flash

PETER GALES

No fill-in flash and no exposure compensation.

SUBJECT DISTANCES FOR FILL-IN FLASH WITH BLUE FLASHBULBS IN BRIGHT SUNLIGHT

(Distance in Feet)

Type of Reflector	Blue Flashbulb	Shutter Speed						
		X Synchronization		M Synchronization				
		1/30	1/60	1/30	1/60	1/125	1/250	1/500
	Flashcube	3½-5-8	2½-3½-6	2½-3½-6	3½-5-8	4-5½-9	3½-5-8	4-5½-9
	Hi-Power Flashcube	5-7-11	3½-5-8	3½-5-8	5-7-11	6-8-13	5-7-12	6-8-13
	Magicube	3½-5-8	NR	NR	NR	NR	NR	NR
	AG-1B	1½-2-3	1½-2-3½	1-1½-2½	1½-2-3½	2-3-4½	2-3-4½	2-3-4½
	M2B	3-4-7	3½-5-8	NR	NR	NR	NR	NR
	AG-1B	3-4-7	3-4-7	2-3-5	3-4-7	4-5½-9	4-5½-9	4-5½-9
	M3B	4½-6-10	3½-5-8	4½-6-10	5½-8-12	6-8-14	6-8-14	6-8-14
	5B, 25B	4½-6-10	2½-3½-6	4½-6-10	5½-8-12	6-8-14	6-8-14	6-8-14
	M2B	4-5½-9	5½-8-12	NR	NR	NR	NR	NR
	AG-1B	4½-6-10	5-7-11	3-4-7	4½-6-10	5½-8-13	5½-8-13	5½-8-13
	M3B	6-8-14	5-7-11	6-8-14	8-11-18	9-13-20	9-13-20	9-13-20
	5B, 25B	6-8-14	3½-5-8	6-8-14	8-11-18	9-13-20	9-13-20	9-13-20
	6B, 26B	FP Synchronization ►		6-8-14	6-8-14	6-8-14	6-8-14	6-8-14

NR—Not Recommended

SUBJECT DISTANCES FOR FILL-IN FLASH WITH ELECTRONIC FLASH IN BRIGHT SUNLIGHT

(Distance in Feet)

Output of Unit BCPS	Shutter Speed with X Synchronization*				
	1/30	1/60	1/125	1/250	1/500
350	1½-2-3½	2-3-4½	3-4-7	3½-5-8	4½-6-10
500	2-3-4	2½-3½-5½	3½-5-8	4-5½-9	5½-8-13
700	2-3-4½	2½-3½-6	4-5½-9	4½-6-10	6½-9-15
1000	2½-3½-5½	3½-5-8	5-7-11	6-8-13	8-11-18
1400	3-4-7	4-5½-9	6-8-13	7-10-15	9-13-20
2000	3½-5-8	5-7-11	7-10-15	8-11-18	11-15-25
2800	4-5½-10	6-8-13	8-11-18	10-14-20	13-18-30
4000	5-7-11	7-10-15	10-14-20	12-17-25	15-21-35
5600	6-8-13	8-11-18	12-17-25	15-21-30	18-25-40
8000	7-10-15	10-14-20	15-21-30	17-24-40	20-28-50

*For cameras with focal-plane shutters, use the shutter speed that your camera manual recommends for electronic flash.

REFLECTORS

Another way you can reduce lighting contrast is by using reflectors. Pose the subject just as you would for fill-in flash, with the sun at his back or side. But instead of using flash to fill in the shadow areas, use a reflector to bounce the sunlight into the shadows. The reflector can be almost anything that will reflect light—a white matte board, a large piece of white paper, a piece of cardboard covered with a crumpled piece of aluminum foil, or even a newspaper. A white shirt on the photographer makes a good reflector for close-ups. Just remember that the reflector must be white or near-white in color, because a colored reflector will bounce colored light into the shadows—an unpleasant effect guaranteed to make you the family's least favorite photographer.

Try to bounce enough light from the reflector into the shadows to make them no more than 1 stop different in exposure from a normal sunlight exposure. Use an exposure meter, and base your exposure on the reading you get from the highlight areas.

Notice how the shadows in the picture on the top have been filled in by the light reflected from a large white card.

PETE CULROSS

Ask a helper to hold the reflector for you, or tape the card to an object such as a camera tripod.

A reflector helped brighten the shadow side of the subject.

The light clothing in this picture acted as a natural reflector and bounced light into the subjects' faces.

NATURAL REFLECTORS

It's often possible to take advantage of natural reflectors, such as sand, snow, water, and light-colored buildings. If you can position your subject near one of these light-reflective surfaces, the reflected light will illuminate the shadows, and you'll obtain pleasing lighting.

As we said before, avoid colored reflectors. If you use a red brick building for a reflector, your subject will resemble the "before" picture in a sunburn-lotion ad.

NORM KERR

Some scenes include natural reflectors, such as water, which will lighten shadow areas. Try to take advantage of them. In this picture, the water in the swimming pool served as a reflector.

ROD GRIMES

In this slide, the book made an effective reflector.

H. MAYER

Light sand and snow are excellent reflectors which lighten the shadows.

IN THE COOL SHADE

When there are no natural reflectors available, you can reduce lighting contrast by having your subject step out of the direct rays of the sun and into the "soft" lighting of open shade. Open shade is the shade cast by large nearby objects; you should be able to see a large area of blue sky overhead. The light falling on your subject will be cool in color or predominantly blue because it's coming from the blue sky, not the direct rays of the sun. You may want to warm up the scene a bit by using a skylight filter. This filter requires no exposure compensation.

When you take pictures of subjects in the shade, it's important that they be entirely in the shade, not partly in sunlight. A subject partly in the shade and partly in sunlight has very contrasty lighting which is usually poor for photography.

WALLACE MAC LAREN

Photograph your subjects in the shade for soft, pleasing lighting. Out of the sun, harsh shadows and squinting expressions disappear.

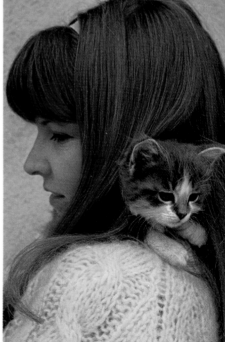

64

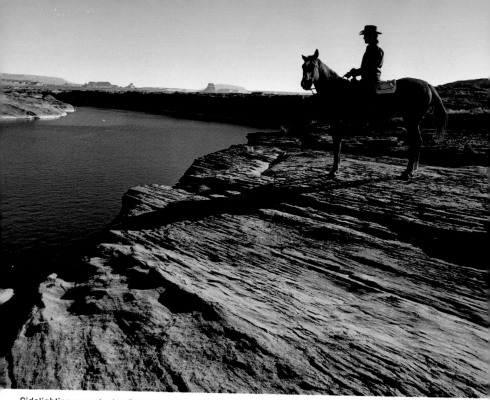
Sidelighting accentuates the texture in the rock and creates highlights on the horse and rider. GEORGE INGRAM
These effects add depth and dimension to the picture.

SIDELIGHTING AND BACKLIGHTING

When there is good color separation between the subject and its background, frontlighting can be very effective. And yet, for striking and dramatic slides, sidelighting or backlighting is often just the ticket. You can use sidelighting or backlighting to produce strong separation between the subject and the background or to reveal the delicate texture in translucent subjects like leaves and flowers. Remember to shield your lens from the sun's direct rays. You can use a lens hood or just the shadow from your hand—but be sure to keep your hand out of the picture.

When you use sidelighting or backlighting, you'll usually need to give the film more exposure than for frontlighted subjects, assuming you're not using fill-in flash or reflectors to lighten the shadows. In close-up pictures, especially of people, the shadows are likely to be large and to contain important details, so an exposure increase is a must. Increase your exposure for sidelighted subjects 1 full stop, and give backlighted subjects 2 stops more exposure than you would a normal frontlighted subject. When your subject is at a medium distance —for example, about 15 feet away— with a sunlit background, give only ½ stop more exposure for sidelighting and only 1 stop more for backlighting. For distant scenes, where the shadows are a relatively small part of the picture and contain no important detail, you don't have to increase the exposure for sidelighting or backlighting.

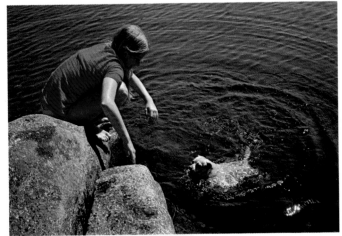

Backlighting made the water sparkle, which enhances this picture of the dog's swimming lesson.

The highlights produced by backlighting separate the subjects from the background and help to create a three-dimensional effect. These two pictures show the same scene (from opposite sides) frontlighted and backlighted.

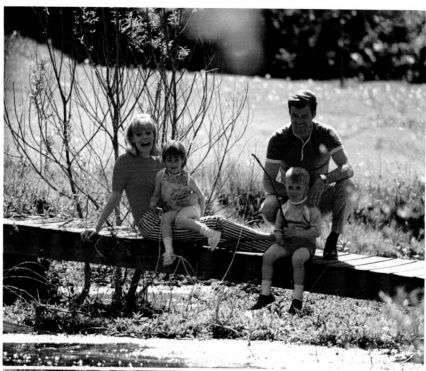

Backlighting helps promote happy faces since your subjects
don't have to face the sun.

The benefits of backlighting have made these slides superb.

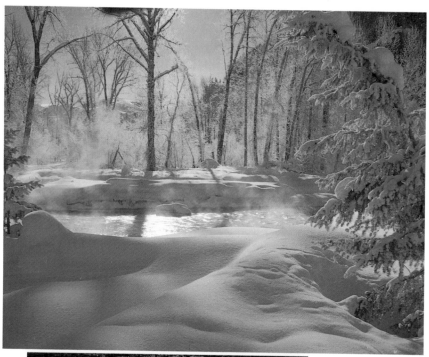

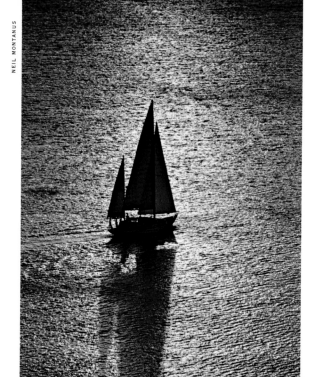

NEIL MONTANUS

HAZY DAYS

A slightly hazy or overcast day is one of the color photographer's best friends. Light coming from the sky on such a day is diffused, soft, and even. The need for fill-in flash or reflectors is eliminated, because there are no harsh shadows. Colors are somewhat less saturated than in bright sunlight, but tend to reproduce as lovely pastels. These conditions are wonderful for taking pictures of people.

When the sky is hazy but there are distinct shadows, exposure is the same as for subjects in bright sunlight. On overcast days when the sky looks white and is described as "Cloudy Bright" (see description on page 51), increase exposure by 2 stops. For conditions in between—when there is a heavy haze, the sun's disk is faintly visible, and shadows are weak and indistinct—use 1 stop more exposure than recommended for bright sunlight.

Because a hazy sky is a uniformly bright light source, it will appear overexposed if it's included in the picture. (On clear days, the blue sky isn't much brighter than the subject itself.) Therefore, it's a good idea not to include much sky area, because a hazy, colorless sky will rarely be pleasing in a color picture. If you use an exposure meter, tip it down slightly when taking a reading. If the meter "sees" the bright sky, it will give a false reading that's too high, and underexposure will result. If you're using a camera that automatically sets the exposure, try to take the picture from an angle that lets you exclude most of the sky from the picture.

70

When the sky is hazy or overcast, it's an excellent time to take pictures of people, because there are no contrasty shadows. The light is diffused, soft, and even, and colors tend to be reproduced as pleasing pastels.

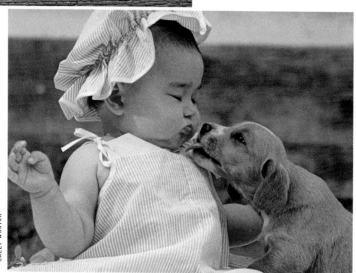

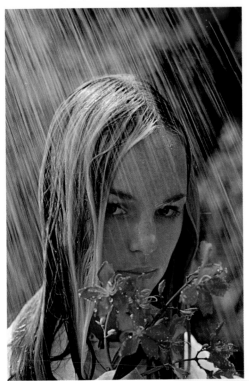

RAINY DAYS

If it seems foolish to think about taking black-and-white pictures on rainy days, it may seem even more foolish to consider using color film in the absence of sun, sparkling colors, and blue skies. Not so! Some of the best "mood" pictures are made on rainy or overcast days. Pictures made under such conditions usually have a characteristic bluish color which can help create an eerie feeling in some scenes.

Under the adverse lighting conditions on overcast or rainy days, the extra speed of KODAK High Speed EKTACHROME Film (Daylight) is very useful. Use an exposure meter or an automatic camera to determine the proper exposure.

J. SCHNEIDER

DENNIS HALLINAN

Try taking pictures right after a rainstorm to capture a fresh, different effect. Any unusual weather conditions provide good picture opportunities.

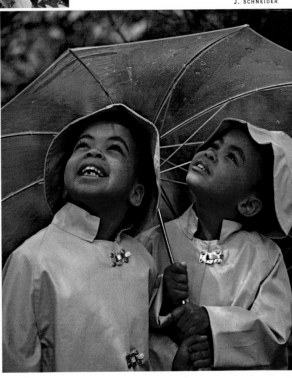

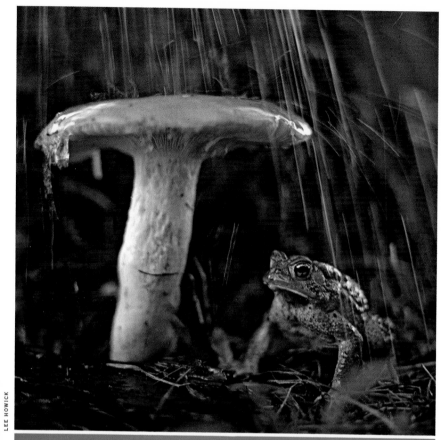

LEE HOWICK

NORM KERR

73

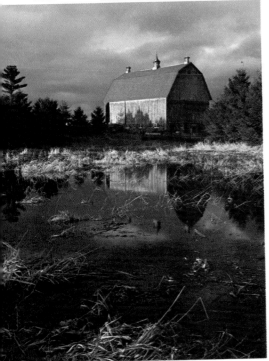

Early and late in the day the shadows are long, and scenes take on the warm glow of the rising or setting sun. This is a good time to make dramatic color pictures. The long shadows bring out the texture in the scene and provide interest for your pictures.

"AFTER-HOURS" COLOR

You may have heard the advice that it's best not to take color pictures during the periods 2 hours before sunset and after sunrise. In a few instances, this is good advice and will keep the people in your pictures from having orange flesh tones. But for many subjects, the warm, reddish-orange color of the rising or setting sun can be used with great effectiveness. Buildings, water, mountains—all are strikingly beautiful when bathed in the warm light of the late sun.

Remember that the aim of color photography is not to reproduce things just as they look by normal daylight but to make a pleasing picture. Many excellent pictorial and mood pictures are made at the "wrong" time, and with the "wrong" light, but they are lovely to look at because they combine colors and patterns to create a pleasing sensation in the viewer.

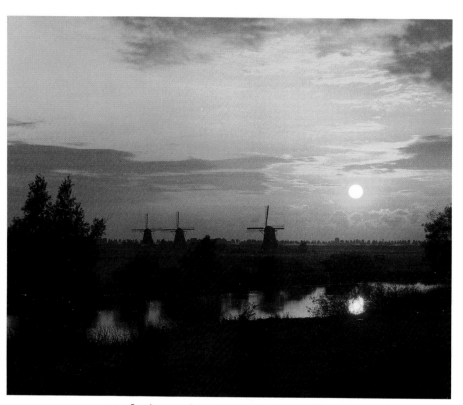

Good sunset pictures will always make a hit
with your audience. Sunsets are easy to take, too;
see page 270 for hints on how to do it.

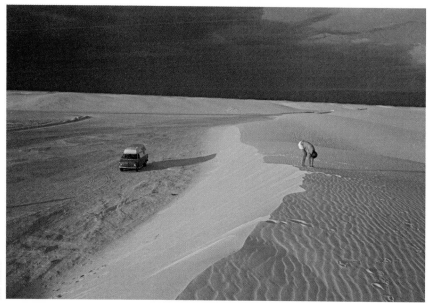

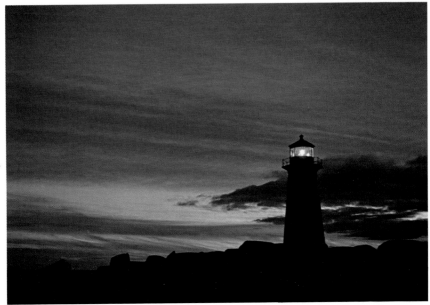

In the short space of time after the sun has disappeared but before it's really dark, you can make pictorial mood pictures.

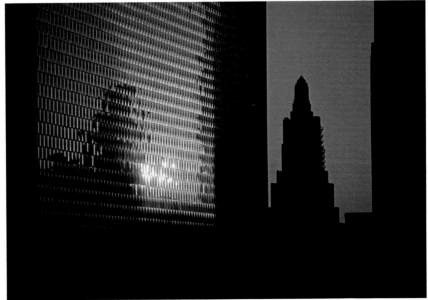

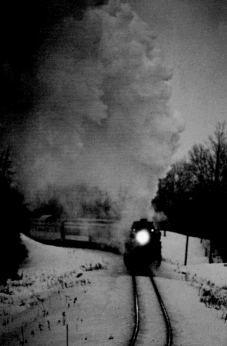

ATMOSPHERIC INFLUENCES

Filling the air with smoke and fumes may be an evil of civilization, but it offers the color photographer opportunities for some truly different pictures. A variety of atmospheric influences, including dust, fog, and smoke, should be included in your slides. Good places to look for these are construction sites, mines, factories, and mills. Large bodies of water often produce rolling banks of fog or mist. These additions to the air around us make the everyday world seem strange and different—even exotic, if handled properly.

Include atmospheric influences such as smoke, fog, and rain in your pictures for variety and mood. Use an exposure meter to determine the exposure for these unusual lighting conditions.

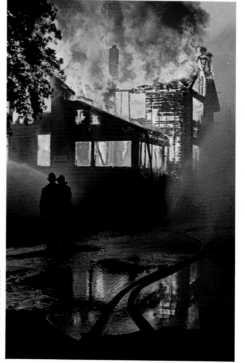

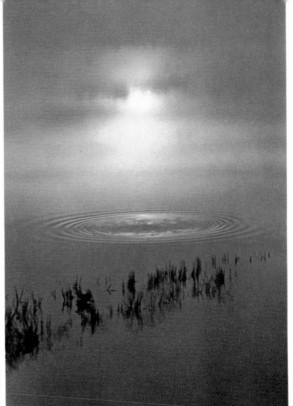

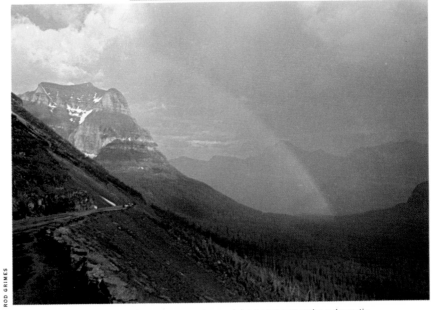

Almost any time you encounter a rainbow, you can make a dramatic
and interesting picture. Expose as you normally would for the sun and sky
conditions. Avoid overexposure to prevent lightening the colors of the rainbow.

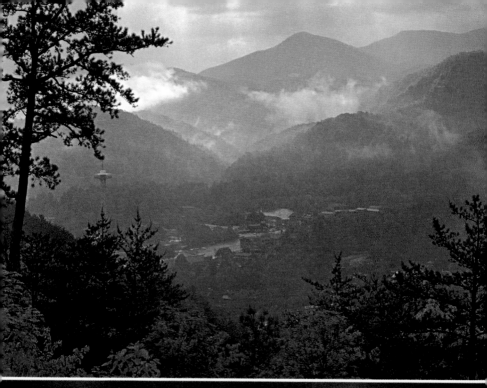

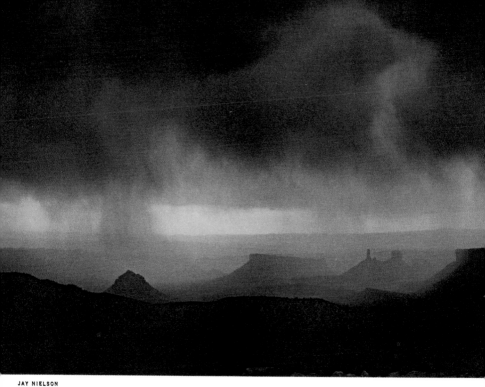

JAY NIELSON
ALLAN HORVATH (TOP)

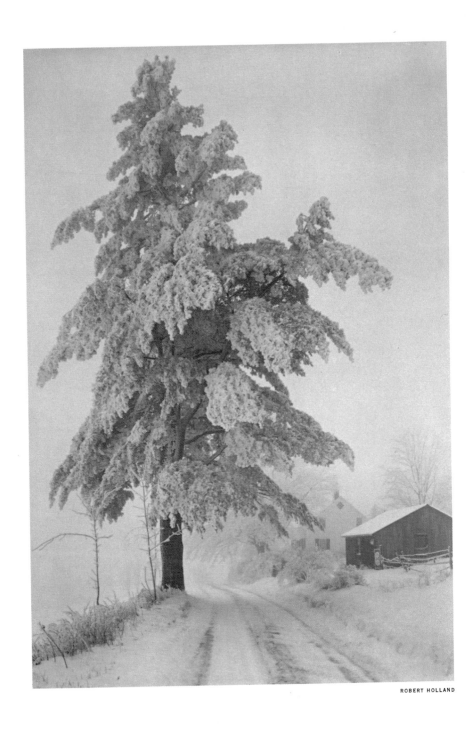

ROBERT HOLLAND

80

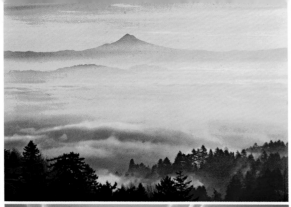

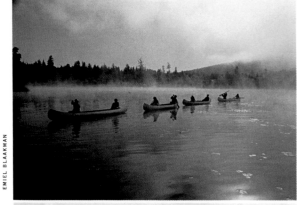

Keep your camera ready
and take several pictures,
because conditions can
change rapidly when an
atmospheric phenomenon
is included in the scene.

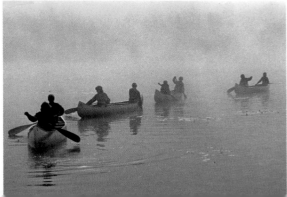

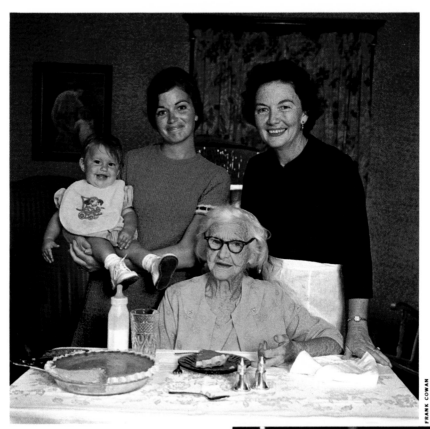

Flash pictures are fun because they're so easy to take. You don't have to be concerned about whether or not there's enough light since you have your own portable light source.

Pictures in a Flash

Many indoor pictures are taken with flash because modern flash equipment makes indoor flash pictures as easy to take as outdoor pictures. Here are some good ideas to help you make the most of your picture-taking opportunities.

FLASH ON CAMERA

Flash on the camera is used by most people most of the time because it's fast, predictable, very convenient, and it can yield first-class pictures.

Exposure for flash pictures is easy. The lens opening you need for good exposure depends on the distance between the flashbulb and the subject. The greater the distance, the larger the lens opening you need. Some modern cameras have the lens-opening scale coupled with the focusing scale. As you focus the camera, the lens opening automatically changes for best exposure.

With manually adjustable cameras, you use flash guide numbers to determine the right lens opening. A guide-number table is included in the instruction sheet packaged with most Kodak color films. Simply divide the guide number by the distance between the flash and the subject. The answer is the right *f*-number, or lens opening, for that subject distance. If the guide number is 110, for example, and you're 10 feet from the subject, you divide 110 by 10 feet. The answer is 11, so set your lens at *f*/11.

Before you take any flash pictures, check the instruction sheet to make sure you're using the right kind of flashbulbs. Kodak color-slide films for daylight are balanced for use with blue flashbulbs or electronic flash.

After you've made a flash picture, your subject will sometimes say, "I think I blinked." If he did, it spoils the picture, of course. When this happens, ask if the flash appeared red or white. If he says "Red," your subject did blink, because red is the color transmitted by closed eyelids, and you'd better take another picture.

A startling effect occasionally appears in color flash pictures, in which the pupils of a person's eyes look red or amber. This phenomenon is

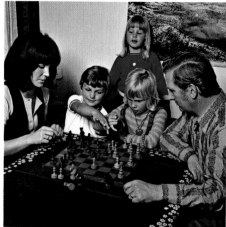

NEIL MONTANUS

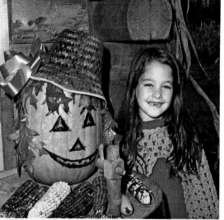
ROBERT CHAET

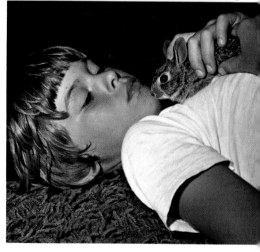

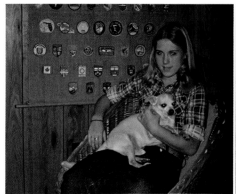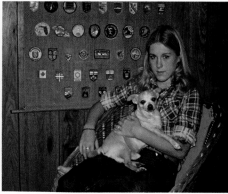

With a camera that doesn't have much separation between the flash and the camera lens, your pictures may show a red or amber reflection in your subject's eyes. To minimize this effect, use an extender, or detach the flash holder to move the flash away from the lens if this is possible with your camera.

caused by light from the flash being reflected from the blood-rich choroid layer behind the retina of the subject's eyes. It's more prevalent in pictures of children than of adults. Such reflections can appear when the flash is close to the camera lens.

You can minimize this effect by moving the flash farther away from the camera lens axis so that the camera doesn't "see" the reflections in the subject's eyes. To increase the separation between the flash and the camera lens, you can use a KODAK Magicube or Flashcube Extender with a KODAK INSTAMATIC Camera, de-

pending on the cube your camera takes, or with other cameras you can hold the flash away from the camera if the flash is detachable.

If your camera takes the eight-bulb flipflash, you usually won't need an extender because one is built into the flipflash. Since the top four bulbs which are in the flash position are separated from the camera lens by the construction of the flipflash, this acts as an extender. However, if your subject's eyes are especially reflective, you can reduce the possibility of eye reflections even more by using a KODAK Flipflash Extender.

By taking the picture at an angle to shiny background surfaces, you can avoid a distracting glare spot in pictures taken with flash on the camera.

When the flash is aimed directly at a shiny background surface, you'll get a reflection of the flash in your picture.

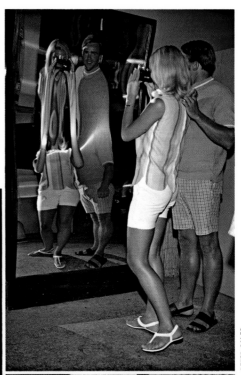

The flipflash has a built-in extender
to minimize red reflections in the eyes.
(Only the top four bulbs will flash when the
flipflash is on the camera.)

Windows, mirrors, and shiny walls are
backgrounds to watch out for. Take your
pictures at an angle to the background to
avoid an annoying glare spot from the flash.
The girl in front of the mirror should move
to one side to take the picture.

Other ways in which you can minimize the red reflections are to turn on all the room lights, open the window drapes in the daytime, or have your subject look directly at one of the room lights or windows. This causes the subject's pupils to contract and reduces the intensity of the reflected light from the flash in the subject's eyes.

Here are two more pointers that will help you take better flash pictures.

1. Watch the background. Mirrors, windows, and shiny walls can bounce light back into the lens and cause distracting reflections in your slides. Take pictures at an angle to such shiny surfaces.

2. Keep the flash *above* the lens. Light from below the subject's face creates poor lighting and an unflattering effect that's strictly for Halloween parties, horror movies, and gag shots.

Flash directed upward from below the subject's face is okay for a humorous effect or to make someone look scary on Halloween. However, this is not a good technique for flattering your friends!

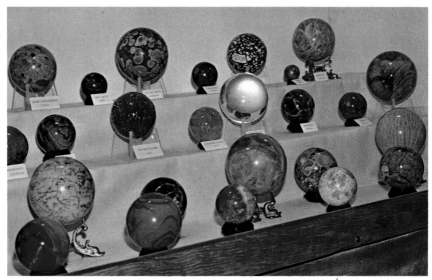

Hobby and trade shows offer many opportunities for flash pictures, such as this slide taken at a rock and mineral show.

A KODAK TRIMLITE
INSTAMATIC 48 Camera with a
KODAK EKTRON Electronic Flash
Unit, Model B.

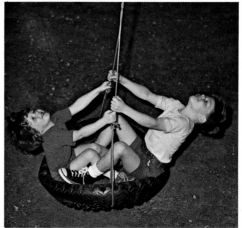

EMIEL BLAAKMAN

Electronic flash "stops" motion
effectively to produce excellent
action pictures.

ELECTRONIC FLASH

Electronic flash units are more expensive to buy initially than other types of flash, but they do offer certain advantages. Electronic flash units have a special lamp called an electronic flashtube. You can get thousands of flashes from one flashtube, and the burst of light produced is much shorter in duration than that from a flashbulb. The extremely short duration of electronic flash is ideal for "stopping" fast action.

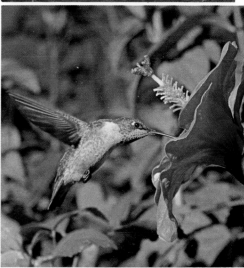

ALFRED SCHULTZ

The brief flash duration allows you to use any shutter speed with cameras that have leaf-type shutters and X synchronization. However, most modern *focal-plane* shutters will synchronize electronic flash only at shutter speeds of 1/60 second or slower. (See your camera manual.) With either type of camera, set the shutter on X synchronization when you use electronic flash. If your camera doesn't have synchronization settings, check the instruction manual to make sure you can use electronic flash with your camera.

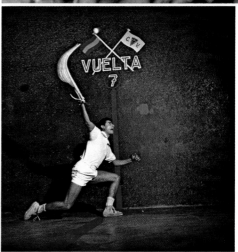

RICHARD BEATTIE

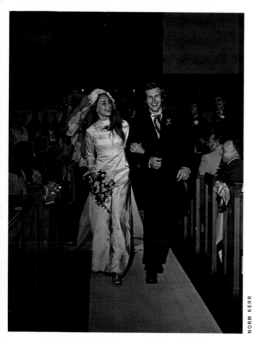

NORM KERR

Electronic flash is especially helpful when you want to take lots of pictures; you don't have to bother changing flashbulbs.

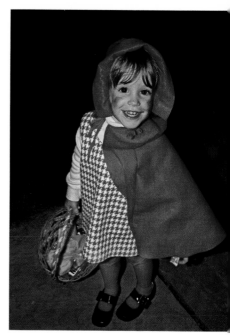

Electronic flash is great for candid pictures of kids. Even if your subjects happen to move as you take the picture, electronic flash will "freeze" the motion.

Exposure with electronic flash is based on the distance from the flash to the subject. Units are available which determine exposure automatically. Once you set the lens opening recommended in the electronic flash manual for the speed of the film you're using, the intensity of the flash automatically adjusts for proper exposure for each picture. With conventional electronic flash units you determine the correct lens opening just as you do when using flashbulbs—by dividing the guide number by the distance from the flash to the subject.

You'll find the guide number for your particular flash unit and film listed on the film instruction sheet. With electronic flash, the guide numbers are the same at any shutter speed. You only have to remember one guide number for each type of film, and it will work with any shutter speed if your camera has a leaf-type shutter and X synchronization.

It's a good idea to use a fast shutter speed of 1/60 or 1/125 second (if your camera permits) if you don't want to record the existing lighting. This is especially important when you use electronic flash to stop action, because with slower shutter speeds you may get double or ghost images of the subject from the existing light in the scene. Remember though, don't use a higher shutter speed than your instruction manual recommends for flash with your camera.

Filters with Electronic Flash

The color of light from most electronic flash units closely approximates that of daylight, and you don't need to use a filter. However, some electronic flash units tend to be slightly blue, especially when the reflector is new. If your electronic flash produces slides that are more bluish than you want them to be, you can use a yellowish filter, such as a No. 81B, to improve the color balance. A ⅓-stop increase in exposure is required when you use this filter. As reflectors age, they may tend to get a little "warmer," or more yellow, in color; after a while you may no longer need the filter.

EMIEL BLAAKMAN

VARIETY IN FLASH LIGHTING

In the preceding two sections we reviewed some of the basic points involved with using flash. As we said before, most of the time you'll probably be using your flash unit on the camera for convenience. However, for those really "special" flash pictures, you may want to spend a little more time and effort, and try some of the following flash techniques. Most of these techniques will work with flashbulbs or electronic flash.

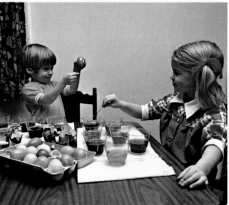

EMIEL BLAAKMAN

Bounce Flash

With this technique you "bounce" the light from the flash off the ceiling or walls of the room. You must be able to remove the flash unit from your camera or tilt the flash so that it's aimed at the ceiling. When you aim your flash at the walls or ceiling, the light which "bounces" back is very diffuse, and it produces soft, even, natural-looking illumination. This type of light is very flattering to your subject because there are no harsh shadows. Avoid bouncing flash from colored walls or ceilings; the color will reflect and tint your subjects.

EMIEL BLAAKMAN

Flash bounced off a white ceiling and walls produces soft, glare-free light which is flattering to your subject.

For bounce flash, you need a detachable flash unit or one which you can tilt upward toward the ceiling.

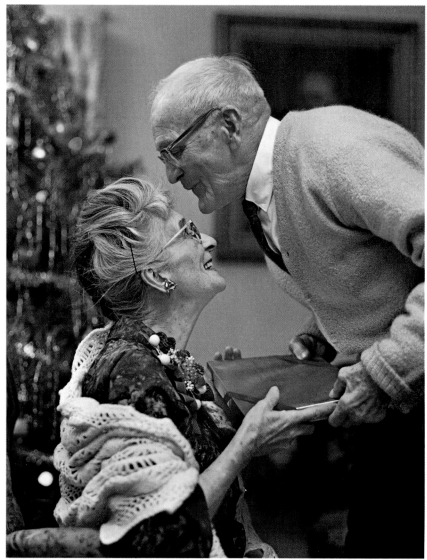

LEE HOWICK

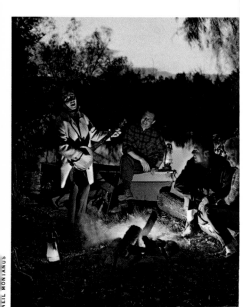

Exposure for bounce flash depends on the size of the room and the total distance the light has to travel from flash to ceiling and back down to the subject. Since the ceiling will absorb some of the light along the way, at least 2 stops more exposure is usually required for bounce flash than for direct flash at the same distance. If you have an automatic electronic flash unit, you'll have to set it on manual and determine the exposure yourself for bounce flash as you would with a nonautomatic flash unit. But if the exposure-sensing device in your flash unit is adjustable so that you can keep it aimed toward the subject, not at the ceiling, you can use the flash on automatic. See the instructions for your flash unit.

Reflectorless Flash

Some flash holders are designed so that you can remove their reflectors. You can obtain a lighting effect similar to bounce flash by removing the reflector and firing a bare flashbulb in the flash holder. You can get the same effect by using a flash holder with a folding reflector in the folded position. The subject is lighted with both direct light from the flash and reflected light from the walls and ceiling.

Bare-bulb flash can give lighting effects that duplicate those produced by a whole battery of photolamps. Careful, though! Colored surroundings reflect colored light, sometimes with unpleasant photographic effects. The best place to try this method is in a small white or light-colored room, such as a kitchen or bathroom. Since no reflector is used to concentrate the light on the subject, exposure will have to be increased by about 2 stops over "straight" flash. For more assurance of good exposure, take additional pictures at 1 stop under and 1 stop over the estimated exposure.

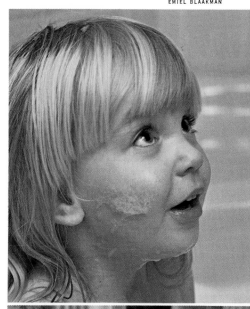

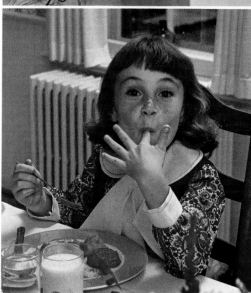

The lighting from bare-bulb flash used at the camera is similar to that from bounce flash except that it is not quite so diffused and soft. Both direct light from the bulb and reflected light from the room illuminate the subject.

A KODAK Flipflash Extender being used for an off-camera lighting effect.

LEE HOWICK

The lighting from off-camera flash produc[es]
shadows that add depth and modeli[ng]
to your subjec[t]

Multiple Flash

You can use more than one flash unit to create a feeling of depth and form in your pictures. With one or two extension or remote flash units, you can have a two- or three-light "studio" anywhere—in your living room, on the back porch, or at a friend's home.

The "main light," which creates shadows and depth on the subject, is usually one of the off-camera units. It is placed closer to the subject than the "fill light." The "fill light" is the flash on the camera which fills in the shadows. You can use a third flash unit to illuminate the background, or as a backlight to produce rim lighting and highlights on your subject. Base your exposure on the distance between the "main light" and the subject you're photographing.

WES WOODEN

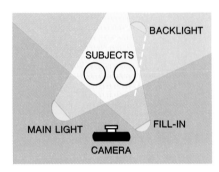

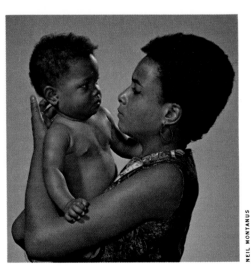

NEIL MONTANUS

Multiple flash with extension or remote flash units can be used to make pictures of excellent quality.

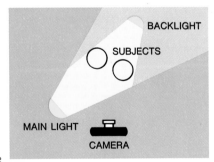

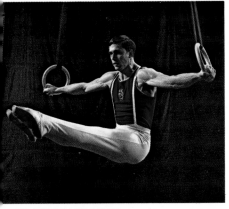

NEIL MONTANUS & BOB CLEMENS

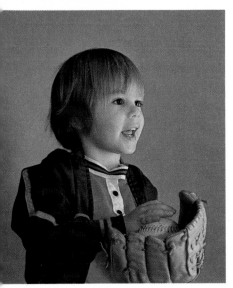

NEIL MONTANUS

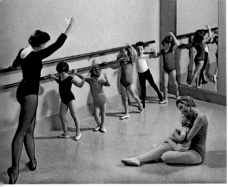

ROBERT PHILLIPS

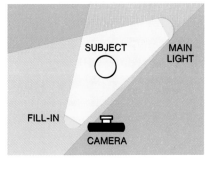

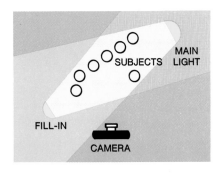

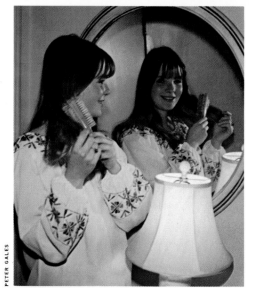

When room lights appear as part of the picture, using a small flashbulb and a slow shutter speed will let those lights register more fully on the film.

Recording Existing Light Plus Flash

When you use flash to take a picture in a brightly lighted room, the light from the flash will tend to overpower the room lights and cause a slightly artificial look. Our eyes are accustomed to seeing light come from the room's lighting fixtures rather than from an unknown source outside the picture. In the same way, flash pictures taken of a fire in a fireplace tend to look somewhat artificial because the flames look dim compared with other subjects in the picture—not at all the way our eyes see it.

To take advantage of the existing lighting and give a more natural appearance to indoor flash pictures, use a slow shutter speed and a small flashbulb. The small bulb—an AG-1B, for example—will require a relatively large lens opening. The slow shutter speed will give the existing illumination more time to register on the film. Result: more natural-looking pictures. Another way to get the same effect is to use bounce flash or reflectorless flash with a slow shutter speed. Both of these techniques require a large lens opening, which helps record the existing light, and the light from the flash reflected by the walls and ceiling is soft and glareless.

Open Flash

Before flash-synchronized shutters were developed and came into widespread use, all flash pictures were made by the "open-flash" method. That is, the shutter was opened, the flash was fired by hand, and the shutter was closed again.

The technique still has many uses. Indoors, where the light is dim, you can open the shutter and "paint" an interior with light from numerous

flashes, covering all parts of the room. Electronic flash is excellent for this because of its low cost per flash.

Open flash is good for recording dim light sources requiring longer exposure times than even the camera's slow shutter speeds would provide. In photographing a lighted Christmas tree, for example, this would be the sequence: Open the shutter for a few seconds to let the tree lights register on the film, fire the flash to provide general illumination, and close the shutter. Or to photograph a jack-o'-lantern at Halloween, open the shutter, let the candlelight "burn in" on the film for a few seconds, and fire the flash to illuminate the outside of the pumpkin before closing the shutter. You can get the same effect with synchronized flash by setting the shutter on "B" and holding it open for a few seconds after the flash.

The open-flash method is suitable only for areas where there is very little existing light. In brighter areas the picture might be overexposed by the long shutter times. A tripod or other firm support is a must for open-flash work. A cable release is also a wise investment for preventing camera movement while the shutter is open.

When a team approach is used, open flash is good for getting the light where you want it without using an extension cord. In the picture of the girl on the stairs, one person stood by the camera while the other carried the flash holder upstairs. The photographer opened the shutter, the partner fired the flash, and the photographer closed the shutter. Many flash units have a button for firing the flash by hand. Other flash units can also be fired manually by short-circuiting the electrical contacts on the flash with a paper clip or other metal object.

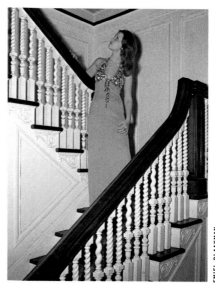

This straightforward flash-at-the-camera picture is technically acceptable, but it has no pictorial punch.

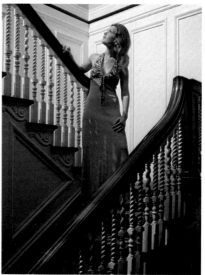

While the photographer held the shutter open, a helper fired a flashbulb at the top of the stairs to create this more provocative lighting effect. Exposure is always based on flash-to-subject distance, not camera-to-subject distance.

JOSEPH SCHNIEDER

EMIEL BLAAKMAN

Pictures of People with Photolamps

We all cherish good pictures of our loved ones. Sometimes casual snapshots aren't enough, and a more serious effort is in order. For a completely professional job of portraiture, there is no substitute for the experience and equipment of the professional portrait photographer. Nevertheless, you can do a creditable job in the home with your present camera and some simple lighting arrangements.

If your camera has interchangeable lenses, use a lens with longer-than-normal focal length. A normal lens has a focal length approximately equal to the diagonal of the camera film plane. For head-and-shoulder pictures, the lens should have a focal length about 1½ to 2 times as long as that of a normal lens. A long-focal-length lens will give you the best perspective for head-and-shoulder portraits because you can get farther away from the subject and still include only the head and shoulders in the picture. As a result, the size relationship of the subject's features appear normal. Also, your subject won't feel so camera-conscious if you're working 6 to 8 feet away instead of right on top of him.

You've probably seen the reverse of this situation, in which a wide-angle lens was used for a close-up picture of a person and the picture looks distorted. The nose appears large while the eyes and ears look too small. The subject certainly wouldn't like such a picture.

SIMPLE LIGHTING ARRANGEMENTS

Here are a few simple steps to help you get started in home portraiture. If your interest grows, there are a number of good books on advanced photographic lighting available at many photo dealers. An excellent Kodak book on the subject is *Professional Portrait Techniques* (O-4), $2.50.

THE LIGHTS AND THE FILM

Chances are you will want to light your subjects with photolamps (3400 K). You will need at least two or three lamps for a portrait. Photolamps can be screwed into any standard light socket. Some photolamps have their own built-in reflectors, so all you need to set up the lighting is a supply of light stands or household lamps with sockets that you can aim. Not only is such lighting less expensive than flash for this kind of picture, but it also lets you see the result of your efforts as you arrange the lights in various ways, and you can use an exposure meter to determine the exposure. Use a film designed for use with photolamps, such as KODACHROME II Professional Film, Type A.

A BASIC TWO-LIGHT ARRANGEMENT

You can set up a simple but effective standard lighting arrangement by putting one light, the "fill-in" light, at the camera and another, the "main" light, high and to one side. Place the main light closer to your subject than the fill-in light and at a 45-degree angle to the line between the subject and your camera. Because the main light is to one side of the camera, part of the subject will be in shadow. This emphasizes the depth and shape of the subject; photographers call it "modeling." You don't want the shadows to be too dark, so use the fill-in light at the camera position to illuminate the shadows.

If you have an automatic camera with a fast lens, you can just aim and take the picture after you have arranged the lights. The best way to determine the exposure for an adjustable camera is with an exposure meter. However, if you don't have an exposure meter, the following table gives some suggested exposures.

The Photolamp Exposure Dial in the *KODAK Master Photoguide* gives more exposure data for this type of simple lighting arrangement. The *Master Photoguide* (AR-21), $3.95, is available from photo dealers.

SUGGESTED EXPOSURES FOR ADJUSTABLE CAMERAS

KODAK Film	Film Speed	Shutter Speed	Reflector Photolamps (3400 K) 500-Watt	
			Main Light—5 ft Fill Light—7 ft	Main Light—7 ft Fill Light—10 ft
KODACHROME II Professional (Type A)	ASA 40	1/30	f/4	f/2.8
High Speed EKTACHROME (Tungsten) with No. 81A Filter*	ASA 100	1/60	f/4 ↓5.6	f/2.8 ↓ 4

*To obtain more natural color rendition with this film and 3400 K photolamps, use a No. 81A filter.

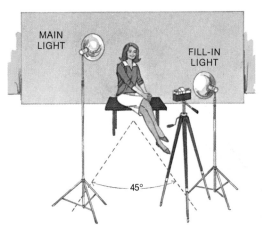

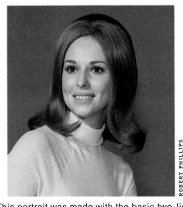

This portrait was made with the basic two-light arrangement. The main light was placed high and to the left while the fill-in light was used at the camera position to fill in the shadows.

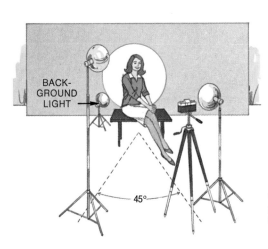

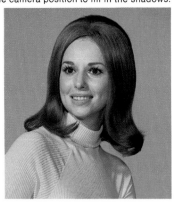

You can improve on the basic two-light arrangement by adding a third light and aiming it at the background.

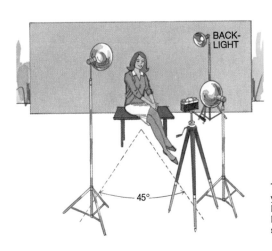

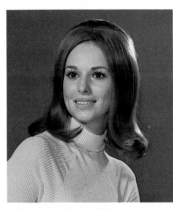

To add to the basic two-light arrangement, you can aim a third light down at the subject's hair from high and behind the subject. This backlight outlines the hair, gives it more sparkle, and separates it from the background.

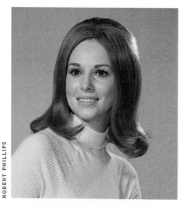

ROBERT PHILLIPS

This picture is just like the one at the bottom of page 100, except that it shows what you can do with four lights. The fourth light is used to illuminate the background.

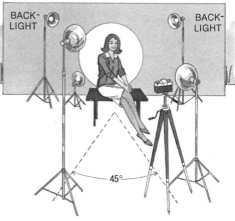

BACK-LIGHT

BACK-LIGHT

45°

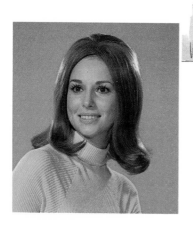

If you have one more light for a total of five lights, you can use the fifth one to light the subject's hair from the other side. This light creates additional highlights on the hair.

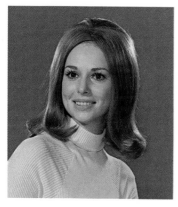

The same lighting arrangement was used for this picture as was used for the one above except that the background light was eliminated; only four lights were used.

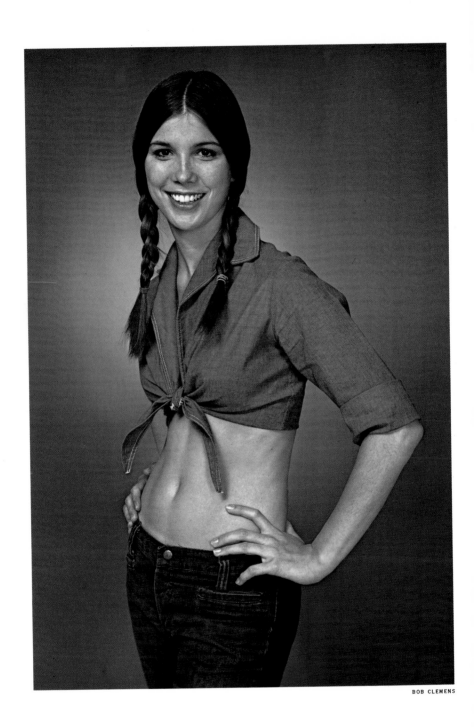

BOB CLEMENS

WITH THREE LIGHTS

You can improve the two-light arrangement just described by the addition of a third light, low and behind the subject, pointed at the background. This helps control the apparent brightness of the background, and provides good separation between the subject and the background.

Another variation of this three-light arrangement is to place the third light above and behind the subject. Shining down at the top and back of the subject's head, this backlight outlines the hair, gives it more sparkle, and separates it from the background. Such a light is especially desirable when photographing women. If you want to go one step further with the hair lighting, you can gain additional highlights and added detail in the hair by using two hair lights. Position both lights above and behind the subject, but with one light on each side of the subject.

You can add one more light so that there are lights on both the background and the hair. *When you use additional lights in this way, the exposure stays the same as for the simple two-light arrangement.*

You can achieve many different effects by using various combinations of these basic lighting positions. You may want to use just frontlighting and backlighting or only frontlighting and sidelighting, for example. Even a single light can sometimes make a dramatic portrait if the subject is holding an open book or a light-colored object to help bounce light into the shadows.

BACKGROUNDS

A matte-finished background is a good background for portraits. It helps avoid glare and reflections from the lights. A flat-painted wall is also a fine background. Keep your subject far enough away from the background so that his shadow doesn't fall on the background.

When posing for color portraits, your subject shouldn't be too close to the side wall either, unless the wall is white, because it may throw some of its own color into important shadow areas. A background of fairly dark color is usually a good choice, although you can make it appear lighter or darker by varying the amount of light you shine on it.

A. PETROCELLI

A plain background is always a good choice for photographs of people.

NEIL MONTANUS

Detail in the background that is natural to the scene and complementary to the subject, while not being distracting, effectively enhances the photograph.

USING AN EXPOSURE METER WITH PHOTOLAMP LIGHTING

The exposure table on page 99 works well, but there will be times when you'll want to use lighting arrangements other than those given in the table. In these situations, you really need an exposure meter.

Using a meter indoors for portraits requires a slightly different technique from that which you use outdoors. If you make a meter reading from the camera position and the background is darker than the subject, the meter will "see" a large dark area behind the subject and a small bit of something bright—your subject—in the middle. Such a reading will be too low and will result in overexposure of the subject. If you take a close-up reading from the subject's face, you make the opposite error by letting your meter see only the brightest part of the scene. Hair and clothes are important parts of the picture and are usually darker than the face. Serious photographers usually bracket exposures by taking extra pictures with ½ stop more and ½ stop less exposure than the meter recommends.

There are four good ways to use an exposure meter with photolamps:

1. Make a semi-close-up meter reading of the subject so that the meter sees the subject's hair, face, and clothes. Don't make the reading so close that your meter measures only the subject's face or so far away that it sees mostly the background.

2. Make an incident-light meter reading instead of a reflected-light reading. Some meters are specially made to read incident light; most others can be adapted to do so. "Incident light" is the light falling on the subject. To measure it, stand at the subject position, and point the meter toward the camera unless the meter instruction manual recommends a different technique.

3. Make a reading from the gray side of a KODAK Neutral Test Card. Your photo dealer will sell you four of these handy cards in an envelope, complete with instructions.

4. You can put your hand in front of the subject's face, palm toward the camera, and take a reading from that. Give twice as much exposure as the meter indicates, or divide the film speed (ASA) by two. The palm of a hand (Caucasian) reflects about 35 percent of the light, while the gray side of a KODAK Neutral Test Card reflects 18 percent of the light. Be sure not to let your shadow or the meter shadow fall on the palm of your hand as you make the reading.

Existing-Light Pictures

Tungsten lighting.

Photography by existing light is the modern way to take pictures
because it lets you record the natural mood of the scene.

Daylight.

Existing light is the light from household lighting fixtures, fluorescent lamps, spotlights, neon signs, candles, and fireplaces; daylight coming through windows; and the light from any other source that provides the natural lighting in the scene. Existing light lends special charm to your pictures because the lighting is natural, the surroundings seem true in color, and people do not tend to "freeze" as they sometimes do for flash pictures. It also allows you to photograph subjects that would be too far away for flash pictures, such as street scenes at night and spectator events. Existing light is easy to use because it's already there, and it's cheaper than using flashbulbs or photolamps.

Because existing light is usually low in intensity, to take pictures by the existing lighting you'll need to use a camera with an $f/2.8$ or faster lens and a fast film, such as KODAK High Speed EKTACHROME Film. This film is well-suited for picture-taking under these low-light conditions. The combination of a fast lens and a high-speed film is the modern way to take existing-light pictures because you can usually hand-hold your camera and capture those candid situations for natural-looking results.

Existing-light conditions normally require large lens openings and slow shutter speeds. Take extra care to hold your camera steady at shutter speeds of 1/30 and even 1/60 second to avoid picture-spoiling camera movement. Because you'll be using large lens openings, you'll need to focus carefully. At large lens openings, depth of field is quite shallow, and slight errors in focusing can be obvious. However, this shallow depth of field can work to your advantage—it turns the background into a soft blur, concentrating attention on your main subject.

Firelight.

Tungsten and fluorescent lighting.

Tungsten.

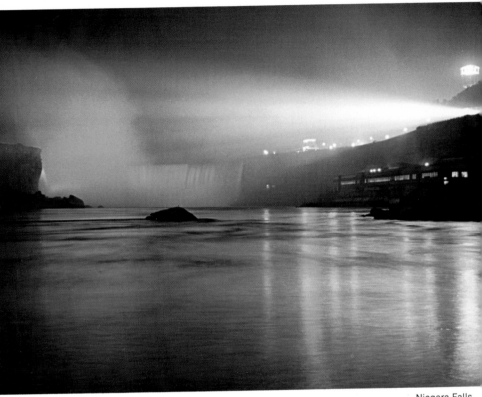

Niagara Falls.

PUSH-PROCESSING *KODAK* HIGH SPEED *EKTACHROME* FILM

Although High Speed EKTACHROME Films have adequate speed for many existing-light situations, it's possible to gain even more film speed through modified processing. This is a big help in getting enough exposure under the dim lighting conditions you'll often encounter.

Kodak will push-process your High Speed EKTACHROME Film, sizes 135 and 120, to 2½ times the normal film speed—from ASA 160 to ASA 400 for Daylight film, and from ASA 125 to ASA 320 for Tungsten film. To get this service, purchase a KODAK Special Processing Envelope, ESP-1, from your photo dealer. The purchase price is in addition to the regular charge for KODAK EKTACHROME Film processing. After exposing the film at the increased speed, put it in the envelope, and have your photo dealer send it to Kodak for processing. Or

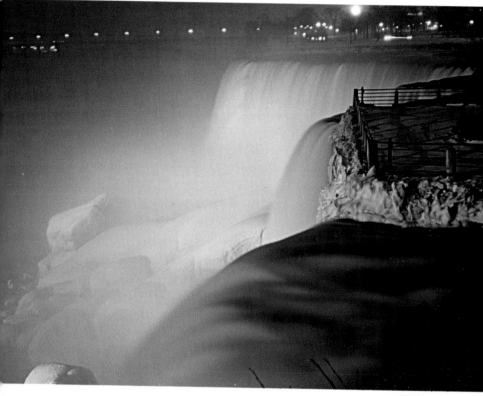

you can send it directly to Kodak in a KODAK Mailer. When you use the ESP-1 Envelope, be sure to follow the instructions that come with the envelope.

If you process your own High Speed EKTACHROME Film, you can increase the speed of the Daylight film to 400 and the Tungsten film to 320 by multiplying the processing time in the first developer by 1.5. If you can afford some loss in color quality,

you can push the speed of Daylight film to 640 and Tungsten film to 500 by multiplying the processing time in the first developer by 1.75.

When High Speed EKTACHROME Film is push-processed, there is a slight reduction in photographic quality. When you're photographing under adverse conditions, however, the benefits of the increased film speed are usually more important than the change in quality.

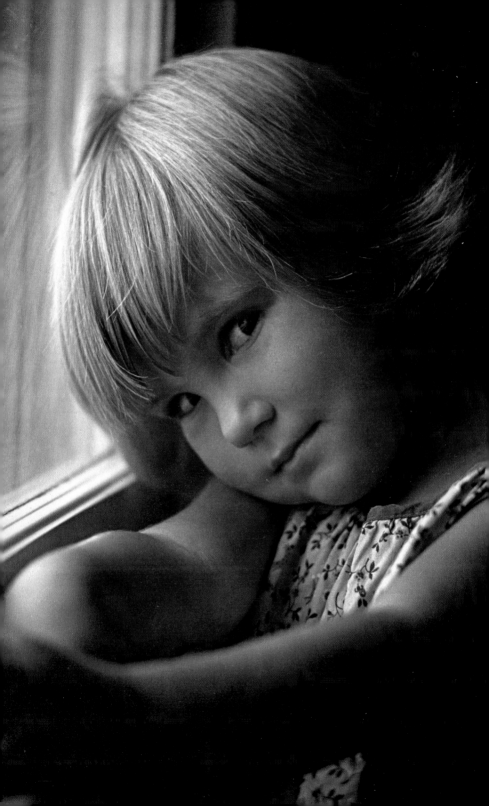

AROUND THE HOME WITH EXISTING LIGHT

Daylight Indoors at Home

Try taking some pictures by existing daylight. Just have your subject sit near a window, and then observe the lighting. Use a daylight film, such as High Speed EKTACHROME Film (Daylight). On a rainy or overcast day, the lighting will be soft, diffuse, and quite pleasing. Open all the window drapes in the room so that you have as much light to work with as possible. Make your meter reading from the most important part of your subject. The light on such days is quite bluish, but a skylight filter will add some warmth. Taking pictures in existing daylight is easy—no lights to fuss with —and it often produces some very pleasing portraits. If you give your subjects something to do, they may even forget that you're taking pictures.

You can also make interesting silhouettes by posing your subject directly in front of a window. Take a meter reading toward the window. Basing your exposure on the window light will cause the subject to be underexposed and appear as a silhouette. If you don't want a silhouette effect, however, you should make a close-up meter reading of your subject or change your camera angle so that a bright window is not directly behind your subject.

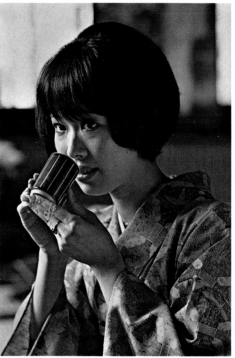

At the large lens openings you'll often be using with existing light, the depth of field is shallow and the background becomes a soft blur.

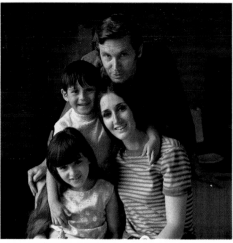

Existing light can produce soft, natural-looking pictures of people.

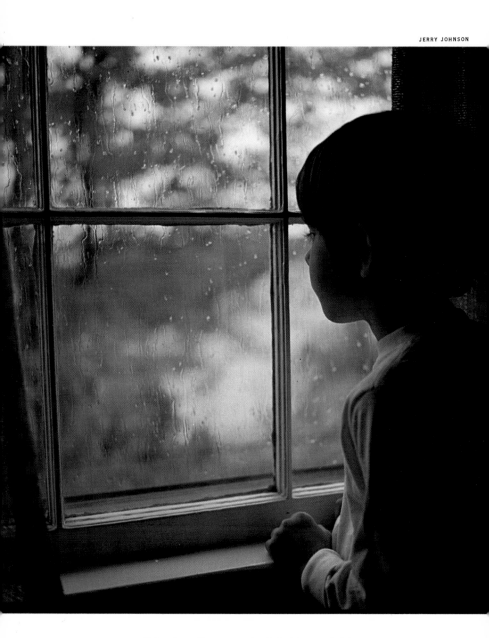

Rainy days offer an opportunity to take mood pictures
of children looking wistfully out rain-spattered windows.

When you use an exposure
meter where there is a
bright window (or a lamp)
behind your subject, make
a close-up meter reading of
the subject to determine the
proper exposure. Otherwise,
your subject may appear as
a silhouette.

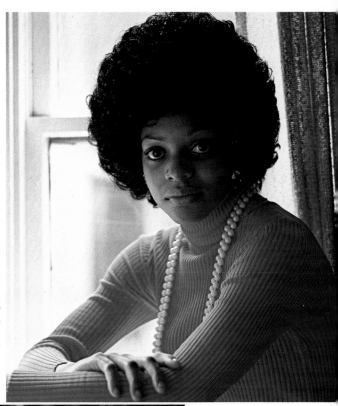

A nearby window
provided the light for
this picture.

115

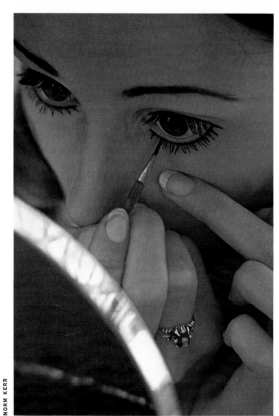

One advantage of taking
pictures by existing light is
that your subjects may not
even realize their pictures
are being snapped, and you'll
capture natural expressions.

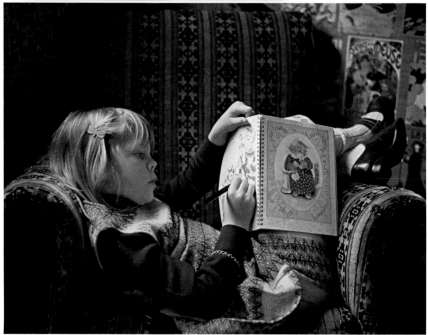

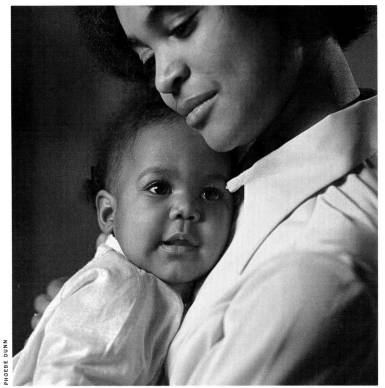

You can capture happy, relaxed expressions and natural lighting when you take pictures by existing light. Indoors at night, turn on all the lights in the room so that you'll have as much light as possible for taking pictures.

Home Lighting at Night

The existing lighting in homes at night is quite dim compared to other lighting conditions, but there is enough light for taking pictures with a high-speed film and a camera with a fast lens. When you use KODAK High Speed EKTACHROME Film (Tungsten), the average living room or game room, brightly lighted with all the lights in the room turned on, will require an exposure of about 1/30 second at $f/2$. In other rooms, such as a bedroom which has only one or two lights, the exposure would be about ⅛ second halfway between $f/2$ and $f/2.8$. But use an exposure meter to be sure. Remember to use a firm camera support when your exposure times are longer than 1/25 or 1/30 second.

Home lighting is more contrasty than it looks, so you can often improve your pictures by adding some fill light. This helps improve the lighting without spoiling its natural appearance. Adding fill light increases the light level and lets you use less exposure, too. A simple way to do this is to aim photolamps at a white ceiling. With this lighting, you can follow kids around the room and give the same exposure at all distances.

Some fluorescent lamps produce an odd color rendition because they're deficient in red light. For best results with fluorescent lamps, use a daylight film. However, your slides will probably still have a greenish cast, but they should be acceptable.

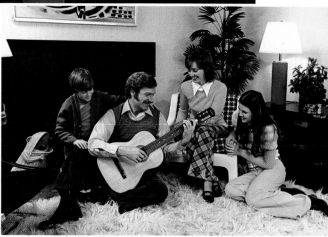

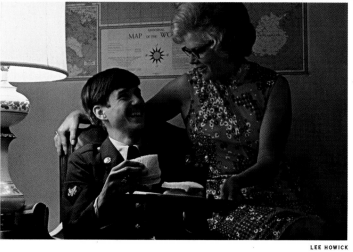

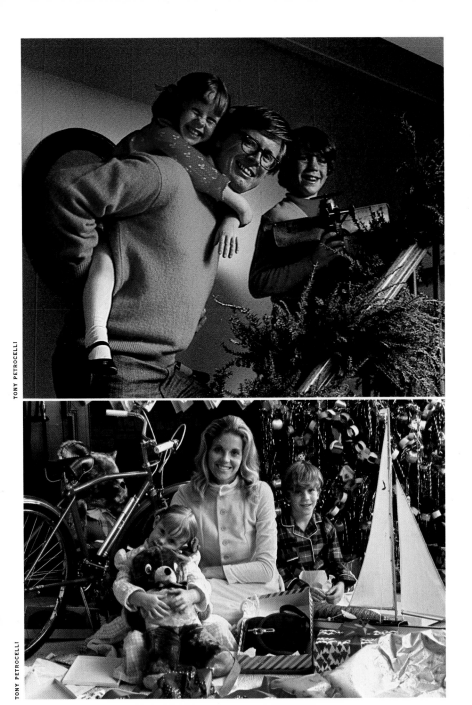

TONY PETROCELLI

TONY PETROCELLI

You can take natural-looking pictures without disturbing your subjects when you use existing light. Home lighting is usually contrasty, so use camera angles that show pleasing shadows on your subjects.

Candlelight Portraits

These unusual portraits are fun to make and require no special equipment. Put two lighted candles on a table, and seat your subject at the table between the candles. This will give fairly even light on both sides of your subject's face. Artificial-light film will help make the subject appear less orange than he would if you used daylight film. KODAK High Speed EKTACHROME Film (Tungsten) is ideal both for speed and for color balance.

To determine the approximate exposure, turn off the room lights and take a meter reading of your subject's face, or try an exposure of ¼ second halfway between $f/2$ and $f/2.8$ with High Speed EKTACHROME Film. You should take a picture at 1 stop on each side of the estimated exposure to make sure of getting at least one good picture. Since you'll be using slow shutter speeds, a tripod and a very still subject are a must.

The candle flames themselves will look about the same over a wide range of exposures. Close the doors and windows so that drafts won't make the flames flicker and look "fuzzy" because of the long exposure times required.

DON MAGGIO

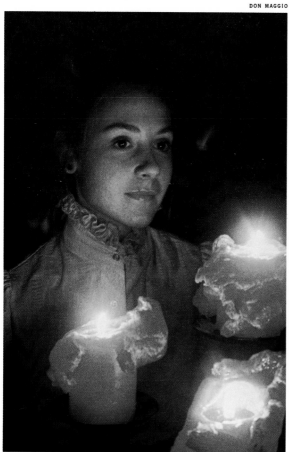

Candlelight pictures like these add variety to your indoor color slides. They're easier to take if you take advantage of the faster film speeds of push-processed KODAK High Speed EKTACHROME Film.

DAVID LICHTENSTEIN, JR.

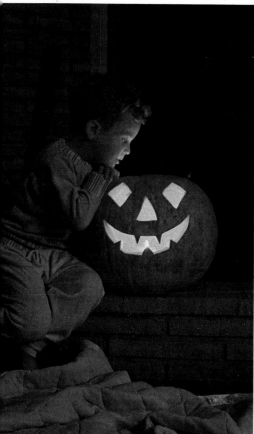

TONY PETROCELLI

JOHN SABO

When you take pictures by existing light, you can record important events without interrupting the proceedings. You can cover a wedding ceremony from the rear of the church and still get close-up views if you have a telephoto lens. Use a railing or a pew as a brace to prevent camera movement.

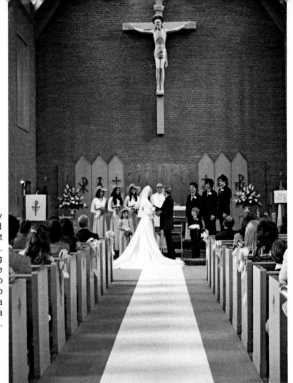

WADI RICHARDS

NORM KERR & DON MAGGIO

Depth of field is usually shallow when you're making hand-held exposures with existing light. Focus carefully so that your subject will be sharp. The shallow depth of field enhanced this picture by making the people in the background soft and unsharp while the main subject, the little girl, appears in sharp focus.

AROUND THE TOWN WITH EXISTING LIGHT

Many cherished moments take place in the home, and in this book we talk about capturing these events in color slides with all kinds of lighting techniques. Such incidents also happen outside the home—weddings, children's recitals, important meetings, plays, and other performances—and you'll want pictures of these for your slide collection, too. However, many times you're in a position where you can't use flash. During a ceremony, flash may not be appropriate because it causes too much of an interruption, and often you're too far away to record the scene with flash. But don't give up in despair! With an adjustable camera and KODAK High Speed EKTACHROME Film, you can capture these memories for your slide collection by using the existing lighting.

122

LEE HOWICK

This picture was made by the existing lighting. In most theaters
you won't be allowed to use flash, so use a high-speed film
balanced for tungsten lighting, such as KODAK
High Speed EKTACHROME Film (Tungsten).

LEE HOWICK

A telephoto lens lets you make close-ups of the
performers on stage. For existing-light pictures with a telephoto lens,
you should brace your camera to prevent camera motion.
You can use a railing in the balcony or convert a tripod into a
unipod. To do this, just tie the three legs of the tripod together.

This picture at the zoo was taken by existing daylight on daylight-type film. Look for interesting positions the animals assume.

Colorful tungsten lighting provided the illumination for this scene at the planetarium. People look much more relaxed and happy when they're doing something natural.

You'll often find exciting picture possibilities on visitor tours through public buildings. KODAK EKTACHROME-X Film.

Photographed by daylight and tungsten lighting on KODAK EKTACHROME-X Film.

The slight blur caused by the motion of the dancers enhances the look of action.

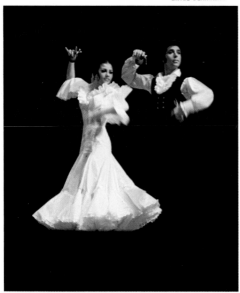

KODAK High Speed EKTACHROME Film (Tungsten) with special processing, which increases the speed by 2½ times to ASA 320, is a good choice for pictures of action on stage. The high film speed lets you use a high shutter speed for stopping action.

José Molina—"Bailes Españoles" (Spanish Dances).

What About Exposure?

If possible, move in close and take a meter reading, particularly for subjects that will be spotlighted. For example, in some small theaters, you may be able to go on the stage before the performance and record the lighting level. However, if you can't move in close, don't try to take a meter reading from your seat. Unless you have an exposure meter that can read a small area of your subject from some distance away, your meter will be influenced by the surrounding darkness and it won't give a correct reading for your picture. You can photograph brightly lighted stage shows at 1/60 second at $f/4$ with KODAK High Speed EKTACHROME Film (Tungsten). With subjects such as a chapel illuminated by daylight, the lighting may be fairly even and you can take a reading from the camera position.

Take your camera along when you attend important events outside your home. You can be unobtrusive about your picture-taking with existing light and still capture these happy occasions for your slide collection.

Ice Shows

Color, spectacle, and beauty are all combined in the popular ice-skating reviews which tour the country. The colorful pageantry of swirling ballerinas, clowning comedians, and nimble skaters makes a paradise for you and your camera. Ice shows are a natural for color movies, too. If you're a slide *and* movie fan, take both cameras. An excellent KODAK Photo Book, *Home Movies Made Easy* (AD-5), $3.25, tells how to get the best results.

Any camera with an $f/2.8$ or faster lens can capture the action on KODAK High Speed EKTACHROME Film. Lighting conditions vary considerably during a performance, but the illumination for an ice show will almost always be floodlights and carbon-arc spotlights used either together or separately, depending on the act. We recommend High Speed EKTACHROME Film (Daylight) for this sort of picture-taking. It produces pleasing results with both the floodlights and spots, and has enough speed to do the job well.

Pictures taken on Daylight film with floodlight illumination alone will appear somewhat yellow-red, but most people find the slides quite acceptable. The ideal situation is to use High Speed EKTACHROME Film (Tungsten) for acts lighted by floodlights and the Daylight film for acts lighted by carbon-arc spotlights.

Exposures will be about $1/60$ second at $f/2.8$ on KODAK High Speed EKTACHROME Film, or $1/125$ second halfway between $f/2.8$ and $f/4$ for push-processed High Speed EKTACHROME Film, when just the floodlights are on. If an act is lighted by floodlights and one or two spotlights or by several colored spotlights, reduce the exposure by about 1 stop. You can capture featured performers

EMIEL BLAAKMAN

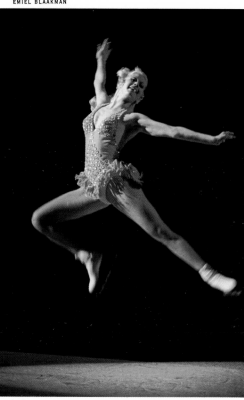

Pictures of the Ice Follies made on KODAK High Speed EKTACHROME Film (Daylight), ASA 400.

A telephoto lens is useful for filling the frame with your subject when you're photographing an ice show in a large auditorium.

illuminated with two or more white spotlights with an exposure of 1/125 second at f/2.8; for push-processed High Speed EKTACHROME Film, try 1/250 second halfway between f/2.8 and f/4. When additional white spotlights are being used on the front or side of the subject, you can reduce exposure still more.

It's usually impossible to get accurate results with an exposure meter when a spotlighted subject is 50 yards away. Your exposures will largely depend on recommendations in this book and in other exposure tables and guides. Fortunately, you'll find that quite a wide range of exposures will produce pleasing results, with slight underexposure often adding a dramatic feeling.

An exposure meter is difficult to use at an ice show for two reasons: (1) The lighting is usually concentrated in small areas with darkness surrounding the performers, which can mislead the meter, and (2) the lighting changes frequently during the show. You may be able to make some representative meter readings close to the performers from the first few rows of the audience and refer to these readings during the rest of the show.

The lower shutter speeds aren't very good action-stoppers, but you can overcome this with skill. When photographing moving skaters, wait

When you're near the ice, a wide-angle lens will help you capture the large formations.

until they are moving toward you—the easiest plane in which to stop action. When very slow shutter speeds are required, try "panning," that is, swinging the camera along with the moving performer as you trip the shutter. The background will be blurred, but the subject will be "stopped" fairly well, with a hint of great speed caused by the slight blurring.

You can probably take most of your pictures while hand-holding your camera. But some sort of camera support will help keep you from jiggling your camera at slow shutter speeds, especially if you want to use a telephoto lens. You won't endear yourself to your neighbors if you lug a tripod

to your seat with you, but there should be little objection to your using a unipod. One of these handy one-legged camera supports will rest snugly between your knees in the most crowded seat to steady your camera at slow shutter speeds. Lacking a unipod, you can make a satisfactory substitute by tying the legs of your tripod together at their tips.

As long as there will be heads bobbing around in front of your lens anyway, why not make the best of them by deliberately including such foreground subjects? They will register as silhouettes on the film, giving an impression of depth and acting as a "frame" for your pictures.

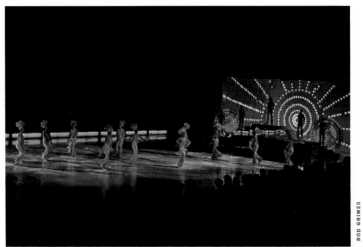

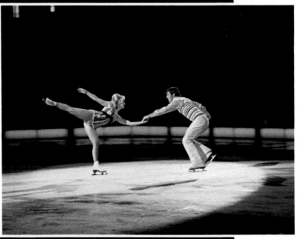

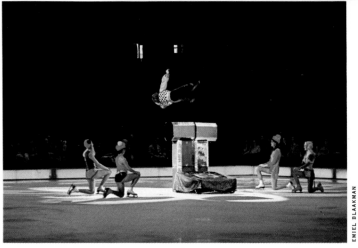

EMIEL BLAAKMAN

EMIEL BLAAKMAN

You can stop the action, even with a slow shutter speed, if you take the picture when the subjects are moving toward you.

There will be times during the ice show when the subjects are standing still. This is an excellent time to capture all the color and beauty of the skaters' costumes.

EMIEL BLAAKMAN

JIM DENNIS

The circus pictures were taken at the Damascus Temple Shrine Circus on KODAK High Speed EKTACHROME Film (Tungsten), ASA 320, except where noted.

The colorful costumes and unusual talents of circus performers provide interesting subject matter for color slides.

The Circus

Clowns and acrobats, animals and magicians, death-defying aerialists and lion tamers—this is the circus. It's colorful and enjoyable, and your camera should go along with you.

When the tent circus was in its heyday, good color pictures were difficult to take because of insufficient lighting. Within the last few years, the circus has gone indoors, and shows under the "Big Top" are rare.

Because most circuses are now held in auditoriums, the photographic conditions are very similar to those at the ice show, and most of the exposure recommendations apply to both. A great variety of subjects is waiting for you at the circus. You can often wander around before the show actually begins and snap close-up pictures of some clowns and performers with flash. Never use flash near animals. The management won't appreciate your dazzling their prize dancing bear with the close-up blast of a flashbulb.

High-wire and other aerial acts will be brilliantly spotlighted. You should be able to snap them at 1/125 second at f/2.8 or f/4 on KODAK High Speed EKTACHROME Film (Daylight) or at 1/250 second halfway between f/2.8 and f/4 on push-processed High Speed EKTACHROME Film.

Keep an eye on the program so that you know what's coming up next. Be prepared to capture the best acts on film. Really serious photographers go to a performance without their cameras for a "dry run" before attempting any pictures, so they know what to look for.

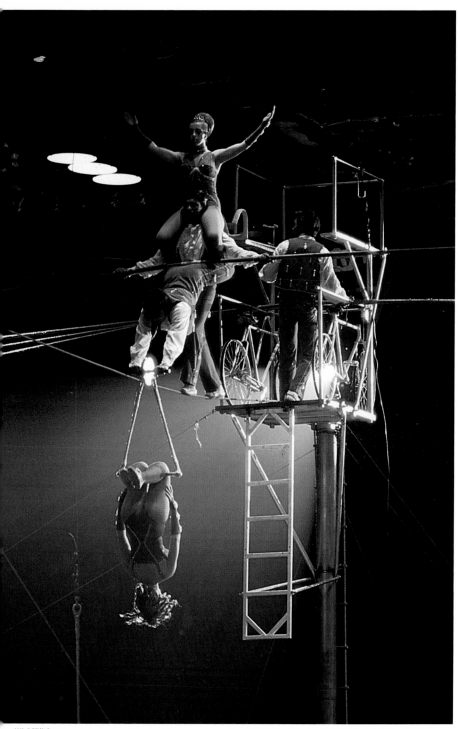

JIM DENNIS

133

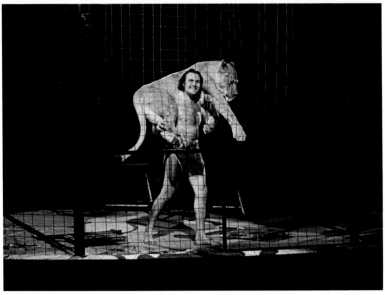

During intermission, the clowns are sometimes available for a picture-taking session—a good opportunity for close-ups.

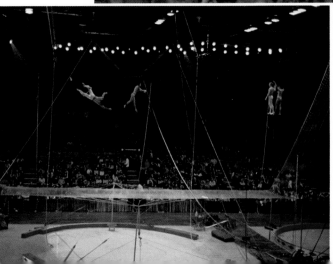

To catch the subject in midair, use the highest shutter speed possible and take the picture when the performer reaches the peak of action.

JIM DENNIS

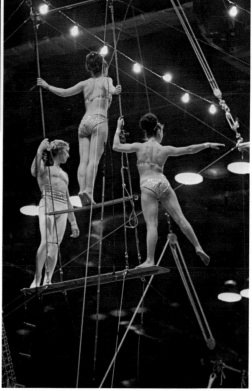

JIM DENNIS

ROD GRIMES

KODAK High Speed EKTACHROME Film
(Daylight) ASA 400.

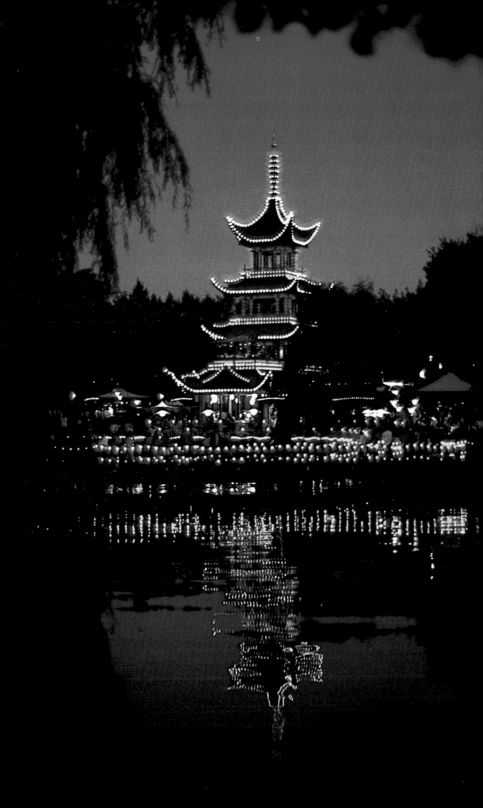

ARTHUR UNDERWOOD

During the brief period just before dark, the sky is still bright enough to register on the film. This is an ideal time to make nighttime color pictures.

EXISTING-LIGHT PICTURES OUTDOORS AT NIGHT

Too many color cameras go to bed early at night. And like folks who leave the party too soon, they miss a lot of fun. Perhaps you've already tried color photography at night; if so, you know how spectacular the results can be.

What kind of film should you use? Neither tungsten-light nor daylight films can be balanced for the wide variety of light sources found on a busy city street, so the choice isn't really critical. The point is to capture the mood and feeling of the city after dark, not to reproduce precisely the colors seen there. Daylight films will render the colors a little warmer than tungsten-light films. The choice is yours.

Actually, it's hard to go wrong taking existing-light pictures at night. There is no correct exposure in the strict sense because the scene usually consists of great areas of darkness intermixed with spots of light from signs and streetlights. Shorter exposures leave the shadows dark while preserving color in bright areas, such as illuminated signs. Long exposures tend to wash out the brightest colors, but there is more detail in the shadows. The total range of brightness is far too great to reproduce in a single picture, so exposure depends a great deal on the results you want. You can use the exposure tables on pages 150 and 151 as a guide. For those once-in-a-lifetime pictures, bracket your exposure 1 stop on each side of the suggested exposure.

Although KODAK High Speed EKTACHROME Film has adequate speed for many nighttime picture-taking situations, you may want to have your film push-processed for extra speed (see page 110). The higher speed will let you hand-hold your camera for most pictures, and you can

139

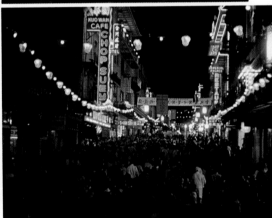

ROBERT ELLENBERG

GEORGE BUTT

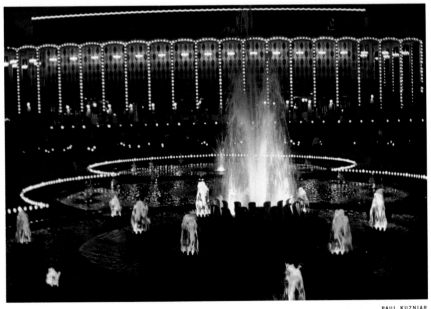

PAUL KUZNIAR

140

use a higher shutter speed or a smaller lens opening for greater depth of field than with normal processing.

You can also use slower-speed films, such as KODACHROME 64 or KODAK EKTACHROME-X Film, for existing-light photography, but most of the time you'll have to use slow shutter speeds and a camera support for night pictures.

Some of the night pictures you take will be time exposures, and any lights that move in front of the lens will record as lines or streaks of light. Automobile headlights become tracings of white or yellow, and the whirling lights of amusement-park rides paint the sky with swirls of color. Such effects convey a sense of motion in an otherwise static picture.

What is there to photograph at night? A few suggestions may put your mental machinery into gear. Sporting events, campfires, lighted signs, carnivals, and fireworks are a few ideas. How about a picture essay of your city at night or a few exposures at the amusement park? Your vacation and travel pictures will be pepped up by the change of pace if you include shots of some floodlighted buildings, fountains, or monuments. Ships in the harbor at night, long spans of bridges, and Christmas decorations make excellent subjects for time exposures. Wet streets are wonderful for nighttime color. They reflect a myriad of colors and make your slides more crisp and snappy. You might try either aiming your camera down into a pool of rainwater to picture the reflections of signs and buildings or using a slick, wet stretch of smooth pavement to mirror your scene.

If you are seeking pictorial effects, several simple techniques can help you produce striking results. Try making a series of exposures on the same frame of film, if your camera permits

ROD GRIMES

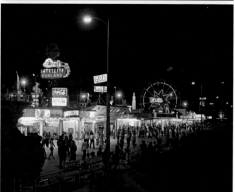

ROD GRIMES

141

You can create a unique
montage when you make
several exposures on
the same frame of film.

HERB JONES

KEITH BOAS

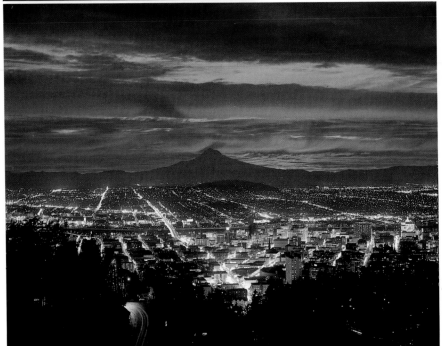

RAY ATKESON

Time exposures will help you record more detail after the sun goes down.
The traffic in the streets has formed the streaks in this picture.

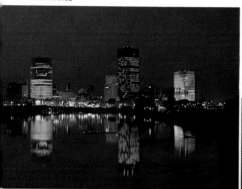

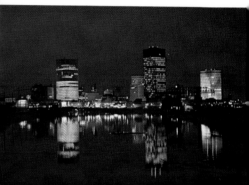

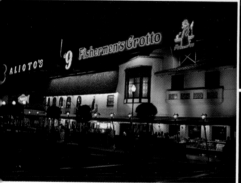

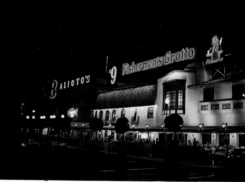

The scenes on the right were photographed
with KODAK High Speed EKTACHROME Film
(Daylight); those on the left with KODAK
High Speed EKTACHROME Film (Tungsten).
The Daylight film renders the scenes warm,
or orange, in appearance, while the Tungsten
film retains some blues and greens and
makes the scenes look more like what the
eye actually sees. Type A film produces
results similar to those on Tungsten film.

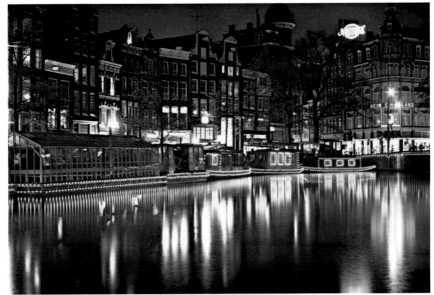

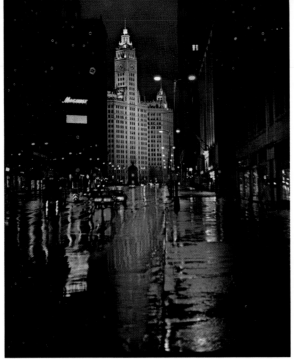

The reflections in the water or in slick, shiny streets add interest and sparkle to the picture. Look for bodies of water to form reflections or take nighttime pictures after a rainstorm.

deliberate double exposures. Four or five nightclub signs or theater marquees exposed on the same frame of film create an interesting blaze of color.

Another technique, which demands a little patience, consists in setting up your camera on a tripod and making a brief snapshot exposure of a scene just after sundown. This will record the sky as dark blue or purple while registering a slight amount of shadow detail in the rest of the picture. Then after dark, when the lights come on, make a time exposure on the same frame of film without moving the camera. The results will be a picture in which all the night lights are visible against the blue, late-evening sky— an effect very similar to what the eye actually sees.

Some nighttime pictures may require either time exposures or reasonably slow shutter speeds, such as ⅛ or ¼ second. Since most people can't hold a camera steady at these speeds, here are some hints to help avoid shake and shudder at slow shutter speeds.

A tripod is always good insurance against camera movement, of course, but this three-legged servant is not always so compact and portable as we might wish. There is another good way to minimize camera jiggle. You can buy a clamping device from your photo dealer. This clamp has a tripod screw and will hold your camera on

Here are two good ways of holding your camera steady at slow shutter speeds or for time exposures. A tripod is always useful. The photo on the top shows a KODAK Compact Camera Stand, Model 2 (with cable release), in use. You can rest a camera stand on a car fender, a fence, a wall, or a tabletop, and it slips easily into your gadget bag.

For best results in photographing fireworks, record several bursts with your camera on a tripod and the shutter held open on BULB or TIME.

C. JOFFE

any tubular or flat support such as a railing, chair, small tree, fence, or car window. Some of these devices attach with a "C" clamp; others have suction cups. Each clamping device has a swivel which makes it easy to lock your camera in any position. Using a cable release with this equipment also reduces camera movement.

You can also make long exposures by bracing the bottom of your camera firmly against a wall or post, then gently releasing the shutter. A rubber Mason-jar ring placed between the camera bottom and the supporting wall makes a good nonskid device. Some cameras have built-in self-timing devices which will trip the shutter. You can use these to good advantage in avoiding camera movement by letting the shutter trip itself while you hold the camera firmly against a support.

One final hint may be helpful. Unless the subject is unusually bright, it may be difficult to frame it properly through the viewfinder of your camera. If you hold a small flashlight above and in front of your camera with the light directed down toward the viewfinder, the light beam will outline the viewfinder frame to make quite clear what will be included in the picture. Don't shine the flashlight on the camera exposure meter or the camera lens while you take the picture. A flashlight also helps you see your camera settings in the dark.

Window displays make intriguing subjects for color slides. Watch out for reflections in the window glass.

ROD GRIMES

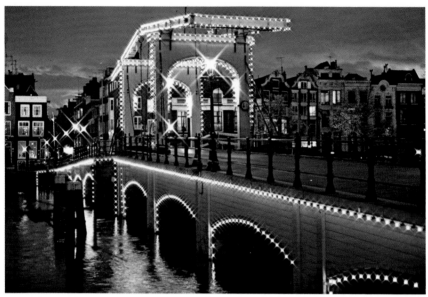

You can get this star effect in your night pictures by putting a piece of window screen over the camera lens. Cut the screen to fit an adapter ring and then put the adapter ring over the lens. One piece of screen will produce four-pointed stars, and two pieces of screen will produce eight-pointed stars if the screens are rotated at an angle to one another. For adequate sharpness you'll need to use a small lens opening. This picture was taken at $f/8$.

For colorful pictorial effects, aim your camera at the whirling lights in an amusement park or the headlights and taillights of moving traffic. Try different exposure times, such as 1, 2, 4, 8, 15, and 30 seconds.

SUGGESTED EXPOSURES FOR EXISTING-LIGHT PICTURES

Picture Subjects	KODAK Film			
	KODACHROME 25	KODACHROME 64 EKTACHROME-X KODACOLOR II	High Speed EKTACHROME— Normal Processing	High Speed EKTACHROME— with ESP-1 Processing
Home Interiors at Night— Areas with bright light	1/4 sec f/2.8	1/15 sec f/2	1/30 sec f/2	1/30 sec f/2.8 ↓ 4
Areas with average light	1 sec f/2.8	1/4 sec f/2 ↓ 2.8	1/8 sec f/2 ↓ 2.8	1/30 sec f/2
Interiors with Bright Fluorescent Light*	1/15 sec f/2 ↓ 2.8	1/30 sec f/2 ↓ 2.8	1/30 sec f/2.8 ↓ 4	1/60 sec f/4
Indoor and Outdoor Christmas Lighting, Christmas Trees	4 sec f/5.6	1 sec f/4	1 sec f/5.6	1/30 sec f/2
Ice Shows— Floodlighted acts	1/30 sec f/2	1/30 sec f/2.8	1/60 sec f/2.8	1/125 sec f/2.8 ↓ 4
Spotlighted acts (carbon-arc)	1/30 sec f/2.8	1/60 sec f/2.8	1/125 sec f/2.8	1/250 sec f/2.8 ↓ 4
Circuses—Floodlighted acts	1/15 sec f/2	1/30 sec f/2	1/30 sec f/2.8	1/60 sec f/2.8 ↓ 4
Spotlighted acts (carbon-arc)	1/30 sec f/2.8	1/60 sec f/2.8	1/125 sec f/2.8	1/250 sec f/2.8 ↓ 4
Stage Shows—Average	1/15 sec f/2	1/30 sec f/2	1/30 sec f/2.8	1/60 sec f/2.8 ↓ 4
Bright	1/30 sec f/2	1/60 sec f/2.8	1/60 sec f/4	1/125 sec f/4 ↓ 5.6
School—Stage and auditorium	—	—	1/15 sec f/2	1/30 sec f/2 ↓ 2.8
Basketball, Hockey, Bowling	—	1/30 sec f/2	1/60 sec f/2	1/125 sec f/2 ↓ 2.8

Picture Subjects	KODAK Film			
	KODACHROME 25	KODACHROME 64 EKTACHROME-X KODACOLOR II	High Speed EKTACHROME— Normal Processing	High Speed EKTACHROME— with ESP-1 Processing
Night Football, Baseball, Racetracks, Boxing	1/30 sec f/2	1/30 sec f/2.8	1/60 sec f/2.8	1/125 sec f/2.8 ↓ 4
Brightly Lighted Downtown Street Scenes (Wet streets add interesting reflections.)	1/15 sec f/2	1/30 sec f/2	1/30 sec f/2.8	1/60 sec f/2.8 ↓ 4
Brightly Lighted Nightclub- or Theater-District Scenes (Las Vegas or Times Square)	1/30 sec f/2	1/30 sec f/2.8	1/30 sec f/4	1/60 sec f/4 ↓ 5.6
Neon Signs and Other Lighted Signs	1/30 sec f/2.8	1/30 sec f/4	1/60 sec f/4	1/125 sec f/4 ↓ 5.6
Store Windows at Night	1/30 sec f/2	1/30 sec f/2.8	1/30 sec f/4	1/60 sec f/4 ↓ 5.6
Floodlighted Buildings, Fountains, Monuments	8 sec f/5.6	4 sec f/5.6	1 sec f/4	1/15 sec f/2
Fairs, Amusement Parks at Night	1/4 sec f/2.8	1/15 sec f/2	1/30 sec f/2	1/30 sec f/2.8 ↓ 4
Skyline—10 minutes after sunset	1/30 sec f/2.8	1/30 sec f/4	1/60 sec f/4	1/60 sec f/5.6 ↓ 8
Burning Buildings, Bonfires, Campfires	1/30 sec f/2	1/30 sec f/2.8	1/30 sec f/4	1/60 sec f/4 ↓ 5.6
Aerial Fireworks Displays— Keep camera shutter open on BULB for several bursts.	f/5.6	f/8	f/11	f/16 ↓ 22

Exposures apply to both daylight and tungsten-light films. Pictures taken under tungsten light (regular light bulbs, floodlights) will look more natural on tungsten-light film, while those taken on daylight film will appear warmer, or more orange, in color.

*Tungsten color film is not recommended for fluorescent light.

NOTE: The symbol ↓ indicates the lens opening halfway between the two f-numbers.

Use a tripod or other firm support for shutter speeds slower than 1/30 second.

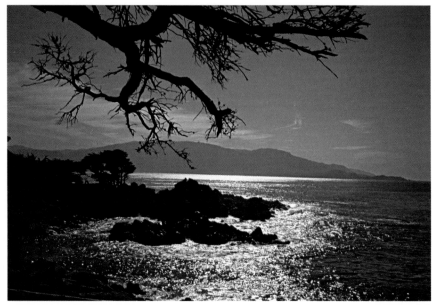

Pseudo-Moonlight

There seems to be considerable interest in taking pictures by moonlight. Actually, some of the best "moonlight" pictures are taken by sunlight! Exposing color film by real moonlight involves several difficulties. Exposure times are long, "reciprocity effect" makes it hard to determine correct exposure, and the moon itself can't be included in the picture because it will appear in the slide as a streak of light due to the long exposure times used. Most important of all, pictures taken by moonlight may not look genuine.

The easiest way to create such scenics is to use an indoor-type film, photograph backlighted subjects, and underexpose by at least 2 or 3 stops. When you use an indoor-type film (Tungsten or Type A) without a filter, an overall bluish cast results and gives the suggestion of night. If your camera is loaded with daylight film, a blue filter, such as a No. 80B filter, will give the same result as unfiltered indoor film. Underexposing adds to the nighttime feeling by decreasing the overall brightness of the scene in your slides. Foreground objects become silhouettes, and the sky is a rich, deep blue. It's even possible to include the ball of the sun in the picture and make it look like the moon; this technique works best when the sun is behind a thin layer of hazy clouds.

Some subjects lend themselves particularly well to this sort of treatment. Photographing directly into the reflections of sun shimmering on snow or water is especially effective.

There are always the ambitious few who want the ultimate in reality, so here's a final suggestion. If you expose a pseudo-moonlight scene without including the sun in the picture, you can then take a picture of the actual full moon on the same frame of film by making a deliberate double exposure. A telephoto lens will make the moon look extra large and give a pleasing pictorial effect.

FLIP ROSS

WILLIAM MICHAUD

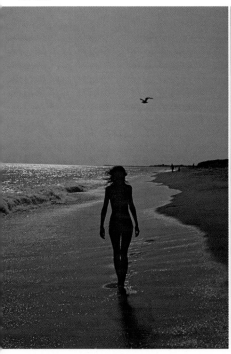

Reflections of the sun shimmering off water or snow are effective for pseudo-moonlight pictures. To achieve this effect, underexpose and use a blue filter, or use Tungsten or Type A film without a filter.

Another way you can simulate a picture taken by moonlight is to underexpose through a polarizing screen. The image of the moon was added to the scene by making a second exposure on the same frame of film with a telephoto lens and no filter. Normal exposure was used for the moon.

Action Pictures

The world we live in is alive with action. Some of the most colorful and exciting pictures show people in action—kids at play, baseball and football games, skiing and skating parties, or friends playing golf, tennis, or badminton. It's easy to capture all this colorful action in pictures, but it does require certain techniques.

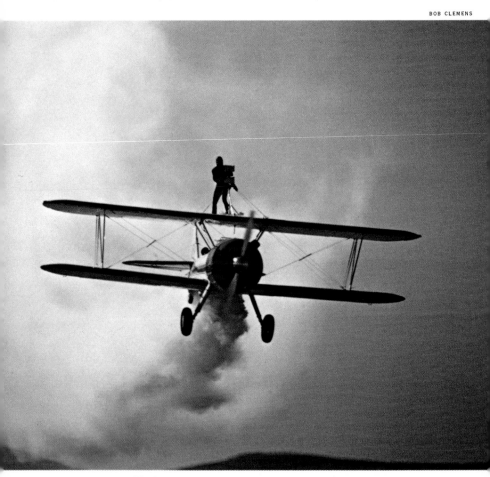

The best way to "stop" action is to use a high shutter speed.

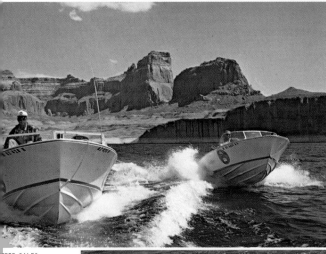

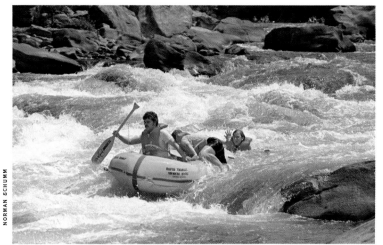

If you can't use a high shutter speed to stop the action, position yourself so that the action is moving toward or away from you.

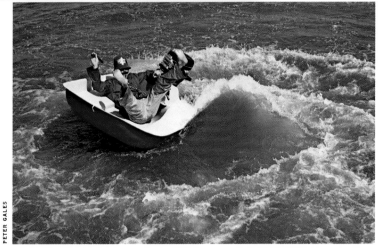

155

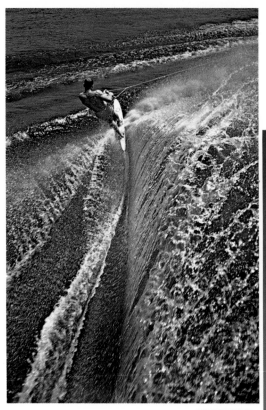

JOHN ZIMMERMAN

Bright scenes like this one allow you to use a high shutter speed so that it's easier to stop the action.

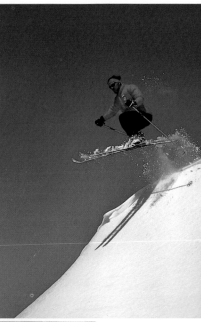

DICK SMITH

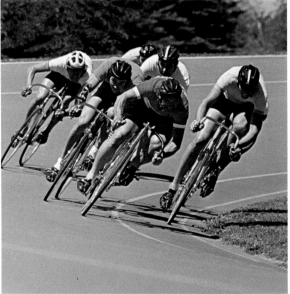

W. WINKIE

You can stop action, even with slow shutter speeds, by taking the picture at the peak of action. At moments such as this, the action is temporarily halted or slowed.

The whales were recorded when poised at the peak of action.

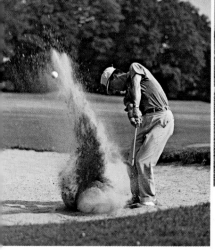

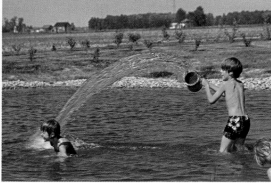

157

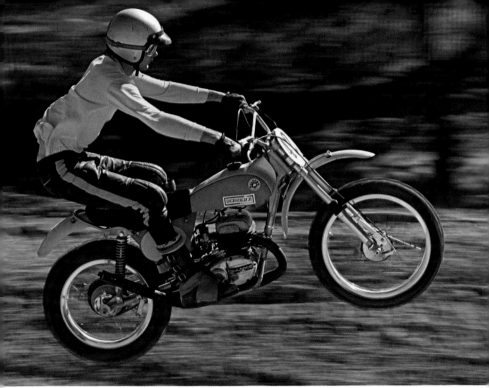

Panning with the action gives the impression of speed. The effect is enhanced by using a slow shutter speed.

STOPPING ACTION

The best way to "stop" action is to use a high shutter speed. Exactly how high depends on how far you are from the action and in what direction the movement is traveling with reference to your camera. Remember that things moving at right angles to the camera require higher shutter speeds than those moving toward or away from you or diagonally. You can stop distant action, such as a football play in midfield, with a slower shutter speed than you'd need for the same action occurring only a few yards away. Every sport has "peak" spots where action is temporarily halted or slowed.

A shutter speed as slow as 1/30 second will "stop" people walking slowly toward the camera, while a fast sprinter running diagonally past the camera would require at least 1/500 second. Generally speaking, use the highest shutter speed that the lighting conditions will allow.

Sometimes, breaking the rules produces more convincing results in photographing action. Action pictures taken at high shutter speeds freeze the movement so effectively that occasionally the photos can look static and lifeless. To overcome this effect, you can use the panning technique to give the impression of great speed. Swing your camera smoothly and keep the subject centered in the viewfinder as you make the exposure. The finished picture will show the moving subject "stopped," but the background will be a racy blur. The slower your shutter speed, the greater the background blur. It's a good trick to remember for dark days when you need to expose color film at slow shutter speeds.

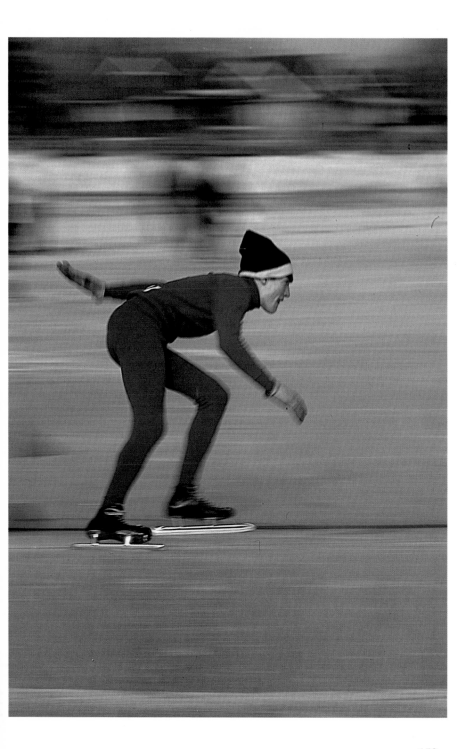

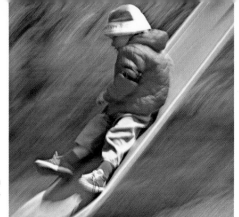

Panning with
the action.

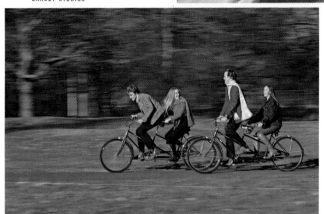

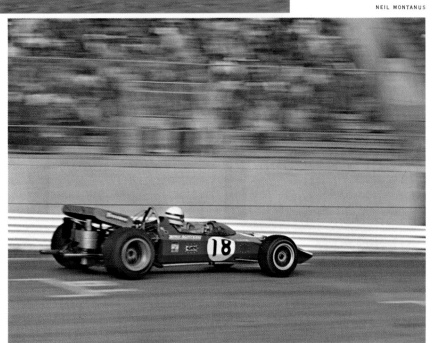

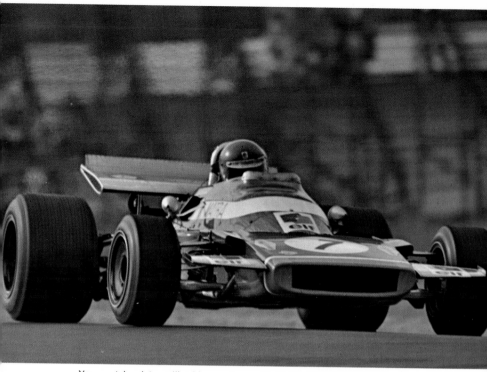

You can take pictures like this one from a safe distance when you use a telephoto lens. Use the highest shutter speed you can, because subject movement and camera movement are more apparent with telephoto lenses.

USING TELEPHOTO LENSES TO PHOTOGRAPH ACTION

The action in sports such as football, baseball, or horse racing is often quite far away. However, you can use a telephoto lens to get a "close-up" view and fill the film frame. Remember, though, that a telephoto lens increases not only the image size but also the amount of image motion on the film. The amount of image movement on the film increases in direct proportion to the focal length of the lens. In practice, this means that if a shutter speed of 1/125 second is satisfactory to stop motion with a 50 mm lens, the same action at the same distance will require a shutter speed of 1/250 with a 100 mm telephoto lens. The longer the focal length, the higher the shutter speed that will be necessary.

Depth of field will be shallow at the large lens openings you use with high shutter speeds, so it's a good idea to use some sort of zone focusing system. Estimate the range in which the action will occur, and set your focusing scale on a compromise distance in the middle. Then you can take pictures quickly without focusing each time, and most of your pictures will be in sharp focus.

KODAK High Speed EKTACHROME Film (Daylight) is a natural for sports and action pictures. This film has a normal film speed of ASA 160, compared with a speed of ASA 25 for KODACHROME 25 Film (Daylight). This means that if the shutter speed you use for a given lens opening with KODACHROME 25 Film is 1/60 second, you can use nearly the same lens opening at 1/500 second with High Speed EKTACHROME Film.

161

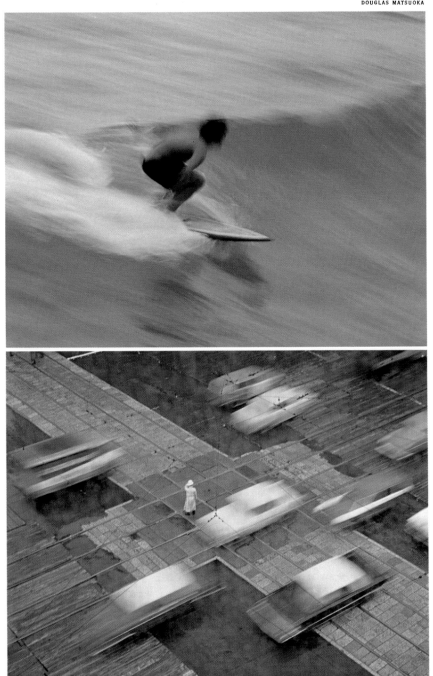

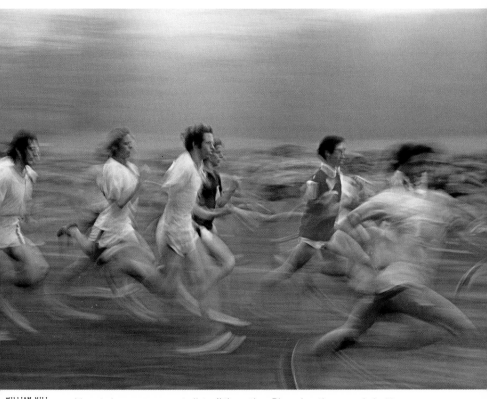

WILLIAM HILL It's not always necessary to "stop" the action. Blurred motion recorded with slow shutter speeds conveys a strong sense of action in still pictures.

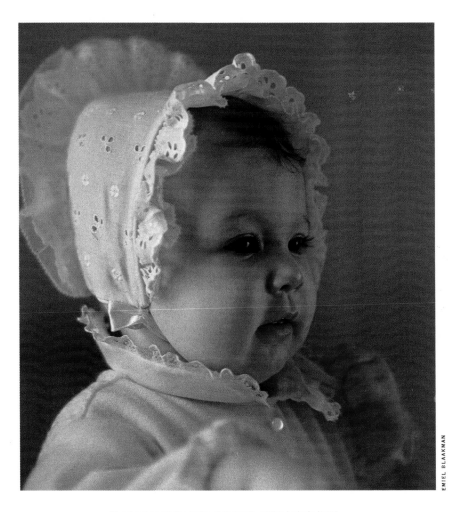

EMIEL BLAAKMAN

The best angle for baby pictures is at the baby's level—
even if it means squatting or getting down on your hands and
knees. Pictures like this one make the effort worthwhile.
Notice how the soft existing light enhances this slide.

Babies and Children

ROCK-A-BYE BABY

There used to be a Kodak advertisement that said, "The pictures you want tomorrow, you have to take today." This is especially so with babies and children, whose expressions and mannerisms change every few weeks. Kids change rapidly as they grow, but you may not realize it as time passes unless you stop and think about it or look at pictures taken earlier. So to keep those cherished moments from becoming just memories, take lots of pictures often.

Good baby pictures often require less technical skill than they do patience. One way of collecting winning photographs of the young ones would be to follow them around during all their waking hours, camera in hand, hoping that they'd do something appealing when the lighting and background were good. No doubt this would be a rather trying and unproductive experience. Try this instead. Have Mother or someone else on the home front keep a camera, ready for action, on a bookcase or in some other handy spot. Then when the baby performs some photogenic antics, the camera will be available on a moment's notice. For quick snapshots, a KODAK TRIMLITE INSTAMATIC 18 Camera and a flipflash are ideal to have around. When loaded with KODACHROME 64 or KODAK EKTACHROME-X Film, this inexpensive camera will make fine slides of anything the baby does in the 5 to 9-foot distance range. There's nothing to set—just aim and snap the picture.

To supplement these "grab shots," you will need some planned pictures built around some familiar item in the baby's life—the bathinette, high chair, or toy collection. Babies aren't noted for their patience and attention span, so have everything set up before the baby appears on the scene. When you use flash or photolamps, have the lights ready to go and your camera focused for the approximate subject distance.

With flashbulbs, be sure to use a flashguard over the reflector for that rare bulb that might shatter. Flipflash, magicubes, and flashcubes have built-in flashguards, but there are precautions for using these bulbs, too, at close distances. See the flashbulb manufacturer's instructions. An electronic flash unit is especially useful for photographing children because it "freezes" any subject motion that may take place as you snap the shutter.

A plain background, such as a painted wall, will focus attention on the baby and not on a dozen other things in the room. Avoid a clutter of furniture, draperies, venetian blinds, or patterned wallpaper in the background.

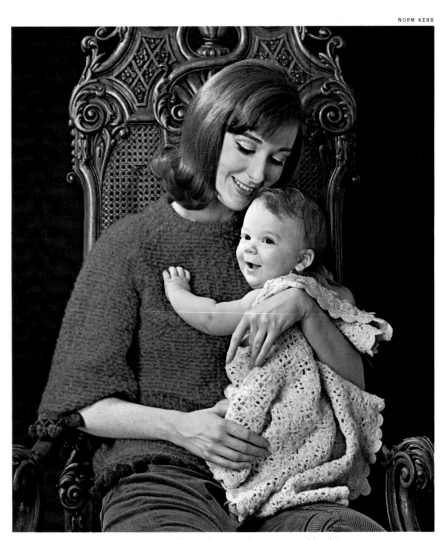

Mother holding the baby always makes a memorable picture.
This makes it easier for you, too, because Mother can keep the baby in position.

JOSEPH SCHNEIDER

Young babies will usually stay where you put them—and that's a real help to a photographer. Photolamps (3400 K) provided the light for this picture.

167

Babies make great picture subjects because their expressions are so appealing. The pleasing lighting for this slide was provided by multiple flash.

Bounce flash.

Existing daylight.

BOB CLEMENS

Electronic flash (direct).

CATCH 'EM IN ACTION!

The most important thing of all is to have the baby *doing* something when the shutter clicks. The pictures illustrating this section owe much of their charm to the fact that something is happening to make a worthwhile picture—a change of expression, the sudden arrival of tears, or the baby's happy discovery of his fingers or toes.

You can encourage such photogenic behavior with a few tricks. Tying a string or putting a piece of sticky tape around a baby's finger often produces some wonderful expressions as he tries to get it off. Seat the baby in front of a mirror and catch his expression as he views himself. Blow up some toy balloons or give the baby a magazine to rip up. Let him listen to a music box or play with a rubber band. Do anything that will take the baby's attention away from you and the camera. It will make for better pictures.

You shouldn't need to be reminded to have your camera handy for every one of the important "firsts" in a child's life—the first Christmas, the first birthday, the first sight of a Halloween pumpkin, the first steps, the first haircut. These will be your most treasured slides of all.

Good pictures of kids don't necessarily have to show them in a happy mood. A picture showing a sad expression and a large tear running down a soft cheek may turn out to be the most prized slide in your collection.

Existing daylight.

Photolamps (3200 K).

You'll capture the most natural expressions when children are involved in playtime activities.

Blue flashbulb.

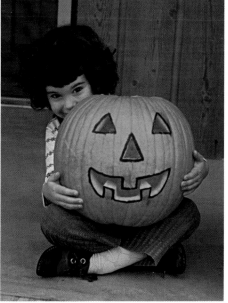

Always have your camera
loaded with film and available
for pictures of those childhood
happenings that will mean
so much to you in later years.

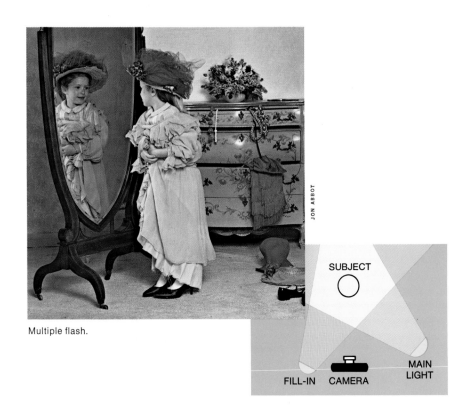

JON ABBOT

SUBJECT

FILL-IN CAMERA MAIN LIGHT

Multiple flash.

APRIL PETRONE

Existing light.

CHILDREN

These hints have concerned the very young. Older children—those in the 3 to 7-year age group—demand different tactics. Once they reach a certain age, kids get camera-conscious and start to mug, prance, and show off. Let them. It makes good pictures in limited quantities. For the most part, you'll have to catch them busy at play —running a model train, dressing in grown-up clothes, or just watching the villains and heroes flit across your TV screen.

You may have to invent things to do. Let them build towers or forts out of blocks. Show them how to make figures from modeling clay. Have Mother or Dad read a favorite story. Ask the names of colors and objects in the room. Make the picture-taking session a big game. When you have to start whistling and shouting for attention, or your son or daughter sheds tears and wants to go elsewhere—forget about taking pictures until next time. The pictures wouldn't be much good anyway.

"A day in the life of" is always a good theme. It takes a certain amount of stamina to keep your camera ready all through the usual day of a peppy youngster. Unless you deliberately plan to make a picture story of this kind, it will never get done, although such a series certainly becomes more precious with the passage of time.

One final point: Take plenty of pictures of each situation. Then you can pick and choose. Nobody gets an outstanding picture of kids with *every* click of the shutter.

PHOEBE DUNN

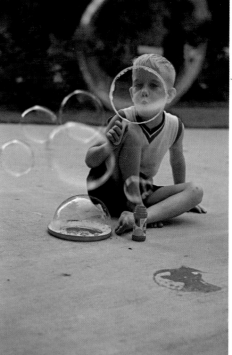

D. WAGHORNE

Photographing the boy through the bubbles helps make this a good slide.

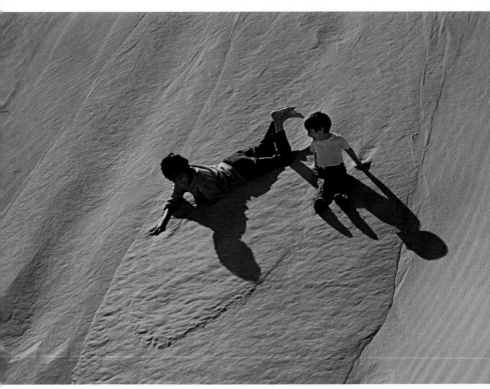

WILBURN COCKRELL

The backlighting creates interesting shadows, the background is simple, and the subjects are busy having fun —unaware of the camera. These characteristics give your slides appeal and impact.

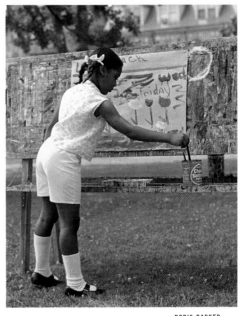

DORIS BARKER

176

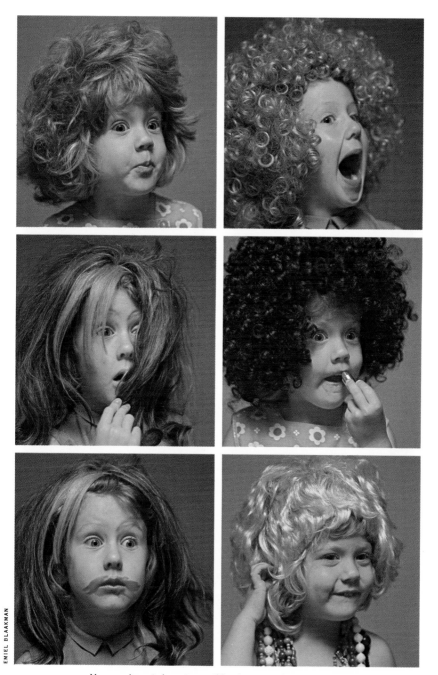

EMIEL BLAAKMAN

You may have to invent something for your subject to do, but
once she's really involved in an activity, she'll provide all sorts of
interesting expressions for you to photograph. An off-camera flash
positioned high and to one side provided the lighting for these pictures.

177

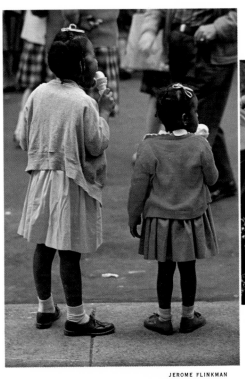

JEROME FLINKMAN

PETER GALES

NEIL MONTANUS

SUBJECT

FILL-IN CAMERA MAIN LIGHT

Multiple flash.

A low camera angle was a good choice for this picture.

WIL BLANCHE

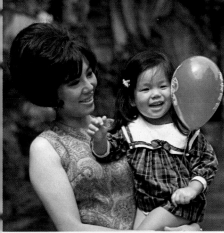

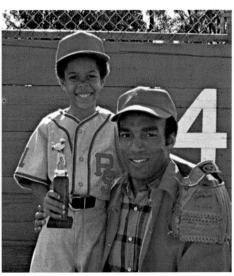

TONY PETROCELLI

A wreath and ribbon make good props for a Christmas scene. You may decide to use a slide like this for your Christmas card. Your photo dealer can have color prints made from your slides and can show you a selection of folders for Christmas photo-greeting cards.

You certainly wouldn't want to miss getting a picture of your boy's first trophy for your family slide collection. Recording the event on the spot is most effective.

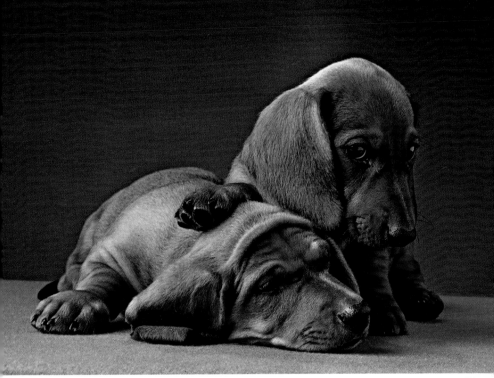

Photographing Pets

DOGS, CATS, AND OTHER PETS

Pets and children are a lot alike in many ways. They're both strong-willed, usually lovable, and occasionally exasperating. And they both require patient photographers for really good pictures.

The techniques for picture-taking are quite similar. Since you can't force Fido and Felix to do what *you* want, have them do what *they* want. If you want a picture of your cat licking the goldfish bowl, rub a drop of fish oil on the bowl. A lump of ground meat will get a nice lick from Rover.

Use your pet's favorite plaything: a catnip-filled mouse, a spool on a string, or a rubber doll. Such objects take your pet's attention from you, localize the action somewhat, and provide interesting antics for your lens.

Kittens love closed places. Let them play in baskets and boxes, or catch them as they poke their heads from under a blanket.

You can take good pictures of dogs or cats with flashbulbs or electronic flash. Because of the movement involved, electronic flash is an ideal light source.

Slumber time is picture time for most pets. They're cute and quiet at the same time, a good combination to soothe frazzled nerves after you've tried to catch them in action for an hour.

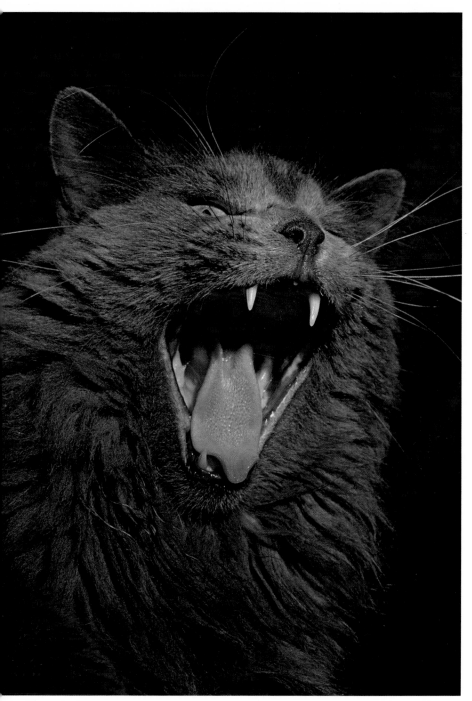

Get down to the animal's level and move in close for the most dramatic
pictures. Close-up views give your slides impact!

PETE CULROSS

Cats generally love to crawl into small, cozy places. Provide a few such feline playgrounds, and you'll have some good opportunities to photograph your pets.

WALTER CHANDOHA

BOB CLEMENS

Use a favorite toy to attract your pet's attention.

Notice the plain background and the simple props in the foreground—
good ideas for anyone photographing pets. Keep it simple.

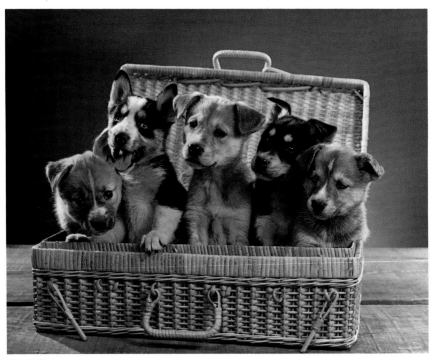

DON MAGGIO

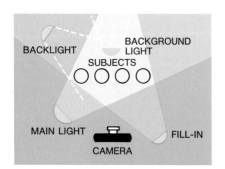

BACKLIGHT

BACKGROUND
LIGHT

SUBJECTS

MAIN LIGHT

CAMERA

FILL-IN

Multiple electronic flash units provided the lighting. Electronic flash is great for pet photography because it "freezes" any movement of the subjects.

PETER GALES

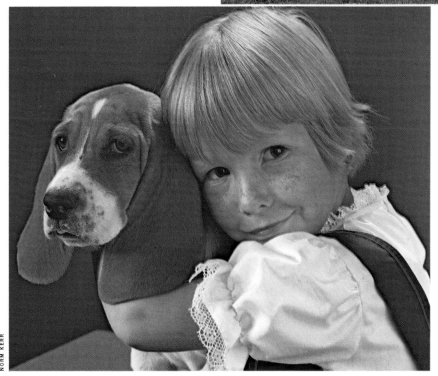

NORM KERR

Children and pets make surefire picture material. Try to fill
most of the picture area with the main subjects.

CHRIS SCHULER

DORIS BARKER

Long-focal-length lenses are especially helpful in making close-up pictures of animals. The foliage acts as a frame which centers attention on your subject.

WINFRIED BERNER

Don't forget your barnyard pets; they make good picture subjects, too!

Watch for interesting lighting effects that can make your
pictures unique, such as the patch of sunlight in the barn and
the pattern of the stained-glass window.

A flash camera lets you capture those candid moments quickly, before the opportunity has passed.

JOSEPH SCHNEIDER

Small pets make good picture subjects if you remember to move in close! To photograph the guinea pig, a handkerchief was used over the flash to cut down on the flash intensity.

MICHAEL HERREL

You can get some prizewinning slides of fish in an aquarium.

FISHY BUSINESS

Many people enjoy photographing pets other than cats and dogs. Fish owners, too, have an interesting photographic subject with lots of possibilities. Photographing fish in their own tank is one branch of "underwater" photography for which you need neither snorkel nor swim fins. Whether your fish are delicately colored tropical beauties or dime-store goldfish, they'll make lovely and unusual picture subjects. Here's how to capture them on film.

A flat-sided aquarium is a must, because a round bowl causes too much distortion. If you use flash on your camera, avoid reflections from the aquarium by taking your picures at an angle to the glass. To avoid light reflections when you're not using on-camera flash, hold your camera perpendicular to the glass; then place your flash holder or photolamps above the aquarium or at a 45-degree angle on each side.

PETE CULROSS

These pictures were illuminated by a pair of
lights mounted at the top of the tank with the
light filtering through the water. To avoid
reflections of the camera in the sides of the
tank, turn off all lights in the room except
those illuminating the aquarium, and move in
close with your camera.

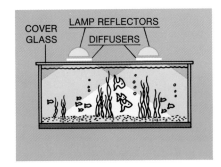

PETE CULROSS

"Catching" Fish in Close-Ups

Most tropical fish are very tiny creatures, and from a normal camera distance they look like mere specks in their underwater world. However, a close-up will reveal all of the intricate detail that is often hidden in pictures taken from farther away. You can make close-up pictures with any kind of camera.

Most adjustable cameras will focus on subjects as close as 2½ to 3½ feet. This is close enough for close-ups of children, large dogs, and other "big" subjects, but it just won't do for those really dramatic close-ups of small things such as fish. The easiest way to take extreme close-ups is with

close-up lenses. Your photo dealer can help you select the size to fit your camera.

Shallow depth of field can be quite a problem in close-up photography unless you arrange to keep the fish within the narrow range of the camera's focus. One good technique is to confine the fish near the front of the tank by putting a sheet of glass in the water. This limits their travel to a few inches. It also reduces annoying reflections of the fish which occur in any air-glass surfaces behind it.

Taking close-up pictures is discussed in more detail in the following section.

Electronic flash is very helpful in photographing fish because of its action-stopping ability. Depth of field will be quite shallow, so it's a good idea to confine the fish to a small area by means of a sheet of glass in the water.

Close-Up Pictures

If you take all your pictures at normal subject distances, you're missing a lot of fascinating and unusual picture possibilities. All too often, we view our surroundings from an overall viewpoint and miss the small bits of our environment which must be viewed close up. Close-up photography lets you capture intricate detail in your pictures, which helps focus the viewer's attention on the small world.

For example, a good way to capture the delicate beauty of flowers for future enjoyment is by taking pictures. And there's no better way to show all the detail of your favorite blossoms than in close-ups. With a close-up picture, you can isolate the smallest bud or bloom and make it fill your whole picture area.

By using close-up techniques, you can take interesting views of many subjects, such as small animals, insects, coins, stamps, scale models, figurines, and parts of larger subjects, such as a person's hands. And when you want to make slides of other photographs or documents, close-up equipment will let you obtain images large enough to fill the picture area.

FRANCES DAVIS

Close-up photography provides a whole new range of subject material. Detail that goes unnoticed at conventional distances becomes the center of interest when you move in close with your camera.

DAVID CHAFARIS

195

Including a familiar
element, such as a
hand, in a picture of
this type establishes
a size relationship
for the main subject.

USING CLOSE-UP LENSES

Close-up lenses make it possible for you to use any camera for close-ups. Making pictures with close-up lenses is easy and convenient because these simple lenses fit over the camera lens like filters and don't require any exposure compensation.

Close-up lenses come in different strengths which allow you to take pictures at different distances. These strengths are indicated by numbers such as +1, +2, and +3. The bigger the number, the stronger the lens and the closer you can get to the subject. It's also possible to use two close-up lenses together to get even closer to your subject than you could with either lens alone. For example, you could use a +2 and a +3 together. This combination would let you get as close as a +5 close-up lens. The stronger close-up lens goes next to the camera lens.

HERB JONES

KEITH BOAS

Close-up subjects are everywhere!

197

FOCUSING WITH CLOSE-UP LENSES

When you make close-up pictures, it's important to place your camera at the correct distance from the subject. This distance depends on the close-up lens you're using. Each close-up lens will focus sharply only within a limited range, so depth of field is quite shallow. To get sharp pictures and to simplify focusing, it's best to use a lens opening no larger than $f/8$.

Close-Up Lens	Close-Up Lens Focusing Range (in inches)
+1	20⅜ to 39
+2	13⅜ to 19½
+3	10 to 13⅛
+4 (+3 and +1)	8 to 9⅞
+5 (+3 and +2)	6⅝ to 7⅞
+6 (+3 and +3)	5⅝ to 6⅝
+8	4⅜ to 4⅞
+10	3⅝ to 4

This pleasing picture shows the narrow range of sharpness you get with a close-up lens. The center of the flower is in sharp focus, but the stem and some of the petals are fuzzy. Focusing is critical, so it's best to measure the distance from the front of the close-up lens to your subject. The instructions with the close-up lens will tell you how close you can get and how much area your picture will include.

At the close subject distances you use with close-up lenses, the viewfinder doesn't show exactly what will be in the picture unless you're using a single-lens reflex camera with through-the-lens viewfinding. This happens because the viewfinder is located slightly higher than the lens or to one side of it, so the viewfinder "sees" a slightly different picture from the one that the lens sees. This is called *parallax*. You can correct for parallax by tipping your camera slightly in the direction of the viewfinder after you have composed the picture. The closer you get to the subject, the more you need to tip the camera in order to get the picture you first saw in the viewfinder.

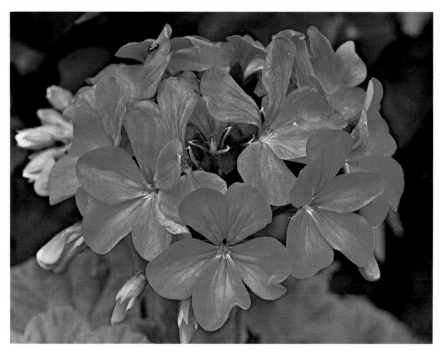

When you see this through the viewfinder, . . .

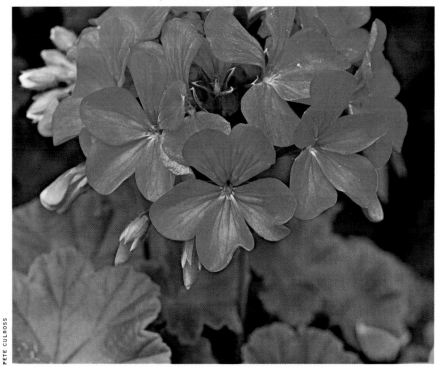

. . . the picture will look like this. So tip the camera
slightly in the direction of the viewfinder to compensate.

A Subject distance.
B Field size, or width of the area that will be in your picture, when subject is at distance A.

MAKING A CLOSE-UP MEASURING DEVICE

It's easy to make a handy cardboard measuring device that will correct for parallax, show how much of the subject will be included in the picture area, and measure the distance to the subject for you. Heavy, stiff cardboard works best. You can obtain this material from art-supply or stationery stores, or you may already have a piece around home that's suitable. Consult the instruction sheet for your close-up lens to determine the subject distance (distance "A" in the illustration) and the width of the area (distance "B") that you'll be photographing at that distance. Cut the piece of cardboard and draw a line down the center as indicated in the drawing above.

If you have a single-lens reflex camera, framing close-ups and focusing will be easy, and you won't need the close-up measuring device. When you look through the viewfinder, you see what will be in the picture because you're looking through the camera lens. Most single-lens reflex cameras have ground-glass focusing, and when the subject looks sharp in the viewfinder, it will be in focus in your picture.

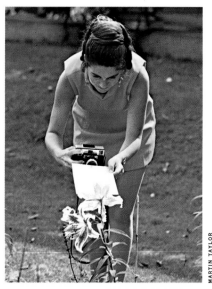

MARTIN TAYLOR

Hold the centerline of the cardboard up to the center of the close-up lens. When the end of the cardboard touches your subject, drop the cardboard and take the picture. Don't use the viewfinder to frame your subject, and make sure that you aim your camera at the same angle as you aimed the cardboard.

BARBARA JEAN

USING EXTENSION TUBES AND BELLOWS

You can also make close-up pictures by means of extension tubes or bellows. However, you can use these devices only with cameras having removable lenses and ground-glass focusing because of the extremely critical depth of field.

One difficulty in using extension tubes or bellows is that the *f*-numbers marked on the lens no longer apply because the ratio of the lens opening to the focal length is changed when you place extension devices between the camera body and the lens. Whenever the long dimension of the area that will be in your photograph, or field size, is less than about 11 inches with a 35 mm camera or less than about 8½ inches with a 126 camera, the lens is extended enough to change the effective *f*-number of the lens, regardless of its focal length. You can correct for this change in effective *f*-number by giving the picture additional exposure.

The tables on page 203 provide a handy way to find how much to increase the exposure with a 35 mm or 126 camera in order to prevent underexposure in close-up pictures made with extension tubes or bellows. If your camera has a built-in exposure meter which measures the light coming through the lens and you're not using flash, you don't need to make an exposure correction because the meter will automatically do it for you.

GENE ANDERSON

Electronic flash is an excellent light source for close-up photography of insects because it "freezes" motion and lets you use small lens openings for good depth of field.

STEPHEN DOUTHAT

202

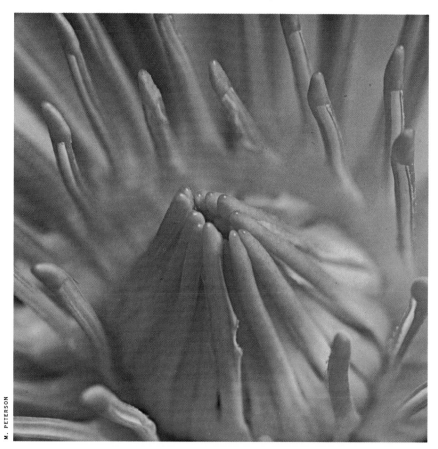

When extreme close-ups are made with extension tubes,
an increase in exposure is required.

Exposure Increase for Extended Lens—Full-Frame 35 mm Cameras with Lens of Any Focal Length

Field Size Long Dimension (inches)	11	5⅛	3¼	2¼	2	1¾	1⅜	1
Open Lens by (f-stops)	⅓	⅔	1	1⅓	1½	1⅔	2	2½
Or Multiply Exposure Time by	1.3	1.6	2	2.5	2.8	3.2	4	5.7

Exposure Increase for Extended Lens—126 Cameras with Lens of Any Focal Length

Field Size (inches)	8½	5½	4	2½	1¾	1½	1¼	1
Open Lens by (f-stops)	⅓	½	⅔	1	1⅓	1½	1⅔	2
Or Multiply Exposure Time by	1.3	1.4	1.6	2	2.5	2.8	3.2	4

LIGHTING FOR
CLOSE-UP PICTURES

Usually, the most convenient way to make close-up pictures is in bright sunlight. Sunlight does create shadows, so check your subject to make sure that it is not in patches of shadow. If it is in a shadow, try to change your viewpoint so that most of the subject is sunlit; or use a large piece of white paper or aluminum foil to reflect sunlight into the shadows.

Indoors, you can use photolamp lighting or flash for close-ups. If you use photolamps, you need to use a film balanced for this kind of lighting, such as KODACHROME II Professional Film (Type A). The best way to determine the exposure is with an exposure meter. Be careful that the lights are not shining directly into the meter when you take the reading.

You can use flash—on or off the camera—for close-up picture-taking outdoors on overcast days or in the shade as well as indoors. Since depth of field is extremely shallow for close-up pictures, using flash close to your subject (or taking the picture in bright sunlight) gives you the advantage of increased depth of field because you'll be using small lens openings.

Since on-camera flash will be so close to the subject, you must cut down the amount of light or the picture will be overexposed (too light). An easy way to do this is to drape a *white* handkerchief over the flash reflector or flashcube. Make sure that the handkerchief doesn't get in front of the camera lens.

If you have an automatic electronic flash unit, you may be able to use it to determine the exposure for close-ups automatically. This depends on the minimum flash-to-subject distance recommended in the instruction book for your flash unit.

You may want to experiment by taking some pictures with the flash unit set for automatic operation. Try using the unit both with and without a handkerchief over the flash. Don't let the handkerchief cover the electric-eye sensor in the flash unit. It's best to use the flash off the camera so that you can aim the flash and the electric eye directly at the subject. Also, keep in

When the sun shines on subjects from the back or the side, it shows their texture and often produces delicate, translucent effects. So when you can, try to use backlighting or sidelighting to enhance your subject.

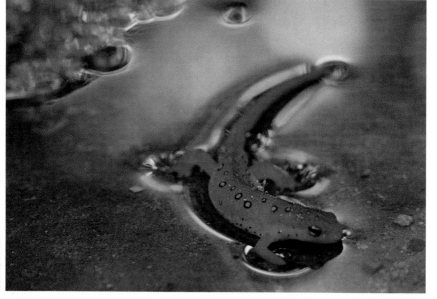

KEITH BOAS

You can obtain dramatic lighting effects with only one light—a spotlight in this instance.

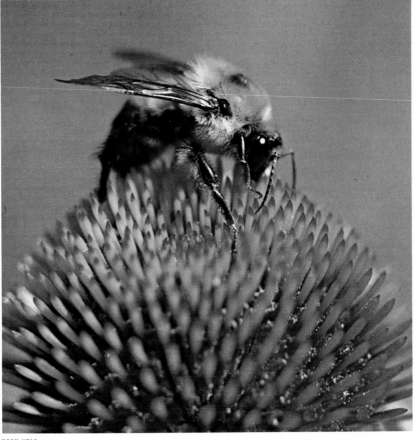

NORM KERR

mind that when you use the flash off camera, and if your sync cord is long enough, you may want to place the camera closer to the subject than the flash. Once you have determined the proper exposure for the flash—for example, an 18-inch flash-to-subject distance—you can move your camera closer to the subject and the exposure will stay the same as far as the flash is concerned. In addition, there's a better chance that an automatic electronic flash will work properly if you don't have to place the flash too close to the subject. If you're using a lens-extension device for close-up pictures, an exposure compensation will have to be taken into account.

However, you may find that the combination of your automatic electronic flash and the film you're using requires a lens opening that is too large for adequate sharpness and depth of field. Under these circumstances, you should set the flash unit for manual operation and determine the exposure from the electronic-flash table below.

FLASH EXPOSURE INFORMATION FOR CLOSE-UPS

The following tables are for use with KODAK EKTACHROME-X Film or KODACHROME 64 Film. Put one layer of white handkerchief over the flash. With KODACHROME 25 Film (Daylight), use 1 stop more exposure than the tables indicate.

CLOSE-UP EXPOSURES WITH FLASHBULBS
1/30 Second X Synchronization

Flashbulb and Reflector Use one layer of handkerchief	Flash-to-Subject Distance Film Speed ASA 64	
	10—20 inches	30 inches
Flashcube or Magicube	f/16	f/11
AG-1B shallow cylindrical reflector	f/16	f/11
Hi-Power Flashcube	f/22	f/16
AG-1B, M2B polished-bowl reflector	f/22	f/16
M3B, 5B, or 25B (focal-plane shutter—6B, 26B) polished-bowl reflector	f/22 with two layers of handkerchief	f/22

CLOSE-UP EXPOSURES WITH ELECTRONIC FLASH
Use Any Shutter Speed at X Synchronization*

Output of Unit—BCPS Use one layer of handkerchief	Flash-to-Subject Distance Film Speed ASA 64	
	10—20 inches	30 inches
700 — 1000	f/11	f/8
1400 — 2000	f/16	f/11
2800 — 4000	f/22	f/16
5600 — 8000	f/22 with two layers of handkerchief	f/22

*With cameras that have focal-plane shutters, use the shutter speed recommended in your camera manual for electronic flash.

Note: For very light subjects, use 1 stop less exposure or add another layer of handkerchief over the flash reflector.

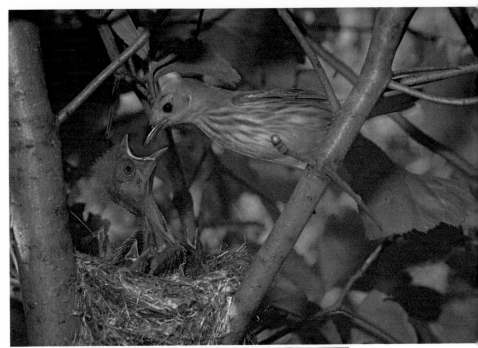

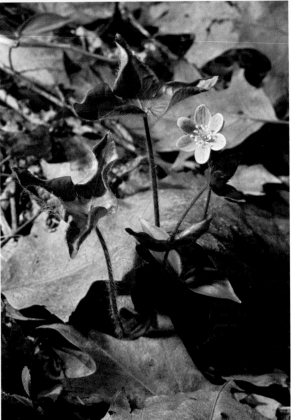

When your subject is in the shade, you can take the picture with flash.

A LITTLE BIT ON BACKGROUNDS

When you take extreme close-ups, the background in your picture will be way out of focus. An out-of-focus background becomes a pleasing, hazy, unobtrusive curtain of color that complements the subject without detracting from it.

To obtain a plain dark background, place or hold a large sheet of black paper behind the subject and use a normal exposure. The subject will stand out in sharp contrast.

If there's no black paper handy, you might ask a friend to stand so that his shadow falls on the background. His shadow will cause the background to be underexposed and dark in the picture.

If you prefer a colored background, you'll find a rainbow selection of large sheets of dull-finish colored paper at art-supply stores. Hold the paper behind the subject, such as a flower, and you have a portable background. Be careful that the subject doesn't cast a distracting shadow on the background paper.

In addition to paper backgrounds, you can use any handy material which complements the subject, such as plain-colored cloth, a piece of wood paneling, or rustic boards. Or you can use a natural background, such as sand, water, or the sky. The main thing to remember is to avoid "busy" backgrounds with too much detail.

Look closely! You'll find a whole world of small subjects that will add a new zest to your slide collection.

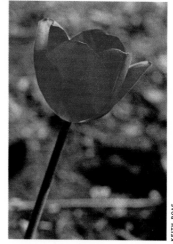

Normal, out-of-focus background.

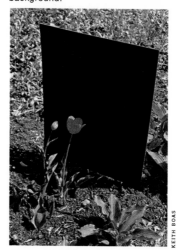

Black-paper background.

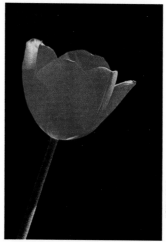

209

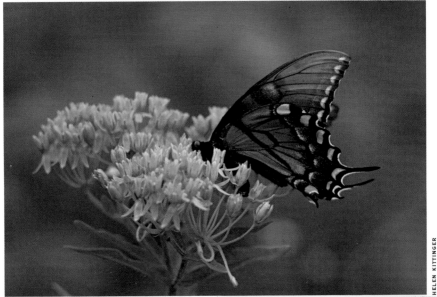

When you can throw the background completely out of focus and it becomes a smooth blur of color, you may not need background paper.

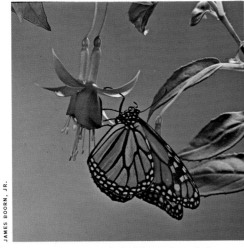

When your target is the bloom of a potted plant, you can tape the background paper to a wall about a foot or two behind the subject.

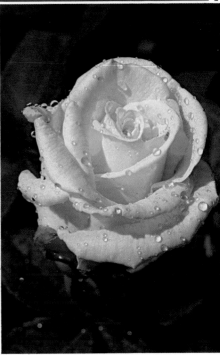

Make your own dew. Add impact to your flower pictures by sprinkling a little water on the blossoms before you shoot. The water will give your flowers a fresh, dewy look that is pleasing in pictures.

You can use telephoto lenses to obtain close-up
views of subjects from a distance.

Tabletops

PICTURES MADE TO ORDER

FRED PHATE

Using sunlight for the dramatic lighting of this toy car and choosing an unusual viewpoint give this picture unique appeal.

The creative spirit is given full rein in the area of tabletop photography. This fascinating branch of photography deals with any subject the mind can conjure up and the hands can produce. It's photography's fantasyland, where anything goes.

In its simplest form, tabletop photography consists in arranging a scene on a table or other suitable surface and photographing it. Popular subjects are model trains, ships, planes, and boats; figures made of clay or pipe cleaners; kitchen utensils; fruits and vegetables adorned with cartoon faces; flower arrangements; tools, machine parts, and gears; toys and puppets; and just about anything else you can imagine.

You can use flash for your tabletop pictures, but it has the disadvantages of costing more and not letting you see the lighting arrangement before you take the picture.

Lighting tabletops is easy because your subject doesn't move. With a set of two or three photolamps you can create a variety of lighting arrangements. You might start out by using the lighting techniques given in the chapter "Pictures of People with Photolamps," which starts on page 98. You can change the atmosphere of a tabletop by just changing the position of the lights. For example, shining the lights on the background instead of on the subject itself will silhouette the subject. This approach produces striking results with many subjects and makes models look more realistic because their minor imperfections are not visible in the silhouetted image.

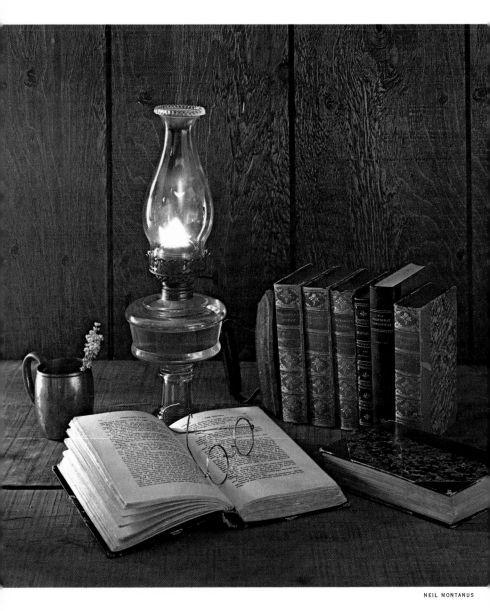

Tabletop subjects can be any small subjects you want to photograph.
Taking pictures indoors is convenient because there's no wind to cause subject
movement, and you have complete control over lighting and arrangement.

Well-executed tabletops are often successful in photographic salons.

It's often effective to have a light source such as a candle as a part of the scene so that it seems to be providing the illumination for the picture. When photolamps are providing the main illumination, you can determine a rough approximation of the exposure by using the photolamp guide numbers supplied by photolamp manufacturers, but an exposure meter is certainly more accurate for flexible and varied lighting arrangements.

You can make backgrounds for your sets from enlarged photographic prints, framed pictures, calendar illustrations, tapestries, a sheet of cardboard, or just the wall of a room.

The most familiar household articles assume a new and exciting air when illuminated by colored lights or seen in a different way. Using spotlights with colored theatrical gelatin filters over them adds a new dimension to your subjects, tabletop or otherwise. Colored lights projected on glassware or statuettes are especially striking. When more elaborate equipment isn't available, colored cellophane held over the lens of a slide projector with a rubber band will make a satisfactory colored spotlight.

If your camera is capable of making double exposures, you can make fascinating multiple exposures by photographing the same subject in three or four different positions, each time illuminated by a spotlight of a different color. You can create "colored" candle flames by using different colored filters over the camera lens for each exposure on the same frame of film. Be sure the filters are perfectly clean and free from fingerprints, or the flames will look fuzzy.

An old folding card table makes an excellent base for many of these tabletop setups. A hole about a foot square cut through the center of such a table, with a piece of opal glass over the hole to hold the subject, will allow spotlights to shine up from beneath the table for special lighting effects.

There are all kinds of household items which you can use to add special effects to your tabletops. For example, you can make "snow" by using baking soda or salt.

Either crumpled cellophane or pebble-surfaced glass makes convincing "water." Tufts of cotton produce realistic-looking "clouds." But these are just the beginning. One ardent amateur takes pictures of candle flames and other objects through a "rainy" windowpane by setting up a pane of glass, smearing it with Vaseline petroleum jelly, and spraying the greasy surface with a spray-type window cleaner to simulate beads of water. (Real water doesn't look like water in this case!)

To photograph Christmas ornaments and other subjects through a "frosty" windowpane, dab rubber cement around the corners of the glass pane and sprinkle powdered sugar on the cement to make frost.

The miniature world of tabletops can be enchanting because there's no limit to the unusual pictures you can create with everyday objects. The next time the photographic urge hits you and there's no one around to be your subject, let yourself in for some fun by trying tabletops!

KEITH BOAS

DICK BODEN

219

J. GABOURY

Toys often make
good tabletop subjects.

en effective to
e a light
as part of
ne.

Not all tabletops have to be photographed
indoors. Put your miniature subjects in an
appropriate outdoor setting and use a low
camera angle for realism.

NORM KERR

221

KEITH BOAS

Colored filters over the light sources made the colorful highlights in this slide.

GEORGE BUTT

In this tabletop, the props were placed on a sheet of glass with the lighting coming from a single light source below the glass.

A single light positioned on the left side illuminates the figurine. Aim the light so that it won't strike the background.

SPOTLIGHT

MATTE
ACETATE
SCREEN

CAMERA

SUBJECT

PROJECTOR

Setup for projected background.

A slide is projected from the rear onto a matte-acetate background. Sheets of matte acetate are available from art-supply stores.

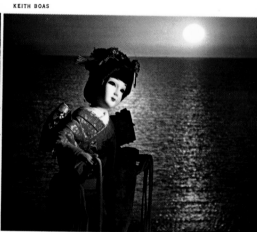

The finished slide.

You can vary the background scene according to the mood you want to create.

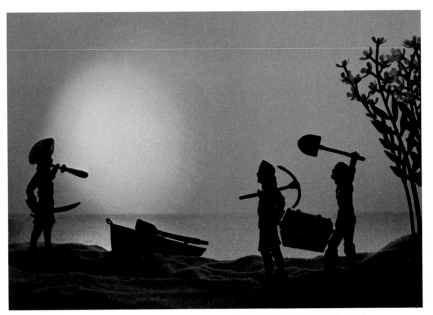

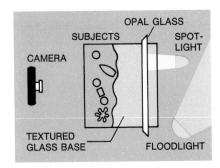

Light from the background puts the plastic figures in silhouette. A piece of opal glass is used for the sky and a piece of textured glass forms the water. Floodlight bounced from blue paper behind the opal glass provides the overall blue in the sky and water. A spotlight behind the opal glass forms the hazy moon.

OPAL GLASS

SUBJECTS

SPOT-LIGHT

CAMERA

TEXTURED GLASS BASE

FLOODLIGHT

With only simple props you can create a clever miniature drama.

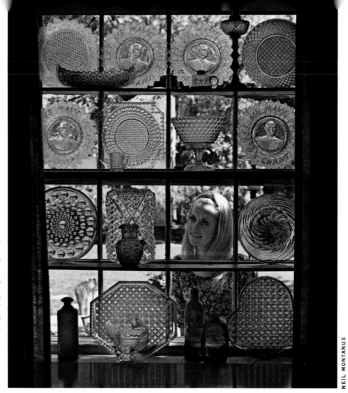

Many gift shops have colorful glassware in their windows, and often it's already arranged in a pleasing composition. Use a daylight-type film.

GLASSWARE

From a delicately beautiful etched crystal goblet to the thickly carved glass of a colorful Early American ice-cream dish, glassware comes in an infinite variety of shapes, sizes, colors, and textures. You can extend all of this variety even further by the use of colored lights and colored liquids, because glassware transmits color and light. These characteristics make glassware one of the most intriguing indoor subjects for your camera. Although it is usually considered a table-top subject, we'd like to discuss glassware separately because it requires special techniques in lighting.

Glassware in Windows

Backlighted translucent or transparent objects make very attractive subjects. Such things as vases and colored glassware displayed in windows are ideal subjects for your color-slide camera. To obtain proper exposure and record color in the glassware,

you should use an exposure about 1 stop more than the outdoor lighting conditions would normally require. Actually, there is surprising exposure latitude in subjects of this nature, and a wide range of exposures will produce pleasing results. If any portion of the interior of the room, such as a drapery or a part of the wall, appears in the picture, it will record as a dark silhouette on the film.

Although you take these pictures indoors, they will naturally require a daylight-type film because daylight is providing the light. Use a large lens opening or take the picture from a low viewpoint to keep the background from being distracting. If your prize colored glassware is competing for attention with the neighbor's garage across the street, the result will be pictorial hash. When you must include a cluttered background, throw it out of focus so that the background detail is soft and unobtrusive.

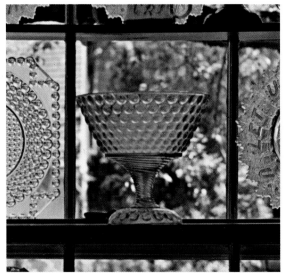

Determining exposure for this type of subject with an exposure meter is tricky because the meter "sees" mainly the bright light outdoors, causing under-exposure of the glassware. Either take a close-up reading of the glassware or try increasing exposure by 1 stop over that required for the *outdoor* lighting.

NEIL MONTANUS

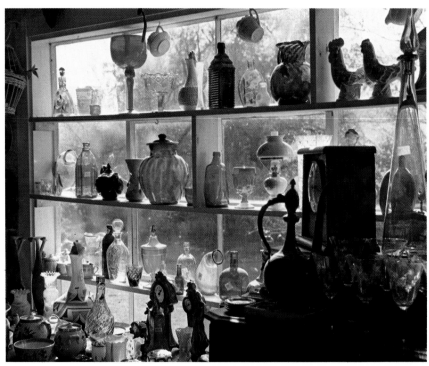

DON MAGGIO

ERWIN HOLTTMAN

Artistic glassware can provide the subject matter for unusual indoor color slides. Use a low camera angle so that you can record the complete rim of each pitcher.

Glassware by Artificial Light

The easiest way to get started taking colorful slides of glassware by artificial light is to arrange the subjects in front of a plain background and photograph them by the light reflected from the background. You can use one or two reflector photolamps as the light source. Aim the lights at the background, and the reflected light will illuminate the glassware. Be sure to turn off the room lights to avoid unwanted reflections. This type of lighting is soft and even, and you avoid the distracting reflections that can appear when a light is aimed directly at a piece of glass.

You can tape a large piece of colored paper to a wall and use it as the background. Leave the bottom of the paper loose and make sure the paper is long enough to serve as the background and still have 10 or 15 inches resting on the table. Arrange the glassware right on the background paper. The foreground will be the same color as the background, focusing attention on the glassware.

227

You can even make your own "red wine" with a few drops of red food coloring in water.

You can create attractive color combinations when you photograph clear glassware. Illuminating a large piece of colored paper behind textured glass allows you to make the background any hue you desire. The orange highlights on the glassware were produced by bouncing light from floodlights off orange paper positioned on both sides of the subject.

JUDY TRENT

PAM TRENT

Tabletop Setup for Photographing Colorful Glassware

Another type of background which is very effective with glassware is textured glass or plastic sheeting. There are two big advantages in using this type of textured background. You can make the background any color you want by placing colored filters in front of the lights, and you can create all kinds of unusual effects by placing glassware behind and in front of the textured background. You'll need two sheets of glass or plastic for the setup illustrated on page 231. The opal glass diffuses the light and helps provide even illumination. The second sheet of glass or plastic provides the textured background. These sheets are available through building-supply, glass, and plastic dealers. You can use 2 x 2-inch hardwood boards with 1¼-inch-deep grooves cut in the board to hold the glass.

One reflector photolamp provides enough light to get you started with this setup. Place the photolamp low and behind the opal glass, and aim it up toward the background. The lighting units used to floodlight a Christmas tree are ideal for this purpose. These units usually contain a reflector flood lamp, a stand with a swivel head, and a number of filters which you can rotate in front of the light to produce different colors. You may want to add a spotlight later to accent small areas from behind the opal glass. The spotlight can be the beam from a slide projector. When you're ready to take the picture, be sure to turn off the room lights or you'll get unwanted reflections on the glassware.

To get the most natural color rendition, select a color-slide film which is balanced for photolamp (3400 K) illumination, such as KODACHROME II Professional Film (Type A).

Now that you have the equipment set up, just arrange your glassware in a pleasing composition and you're ready to take the picture.

Use a low camera angle to keep the line where the background and foreground meet low in the picture area. This low angle also allows you to record the entire rim of the glassware, which will contribute to the composition. Since glassware is often small, you may need to use a close-up lens or a camera with extension tubes or bellows to fill the picture area with your subject. For information on making close-ups, refer to page 194.

You can determine the exposure easily by taking a reflected-light reading from the camera position or by using an automatic camera. Since color saturation can vary with the exposure, it's a good idea to bracket your exposure and then select the slide you like best.

We described how you can add color to the background by placing colored filters over the lights. You can also make a multicolored background or vary the intensity of the color by taping pieces of colored cellophane to the opal glass. To make your glassware more colorful, put some water in the glasses and add a few drops of red food coloring. You'll have instant "red wine."

With this kind of photographic setup, you can have a lot of fun creating unusual and colorful effects with glass, for the possibilities are limited only by the extent of your own ingenuity. If you're craving an indoor photographic challenge, this is it!

For multicolored backgrounds, you can obtain panels containing pieces of colored plastic from stores which sell building supplies.

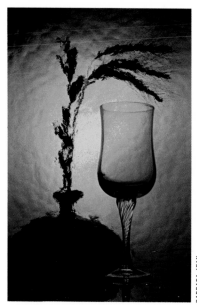

You can place the glassware on both sides of a textured-glass background to create unusual effects. The subjects in this photograph were placed behind rippled glass, and the texture of the glass converted this ordinary subject into something special. The light from a slide projector with a gold-colored filter provided the spotlight and a center of interest.

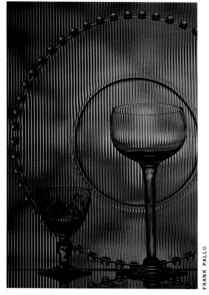

The colored-plastic panel was used between the light source and the sheet of fluted glass. The glass diffuses and softens the image of the colored panel.

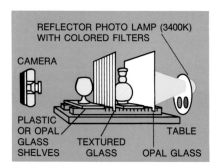

Use 2 x 2-inch hardwood with grooves cut 1¼ inches deep, for holding the glass. Grooves are spaced 1 inch apart and are alternately ⅛ and ¼ inch wide to accommodate different thicknesses of glass.

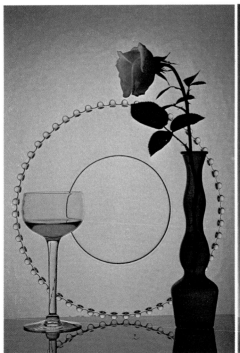

Hammered-texture-glass background. Fluted-glass background.

FRANK PALLO

This red effect was achieved by using a red
filter in front of the light. Two small-beam
spotlights were aimed at the opal glass
behind the fluted glass to form the white
highlights.

FRANK PALLO

The lighting for this close-up of a vase was provided by a floodlight
behind a colored panel like the one shown on page 231. A sheet of opal glass was
used between the colored panel and the vase to diffuse the light pattern.

Telling a Story with Your Slides

Everybody loves a story. That includes everybody who sees your slides, too. To make your pictures more interesting and meaningful, put them in a logical order and make them tell a story. Almost any of your activities—traveling, vacationing, picnicking, celebrating a holiday, or even just spending a typical day in the life of your family—lends itself to telling some kind of story.

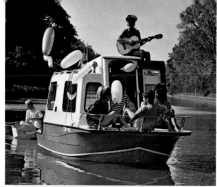

Special events that would make interesting picture stories may not be repeated, so be prepared to capture them on film. You'll treasure pictures of such memorable events in your slide collection.

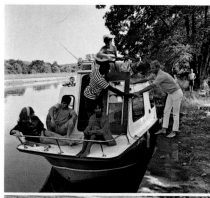

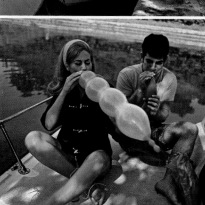

NORM KERR

Pictures Tell the Story

Susie can hardly wait for the party to start.

Janet's not quite sure how to open her party favor.

"I'm so glad that all my friends could come."

"It says there's a tall dark man in my future."

"I wonder what's inside all those beautiful packages."

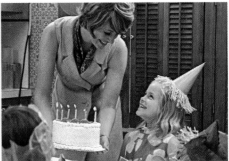

"Mom, that sure is a pretty cake!"

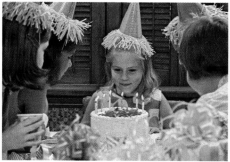

"Let's see now—what should I wish?"

"Umm, that's good!"

Susie's wish will come true because she blew out all the candles.

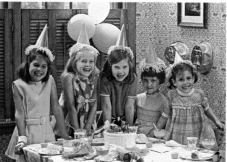

"Birthdays are so much fun!"

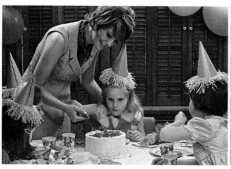

"How big should I make the first piece?"

"It's hard to know where to pin the tail when you're blindfolded."

Why not try some story-telling sequences like this yourself?

KEITH BOAS

Making Titles

Every Hollywood epic has titles—and so should your slide stories. Titles help you organize your slides and make your slide shows more interesting. Titles also help explain your slides and add a change of pace to your presentation. It's easy to make titles on picture-taking excursions or at home.

Titles can be the simplest things imaginable, such as roadside signs, historical markers, or even advertising billboards. Almost any state or national park has a sign naming the park and others marking the various attractions within the park. As you travel around, take a picture of each of these signs. It will help keep your audience with you on your travels and remind you of which slides were taken where.

A little ingenuity will produce any number of clever and functional titles. For spur-of-the-moment titles, try writing in the sand or spelling out words with sticks and stones on the ground. At home you can cut out letters from colored construction paper, draw a title with colored crayons, daub letters with finger paints on a sheet of glass, or spell out titles with letters from a Scrabble or Anagram set. You can cut out interesting titles and captions from magazines and arrange the

HERB JONES

Title as you travel by photographing roadside signs and historical markers. They show where you went and how you got there.

ROD GRIMES

Try to include members of your family in your title slides. What better way to make your pictures more interesting and show you were there?

Look for lighted signs at night—they make great titles.

The natural titles you photograph during your travels are often more rewarding and are easier to make than those you make after the trip is over.

239

Here's a clever way to create your own title. Backlighting made the letters in the sand stand out more clearly.

BARBARA JEAN

You can photograph travel brochures or postcards for title slides by using close-up techniques.

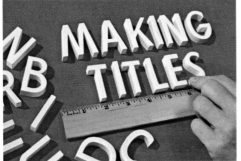

KEITH BOAS

When you want to make more professional-looking titles, you can use plastic letters, available in camera shops.

words on a colorful background. If you're making titles to accent a travel slide show, you might make a close-up of a map on which you have marked your route with a marking pen. Some people collect picture postcards when they travel and then photograph them to make titles when they return home. For a "3-D" title effect, include small seashells or other souvenirs of your trip on a postcard or a picture of the place you visited.

If you want really professional-looking titles, you might invest in some inexpensive plastic letters. Many camera shops sell complete titling outfits, including a variety of three-dimensional letters and symbols in different sizes. These letters are easy to use; you simply spell out your title on an appropriate background. The background can be anything—a plain piece of colored paper, a textured cloth, a map, a calendar, or a photographic print.

Some kinds of titles needn't even include words. A close-up of a single Christmas-tree ornament could introduce pictures of that holiday. An appropriate beginning to your picture story of the new baby might be a close-up shot of a baby bottle and a stuffed animal.

You'll need to use a close-up lens to photograph most titles because the subject will be small and you'll want to fill your picture area with the title. You can make a cardboard measuring device for photographing titles. This device will show you how close to get to your subject and how much of the subject will be in the finished slide. Of course, if you own a single-lens reflex camera, you won't need a measuring device because you can see how much of the subject is included in the picture area and whether the subject is in sharp focus by merely looking through the viewfinder.

Here plastic letters were placed on a color enlargement and photographed on slide film.

Dark blue material and a wedding veil were used as the background for the plastic letters.

You can buy transfer letters from art-supply stores. These letters are easy to use; you just rub the front surface of the letter with a smooth object and the letter will transfer to a surface such as colored paper.

Ice

Capades

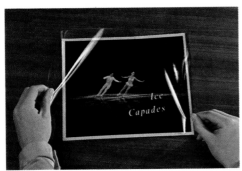

You can put transfer letters on clear plastic sheeting, lay the plastic over a photograph, and make a title slide with your camera. This is a good technique to use when you want to repeat the same title with different backgrounds or when you don't want to harm the background photograph by placing letters directly on it.

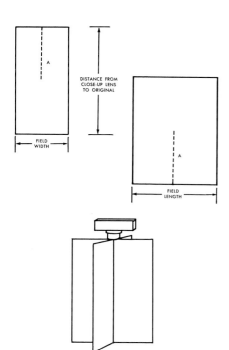

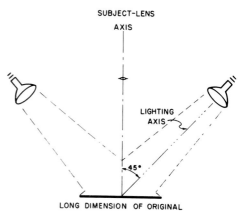

You can make a cardboard measuring device that will help you position your camera for copying. Just line up the center of the device with the center of your camera lens. If your camera is a single-lens reflex and you view the subject directly through the lens, you won't need a measuring device.

Making a Cardboard Measuring Device

You can make a cardboard measuring device simply by cutting two pieces of cardboard. You'll need to know the distance between the close-up lens and the subject, as well as the field size (width and height of the area photographed) for the close-up lens you'll be using. These figures are given in the instruction sheet that comes with the close-up lens. Cut the cardboard as shown in the accompanying illustrations.

Films for Photographing Titles

For outdoor titles in the daytime, you can, of course, use any of the daylight color-slide films. To photograph

lighted signs at night for titles, follow the recommendations in the section "Existing-Light Pictures Outdoors at Night," beginning on page 139.

Indoors you can use 3400 K photolamps and KODACHROME Professional Film (Type A). However, you can also use any of the other Kodak color-slide films if you use the appropriate conversion filter. The film instruction sheet will tell you which filter to use and the speed of the film with that filter.

Lighting and Exposure

You can use a lighting setup like the one in the diagram. Two gooseneck lamps will hold the photolamps. The lamps should be of equal intensity.

Use an exposure meter to determine the exposure. If you use a reflected-light meter when photographing a title on a white background, use 2 stops more exposure than the meter indicates.

The value of using titles to make your slide shows smoother and more "professional" can't be overemphasized. Titles pay big dividends for the small effort invested.

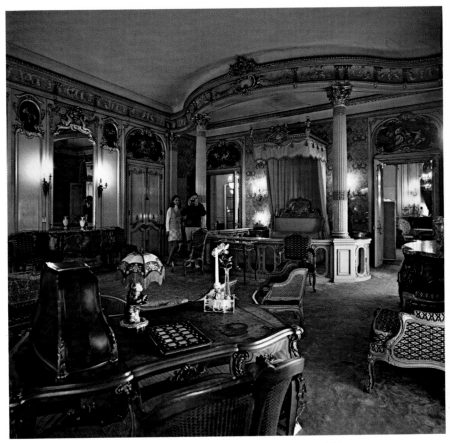

Slides of your visit to the Vanderbilt mansion would be inadequate without views of the interior grandeur.

More Ideas

Even the most ardent picture fans occasionally find their cameras gathering dust on the shelf. "I enjoy taking pictures," they say, "but I just can't think of any good subjects." Pleasing scenic and pictorial slides are fun to look at, but a steady diet of the same old subjects can jade the eye just as surely as too much steak can dull the palate. Maybe that's why every photo enthusiast seems to reach a plateau at some time when it appears that there's nothing left to photograph. The urge to go out and take more pictures is still there, but for some reason the ideas just don't come.

This section is designed to stimulate the imagination and create a familiar itch in your shutter finger by suggesting a few possibilities for types of pictures you may not have tried. We hope you'll find that the suggestions and ideas in the pages that follow will bring your camera out of retirement and help you to have more picture fun both indoors and outdoors taking color slides.

INTERIORS AT HOME AND AWAY

At Home

Chances are that you're especially proud of at least one room in your house or apartment—a beautifully furnished living room or an invitingly comfortable game room or den. The chances are also good that you don't have any topflight color pictures of these interiors. You may have some flash snapshots showing people sitting in various parts of the room, but no carefully planned pictures that will show off each room to its best advantage.

By the way, it's an excellent idea to make at least record photographs of each room in your house. Such pictures form indisputable evidence of your possessions for insurance purposes.

BARBARA JEAN

Take some pictures in your own home to show the rewards of your decorating efforts. Pictures such as these are good for insurance purposes, too.

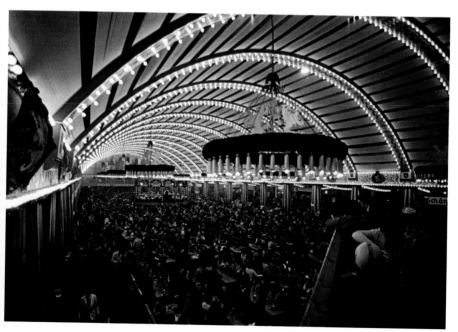

Be sure to capture some indoor activities to complete your travel slide show. Photographing by existing light was the most effective way to capture this Oktoberfest scene.

BARBARA JEAN

KEITH BOAS

Preparation

Before starting your picture-taking session, take a little time to prepare. Make sure the room is "picked up." Any clutter of magazines, toys, or newspapers will be faithfully recorded by your trusty camera. It's discouraging to spend an evening making some good interior pictures only to discover when viewing the results that all the Sunday funny papers were scattered around!

Find the best spot to place your camera for the view you want. It will probably be in a corner of the room. A tripod will be a big help in composing

your pictures because it lets you carefully study what will be included in the slides. For some of the techniques we're going to discuss, it will be essential. A wide-angle lens is a handy tool for interior work, when often you can't get enough of the room in the picture with a normal-focal-length lens. When setting up the camera, especially if you're using a wide-angle lens, make sure that the camera is perfectly level—not pointed up or down—so that the vertical lines of walls and doorways don't appear to converge in the picture causing a distorted effect.

Picture-Taking Techniques for Interiors

There are several ways to photograph interiors in color. If you have control over the situation, it's best if all the light in the picture is of one color quality. That is, you shouldn't mix tungsten light from photolamps with sunlight streaming in through a window. For some subjects, mixed light sources are all right, as in taking night-time pictures by existing light.

In light-colored rooms with several windows, you can let the existing day-light illumination supply the light. Take meter readings from various places in the room and use the average exposure. Then bracket by making one picture at ½, and another at 2 times, the exposure indicated by the meter. Use the smallest lens opening you can to get the whole room in focus. Since the exposure is based on the light reading you made *inside* the room, any part of the outdoors seen by the lens will be overexposed and will look white or "snowy" in the slides. You can avoid this by closing the drapes of the windows that will be in your picture. Leave the other window drapes in the room open to let in as much light as possible for picture-taking.

If there isn't enough existing light, or if the lighting is uneven, you can light the interior of your room by bouncing light from a photolamp off the ceiling. Bounce lighting is even and very natural-looking. Of course, you'll have to use film balanced for photolamp (3400 K) lighting or the appropriate conversion filter with tungsten film (3200 K) or daylight-type film. The film instruction sheet will tell you if you'll need to use a filter and what kind to use. Either use this lighting technique at night or close the draperies to avoid mixing photolamp light with daylight. To make the room lights look natural,

open the camera shutter with only the room lights on and then have a "helper" turn on the photolamps to expose the rest of the room. A firm camera support is a necessity for the long exposure times you'll be using.

One other technique you can use for illuminating home interiors is open flash. See page 96 for a complete discussion of open flash.

GEORGE BUTT

The illumination provided by the existing lighting is often excellent for photographing interiors.

Away

On your travels, you may see the interiors of beautiful cathedrals, museums, and other famous buildings. You can record these magnificent structures for your slide collection and share them with your friends when you return home. Some of the techniques for photographing large interiors are much the same as the techniques you use to photograph your living room. There is one difference, however. At home you have control. You can arrange the room and the lighting the way you want it. In public buildings, you have to take things the way you find them. But these buildings are often so beautiful you probably wouldn't want to change

anything even if you could. You may have to be patient, though, and wait until other tourists move out of the way so that you can get an uncluttered picture.

In a large interior, use existing light, because a flash won't be effective. Since the lighting is often dim, you may have to make a time exposure. Of course, whenever you make time exposures, you'll need to use a tripod or another kind of camera support. Then you can use a small lens opening to get the maximum depth of field. Always check with a guard to be sure you're allowed to set up your tripod.

KEITH BOAS

KEITH BOAS

In large interiors, flash usually won't provide enough
illumination for correct exposure. Here the existing light
was more than ample.

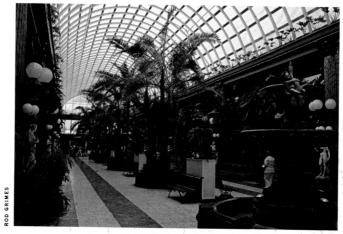

ROD GRIMES

249

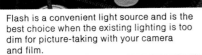

Existing light.

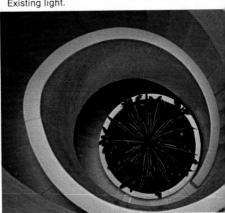

Flash is a convenient light source and is the best choice when the existing lighting is too dim for picture-taking with your camera and film.

Museum dioramas are as close to you as the nearest museum. Dioramas offer ready-made scenes for your camera, complete with realistic lighting and backdrops. A sensitive reflected-light exposure meter is useful in determining exposure under these low light levels. It's always a good idea to contact the museum curator beforehand to find out if picture-taking is allowed.

MUSEUMS—FROM MUMMIES TO MUSKETS

The museum near your home has more picture material under one roof than any other place we can think of —everything from mummies to muskets. If you have never thought of a museum as a place to take pictures, you've missed some wonderful opportunities. Happily, it's never too late to start.

One of the first things to catch your eye in the museum will be the dioramas. They consist of two kinds— the small-scale tabletop variety, peopled with figures only a few inches high, and the large, life-size dioramas portraying animals and sometimes people in their native surroundings. Each requires a slightly different photographic technique.

A small diorama is a sort of ready-made tabletop scene, painstakingly built, perfectly proportioned, and expertly lighted. Good pictures of such scenes make them look like the real thing, not like miniatures at all. Because these displays are dramatically lighted, you'll want to use the existing lighting instead of flash. Some museums don't allow flash anyway. Using the existing light will call for long exposures, because the lighting is dim and small lens openings will be in order to provide the necessary depth of field. A cable release and a tripod are virtually indispensable for preventing camera movement.

If you wonder whether your museum allows tripods or flash equipment, check beforehand. In fact, making your museum picture-taking arrangements beforehand is always a good idea. A number of the nation's top museums have been contacted

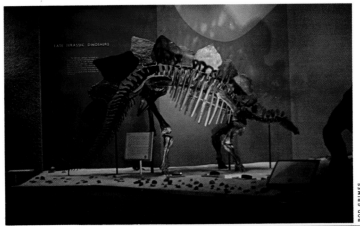

LATE JURASSIC DINOSAURS

concerning what photographic equipment and practices they allow. Almost without exception they are extremely cooperative with serious photographers. Many museums go so far as to open glass cases, supply technical information, and turn off adjoining lights to stop glaring reflections that might spoil pictures. The only thing they ask is that a photographer call or write beforehand to tell them he's coming. When you explain to the curator that the pictures you take are for your own personal use and not for sale or publication, you will very likely find the curator willing and cooperative.

Lighting may be either tungsten or fluorescent. Experience has shown that artificial-light films produce pleasing results with tungsten lights, while daylight-type films work well with fluorescent lights. Slides made with fluorescent light will probably appear greenish, but should be acceptable.

A good light meter is necessary—the more sensitive the better, because museum light levels are frequently low. Make readings from as close to the subject as possible. Bracket the estimated exposure by 1 stop in each direction to help achieve successful results.

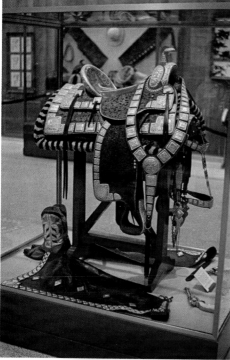

Curators of museums make a great effort to provide visitors with historical and educational displays. Whatever your interests, you're bound to find this material fascinating when you can see it firsthand. By taking pictures, you can share your experiences with your friends. These slides were made on High Speed EKTACHROME Film (Tungsten) by existing light without using a tripod. Buffalo Bill Historical Center, Cody, Wyoming.

Most small dioramas and many other displays are behind glass. Glass often means troublesome reflections. One way to eliminate them is to include a large square of black cloth in your camera bag. You can hold one corner in the hand that's holding the cable release and the other corner in your other hand. Photography demands a host of skills! The cloth will effectively shield the glass from the lights causing the reflections. If you use flash, remember to take pictures at an angle to the glass, not head on. Otherwise, you'll spoil the picture with a bad reflection from the flash.

This diorama was photographed with flash. The picture was taken at an angle to the glass to avoid reflections.

The large dioramas usually feature some life-size models against a painted backdrop. Here it's good *not* to have a lot of depth of field. Throwing the painted background slightly out of focus will make it look more "real" in the finished slide than if it were in needle-sharp focus. One good way to get backgrounds out of focus is to take the pictures with a camera that has a fast lens and use a large lens opening. And if you use High Speed EKTACHROME Film with ESP-1 Processing, you can usually hand-hold your camera for convenience. Another way to throw the background out of focus is to use a telephoto or long-focal-length lens. Such a lens will increase your scope tremendously by letting you "get inside" those displays to take a close-up of a snarling lion's head or a slide-filling image of an airborne eagle.

Most museums have displays of birds and animals in an appropriate natural setting. In well-made pictures, these are almost indistinguishable from live specimens.

Besides dioramas, museums contain exhibits of just about any subject you might be interested in. There are displays dealing with archaeology, botany, natural history, Indian lore, native crafts—well, just about everything! If you own a camera and a light meter, and there's a museum near you, put them together for some unusual photographic fun.

A visit to the Air Force Museum in Dayton, Ohio. Museum pictures are good supplements to your travel slides.

STAINED-GLASS WINDOWS

The blending of man's ancient art of stained-glass making and his modern art of photography produces striking and lovely results. Photographing stained-glass windows is quite simple and straightforward.

It's best to wait for a time when the window is uniformly illuminated from outside and contains no shadows. A reflected-light exposure meter will indicate an approximate exposure if you can get fairly close to the window. If it's a high, inaccessible window in a large cathedral, your meter will "see" a large dark area around the bright window and give a light reading that is too low. If the sun is shining on the window, an "average" exposure for a film with a speed of ASA 64 is 1/125 second at $f/4$. On a bright day when the sun isn't striking the window, try 1/30 at $f/2.8$. In any event, it's wise to take additional pictures at 4 times and ¼ the exposure indicated by the meter to be sure of getting at least one top-notch transparency. Where dark and light colors appear in the same window, no single exposure may record them both satisfactorily, so if you have a series of exposures, you can pick the most pleasing rendition.

Adding a dash of fill-in light by means of a blue flashbulb or an electronic flash unit has the effect of lightening up the area surrounding the window and making it look more as the eye sees it. Use daylight-type film.

Multicolored stained-glass windows make good indoor picture subjects. Slides like these add interest and variety to your slide shows.

Base your exposure on the window by getting close enough with your exposure meter to exclude the dark surrounding area. If you don't have an exposure meter, try an exposure of 3 stops more than you would use for the outdoor lighting conditions. Use daylight-type film.

JOHN BRANDOW

260

SILHOUETTES

If you're old enough, you may remember those carefully framed silhouettes that used to grace Grandma's parlor. This art form was very popular at one time. No house was complete without a set of family silhouettes on display.

As a color photographer, you can produce the rocket-age counterpart with a lighting trick or two. All you need to do to make silhouettes is to backlight your subject with a solid, bright area of light, such as a large window. Better yet, stretch a sheet across a doorway and put a photolamp behind it. Then place your subject in profile in front of the sheet. Make sure the subject is positioned so that the light source is behind him to shield the lens from the bright glare of the bulb. Otherwise, you may have lens flare in your picture or a "hot spot" on the sheet. Make the rest of the room dark by turning off the lights and closing the window drapes.

Now expose for the brightest area in the picture, the brightly illuminated sheet. The shadow side of the subject will be underexposed and will record as black on the slide, forming a perfect silhouette.

Putting colored theatrical gelatin filters over the photolamp will make interesting black silhouettes against a background of any color you choose.

Some rainy night, try making a silhouette picture of each member of the family. It's different, easy, and fun to do.

Sometimes a silhouette is more dramatic than a photograph showing all the details of the subject. High Speed EKTACHROME Film (Tungsten) backlighted through a cloth sheet with a 3200 K floodlight.

RAYMOND COOPER

By putting a filter over your camera lens or the light source, you can completely change the mood of the picture. Increase your exposure to compensate for the filter.

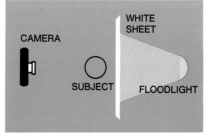

CAMERA WHITE SHEET SUBJECT FLOODLIGHT

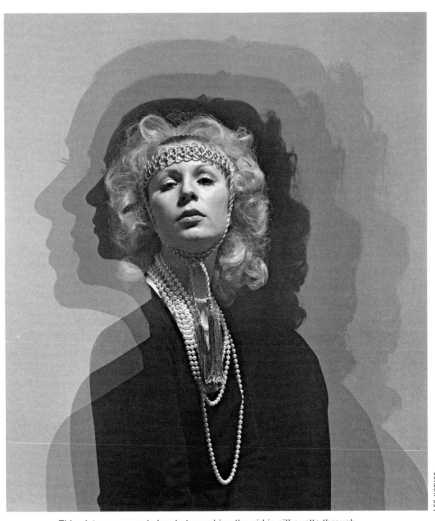

LEE HOWICK

This picture was made by photographing the girl in silhouette through
blue, green, and red filters in front of a white wall. The camera was moved in
closer to the girl after the first and second exposures. Then she was
photographed with conventional lighting without a filter so that the image was
positioned in the dark area of the silhouettes. Four different exposures
were made on the same frame of film.

You can make some very effective
silhouette slides outdoors, too, by using
backlighting and underexposing your subject.

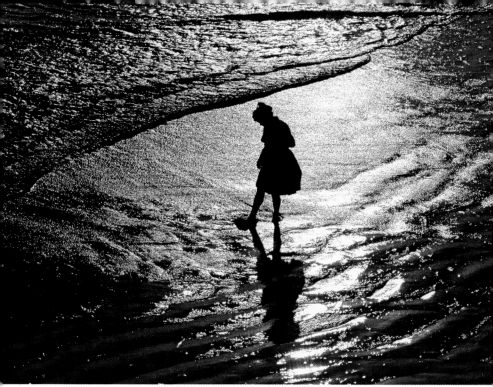

BILL HARLEY

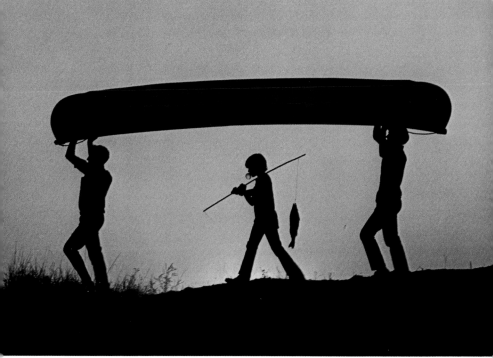

JAMES HOWARD

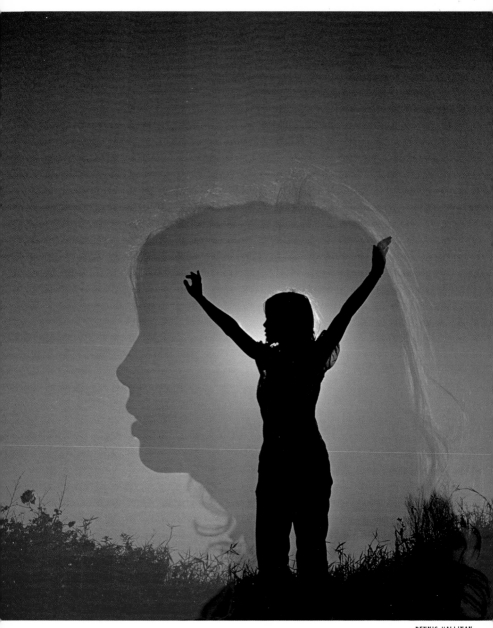

Here a double-exposure technique was used outdoors for a creative silhouette effect.

PHOTOGRAPHING COLLECTIONS

What do you collect? Carved ivory, glassware, coins, model ships? Antique automobiles, paintings, ceramic figurines? No matter what your reply, your camera offers a source of untapped enjoyment for you.

If you don't have pictures of the items in your collection, why not take some? It's easy to do, and the rewards are great. If the things you collect are valuable, fragile, or cumbersome, they're not easily shared with fellow hobbyists. But with pictures, you can exchange collections by mail, illustrate hobby magazines, or show off your prizes wherever you travel while the originals are safely at home. When it comes time to sell or buy, you can exchange pictures, not samples.

Pictures form the basis for a wonderful filing system for such things as rocks and mineral specimens so that you know exactly what you have and what condition it's in. Pictures can provide a graphic inventory for insurance or appraisal purposes.

But most of all, you're probably proud of your personal collection. And the easiest way to show it off is through a series of well-made pictures. If it consists of small items, such as arrowheads, you can photograph them on a table by using a few photolamps (3400 K) with a film such as KODACHROME II Professional Film (Type A). If you need to get closer to your subjects than the focusing scale on your camera permits, use a close-up lens. See page 197 for more information on using close-up lenses.

When you're a hobbyist with an eye-catching collection you're proud of, you have an excellent subject for pictures. Here the helmet gives scale to the models and tells the viewer that the owner's interest extends to the real thing.

Photolamp lighting is a good choice for photographing collections because you can see the effects of the lighting before you take the picture.

The backlighting on this mineral collection emphasizes the texture of the minerals.

Some collections are best photographed outdoors.

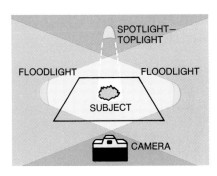

SPOTLIGHT—TOPLIGHT

FLOODLIGHT FLOODLIGHT

SUBJECT

CAMERA

Top and side accent lights were used for this mineral sample to show its texture, color, and translucence to best advantage. A sheet of textured paper was used under the sample for the background.

267

NEIL MONTANUS

A sheet of ground glass supports this paperweight collection.

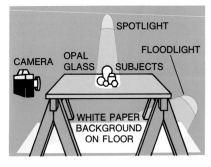

SPOTLIGHT

FLOODLIGHT

CAMERA OPAL
GLASS SUBJECTS

WHITE PAPER
BACKGROUND
ON FLOOR

A spotlight overhead provides toplighting and a circle of light surrounding the weights. A floodlight was bounced off white paper from below to light the glass background. The green and blue backgrounds were produced by putting a filter over the floodlight.

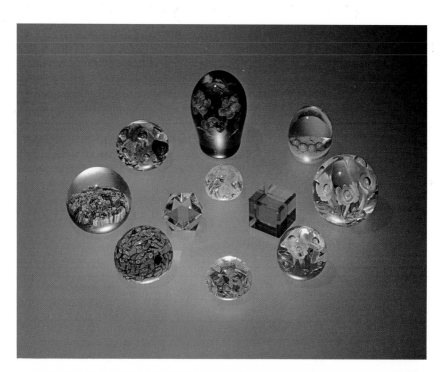

NEIL MONTANUS

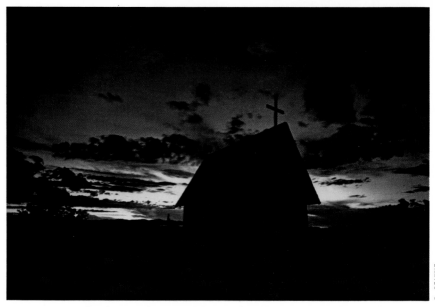

Good sunset pictures are easy to make and are very rewarding.
Include some sort of foreground figure or object in your sunset pictures.
The resulting silhouette will add depth, perspective, and interest.

SUNSETS

Brilliantly colored slides of sunrises and sunsets are breathtakingly beautiful. Fortunately, they are among the easiest pictures to take, because exposure is not so critical. Overexposure makes the sunset appear lighter and earlier, while underexposure gives deeper, richer colors, making the sunset look more advanced. A typical exposure for a setting sun partially obscured by clouds would be 1/60 second at $f/5.6$ for KODACHROME 25 Film (Daylight), or 1/125 at $f/5.6$ for KODACHROME 64 Film (Daylight) or KODAK EKTACHROME-X Film. When you use an exposure meter, the reading should be based on the brightness of the sky and clouds. This will render the foreground dark and the sun slightly overexposed, with rich colors in the clouds. Any objects such as trees, buildings, or people appearing in the foreground will be silhouetted against the sky to form a dramatic frame for the subject. Try a series of pictures showing the progression of a

sunset by making an exposure every 5 minutes or so. To photograph the afterglow immediately following a sunset, try 4 to 6 stops more exposure than for a normal sunlit scene.

In photographing sunsets, the use of a long-focal-length lens is often desirable to make the flaming ball of the sun appear larger. The narrow angle of view provided by such a lens also simplifies the task of eliminating unwanted foreground objects.

To avoid lens flare when photographing sunsets (or any backlighted subjects), the camera lens must be extremely clean. Dust particles or other foreign matter on the lens increases flare considerably and may ruin your pictures. Even the finest lenses are subject to flare when pointed directly at a bright object like the sun. A photographer using a reflex camera, or any other type of ground-glass focusing, will usually be able to see and control flare before taking the picture. A lens hood is often a great help in avoiding lens flare.

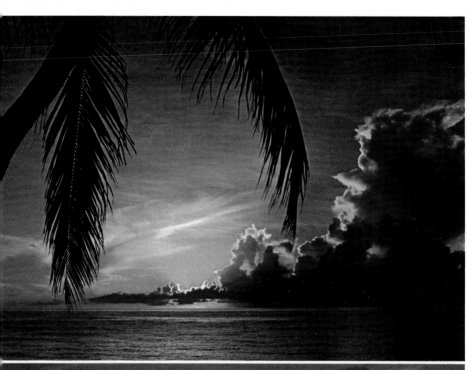

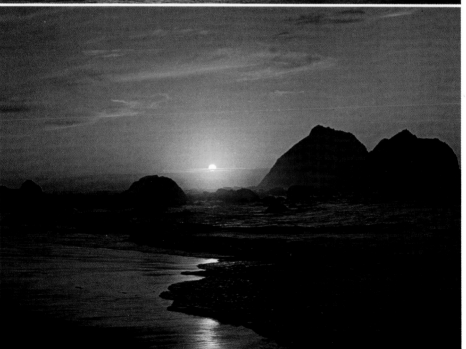

When the sun is near the horizon, try an exposure of 1 or 2 stops more
than you would use for an ordinary sunlighted subject.

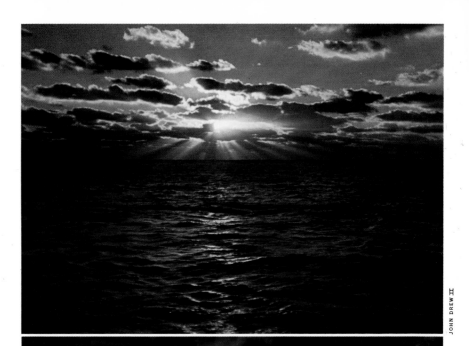

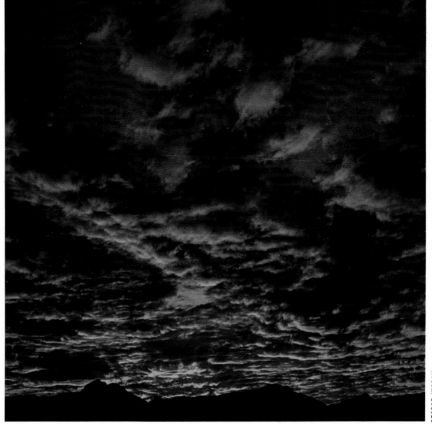

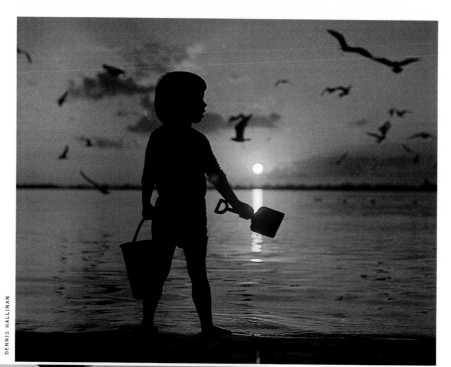

DENNIS HALLINAN

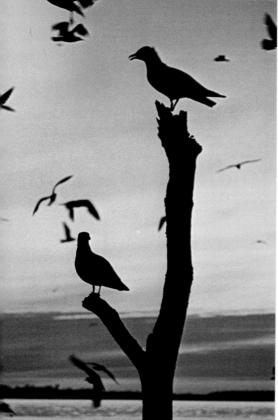

With an exposure meter, take a normal exposure reading of the sunset. The sun shining on your meter will cause you to under-expose any objects in the foreground, and they will be silhouetted. Keep your lens clean to reduce lens flare.

GEORGE BUTT

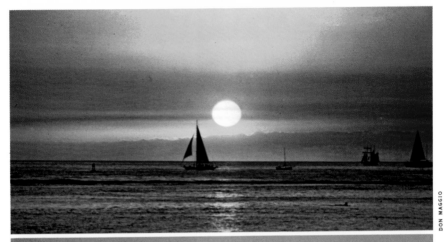

DON MAGGIO

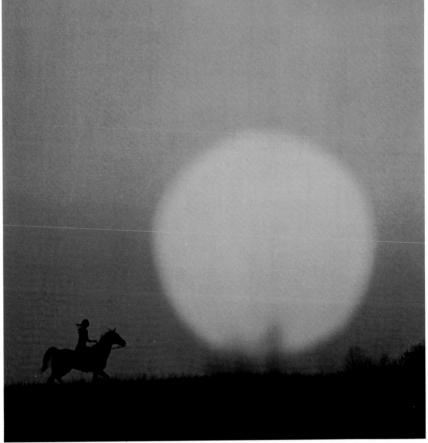

PHOEBE DUNN

The use of a long-focal-length or telephoto lens will make the ball of the sun look bigger; the narrow angle of acceptance of the lens will help to eliminate unwanted foreground objects.

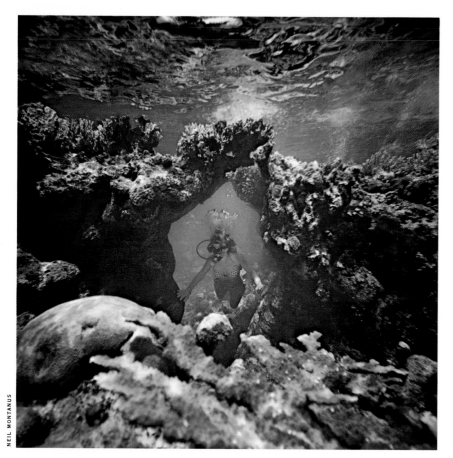

Exposure underwater depends on the depth and clarity of the water, the color of the bottom, and the position of the sun.

PICTURES UNDERWATER

More and more people are imitating fish in these days of snorkels and swim fins—and they're taking their cameras with them.

The prime requirement is some sort of waterproof housing for the camera which will keep it safe and dry and at the same time allow easy operation of its controls. The range of available housings is quite extensive and will probably increase as the sport becomes more popular. Underwater housings can be anything from a simple rubber or plastic bag with a trans-

parent faceplate to a complex cast-metal housing costing as much as the camera it contains. Some cameras are specially designed for underwater photography and don't require an underwater housing.

It's possible, of course, for even the rankest landlubber to take underwater pictures of a sort without ever getting wet. Thousands of these pictures are taken every year at places like Florida's Marineland, Silver Springs, Rainbow Springs, and the Miami Seaquarium, where all you have to do is

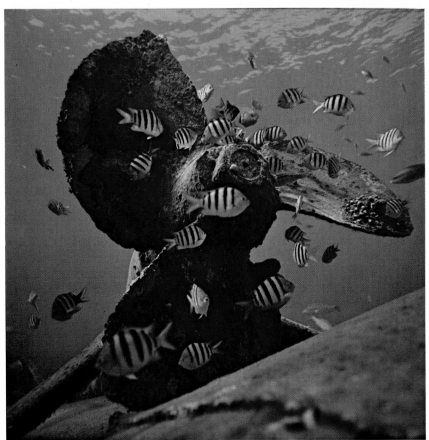

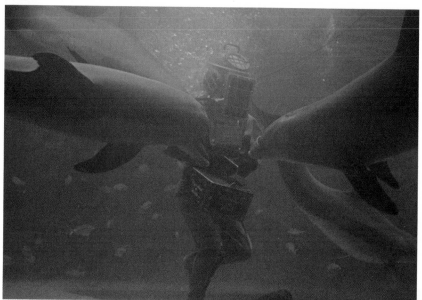

At some aquariums and resorts you can make underwater pictures the easy way, through a glass-walled tank.

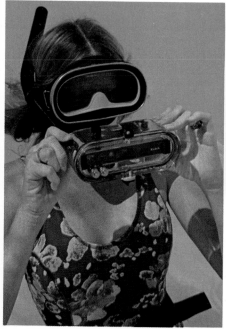

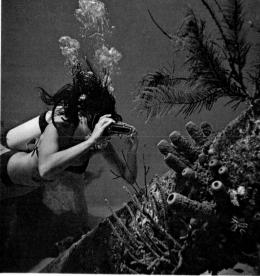

A wide variety of underwater camera cases is available for skin-diving photographers. This young lady is using a KODAK Pocket INSTAMATIC Camera in an underwater housing. The exposure meter built into the camera automatically adjusts the camera for correct exposure.

277

stand outside the glass wall of the tank and snap away. Exposure information for various films is usually posted at such places.

To take pictures underwater, you need to learn a new set of rules. To begin with, the red in the spectrum is quickly absorbed by the water, so underwater pictures will appear quite bluish. At a depth of less than 30 feet, you can use a filter such as a KODAK Color Compensating Filter, CC30R, to reduce the strong blue cast, but this may destroy the "underwater atmosphere" obtained in unfiltered pictures. When using the CC30R filter, increase exposure by $\frac{2}{3}$ stop.

Another change that takes place is that your camera lens no longer "sees" the same field of view as it does in air. The refraction of light rays through water magnifies everything slightly, so that objects appear to be only three-fourths of their actual distance away. Consequently, you have to get farther away from your subject to get it all in the picture. When using the simple plastic bag type of camera case, you can't use the rangefinder or viewfinder at all—picture-taking becomes a sort of "point and shoot" proposition.

If you have an underwater housing which will let you focus your camera through the housing, a rangefinder or reflex camera will focus correctly, in the same way as it does above water. Since the refractive index of water affects your eyes in the same way as it affects the camera lens, you can judge distance underwater just as you do above the water.

It's desirable to use a short-focal-length or wide-angle lens, because it lets you move in closer to your subject, thus reducing the amount of bubbles and water debris between your camera and the subject. Since you'll be using large lens openings, a wide-angle lens will give you the advantage of increased depth of field.

Underwater exposure depends on the type of day, angle of the sun, depth of the subject, turbulence of the water, and color of the bottom. That's why a camera with automatic exposure control works so well for underwater photography. With an adjustable camera, try the exposures in the following table.

The exposure information is based on a bright, sunny day, between 10 a.m. and 2 p.m. with winds blowing slightly, and an underwater visibility of about 50 feet.

Exposure Compensation for Underwater Photography

Depth of Subject	Increase Normal, Above-Water Exposure By This Amount
Just under surface	1½ f-stops
6 feet	2 f-stops
20 feet	2½ f-stops
30 feet	3 f-stops
50 feet	4 f-stops

Flash Pictures Underwater

You can take underwater flash pictures with flashbulbs or electronic flash. Underwater flash equipment is available which attaches to the underwater camera housing.

Flash has several important uses in underwater photography. You can use flash as the primary light source when there's not enough daylight available to take pictures. Flash becomes a necessity as you go deeper underwater and more daylight is absorbed.

A very important advantage of using flash is that it brightens colors which appear drab underwater. The light from the flash enables the film to record the natural colors of subjects at depths where the red and orange light from daylight does not penetrate.

There are two ways you can de-

Flash is good for underwater close-ups because it enhances the color of underwater subjects. The light from the flash doesn't have so much water to go through as the natural lighting does. Using the flash on an extension arm above the camera minimizes backscatter from any particles in the water illuminated by the flash.

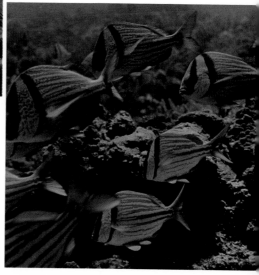

These close-up pictures were made with flash.

DANTE RUSSO

termine flash exposure. In an average situation when the water is clear and visibility is good, divide the normal above-water guide number for your film-and-flashbulb combination by 3. For example, if the normal guide number is 120, you would use a guide number of 40 underwater. Remember, you must divide the *actual* subject distance into the guide number. The actual distance will be about 1.3 times the *apparent* distance.

Or you can divide the above-water number by 3.9 and then work with the *apparent* underwater distance. If you focus underwater using a rangefinder or ground glass, the distance on the lens scale will be the apparent distance. Whichever method you use, it's a good idea to bracket underwater flash exposures. When visibility is poor, take additional pictures, varying the exposure by several stops to give more exposure than the *f*-number calculated from the guide number.

In underwater photography, you can use either blue or clear flash with Kodak daylight color films. If your subject is 5 feet away or closer, use blue flashbulbs. If your subject is more than 5 feet away, you may want to use clear bulbs. The filtering effect of the water will absorb the warm light of the clear bulbs, and your pictures will be less bluish than with blue bulbs.

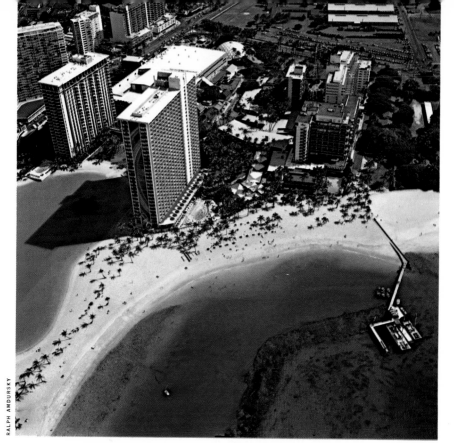

Pictures from the air offer a new way of seeing familiar scenes.
A high shutter speed is necessary to minimize the effects of motion.

PICTURES FROM THE AIR

The opposite of underwater picture-taking is aerial photography. Pictures from the air offer opportunities for re-discovering a picturesque world from a new viewpoint.

For the best view of the ground, select a seat on the airplane, next to a window in front of or behind the wing. Make sure you're sitting on the shaded side during the flight. Focus your camera at 50 feet so that the wing of the plane and anything beyond will be in focus. For the clearest pictures of subjects on the ground, take pictures right after takeoff and right before landing.

There are a few special techniques that will help you take good aerial pictures. One of the things you'll discover when you go aloft to take pictures is haze. Haze is always present in the atmosphere, and it tends to cause a bluish cast in color slides. The effect increases with altitude and distance. You can reduce the effect of haze by taking the picture with the sun behind the camera and using a sky-light filter over the lens. No exposure increase is necessary when you use a skylight filter.

Since the plane will be in motion, it's best to use a high shutter speed. At high altitudes (above 1000 feet), use 1/250 second; at low altitudes, use

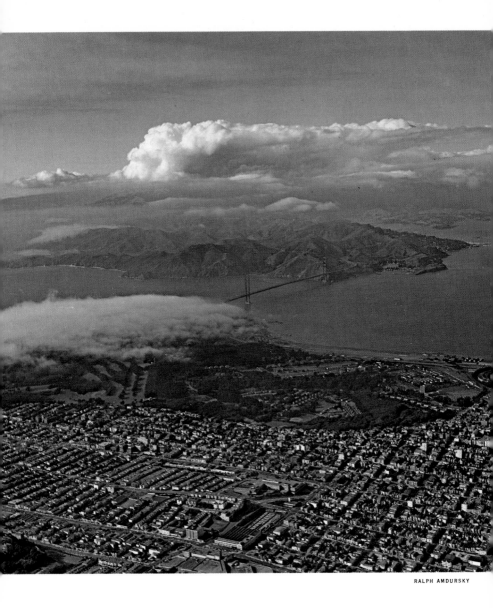

the highest shutter speed that the lighting conditions will allow. Airplanes vibrate, so don't let any part of your camera rest against the window. Because the brightness range of the scene is compressed at high altitudes, your exposures can be varied over quite a range and still produce good slides. Since several of the slides will be of acceptable quality, it's a matter of personal choice as to which exposure is "right." At low altitudes, use the same exposure as you would on the ground. When the plane is between 2000 and 4000 feet, decrease the lens opening by ½ stop; above 4000 feet, decrease the lens opening by 1 stop.

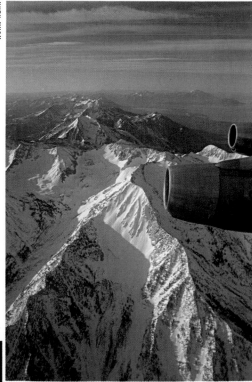

Beautiful cloud formations are a part of your aerial experience, so be sure to take some slides of these, too.

Be sure to include part of the plane in your aerial picture collection.

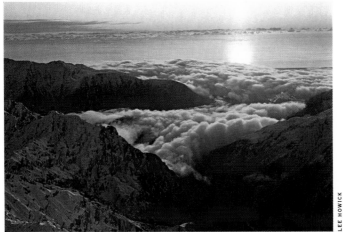

Niagara Falls.

Take some pictures inside the plane to show how you traveled.

RALPH AMDURSKY

RALPH AMDURSKY

You can make good pictures of airports, large cities, and complex
highway patterns just after takeoff and just before landing.

If you take a ride in a small plane or a helicopter, you can get some "close-up" views.

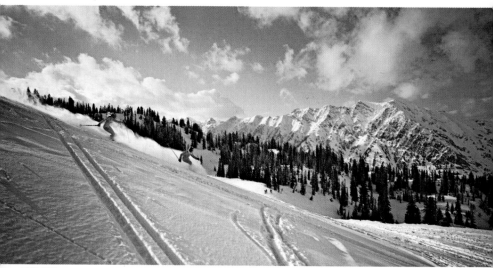

Snow looks best on bright, sunny days. Sidelighting
or backlighting helps to show its texture.

COLD-WEATHER PICTURES

Try to take snow pictures on bright, sunny days. Snow photographed on dull days looks dull and drab in your pictures. Sidelighting and backlighting reveal snow texture best. Snow is a bright subject, so use an exposure 1 stop less than normal for sunny days, unless there are nearby people in the scene—then use normal sunlight settings on your camera.

Load your camera with film before you leave the house. Carry spare rolls in an inside pocket, where they'll keep warm. You may want to use a skylight filter over the lens. It helps remove excess blue from the scene and protects your lens from snow. "Wear" the camera inside your jacket between exposures to keep it warm and working properly. Extreme cold can make camera shutters slow and sluggish, resulting in overexposure. Advance and rewind the film slowly to keep it from breaking and to help avoid static-electricity markings.

When you take a cold camera into the house, moisture will condense on its lens. Wait until it evaporates before you take more pictures.

Bright, colorful clothing adds color
to winter scenes.

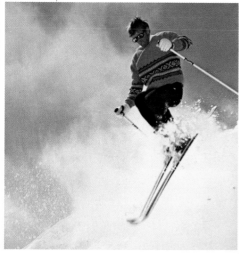

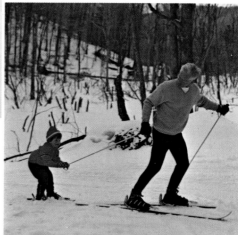

Winter sports are excellent subjects for action pictures.

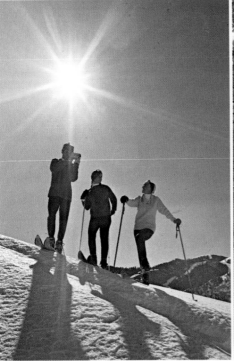

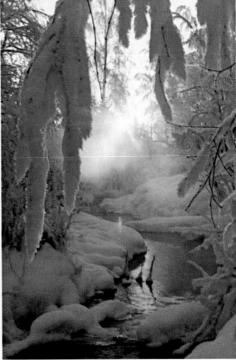

Backlighting is great for snow pictures, because it emphasizes texture and adds sparkling highlights to ice crystals.

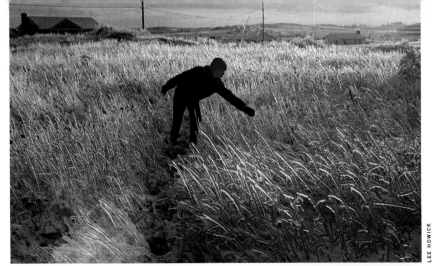

Wintertime is a good time to record
family activities.

Be on the lookout for the unusual.

There are caverns in many parts of the country where you can make pictures like these. If you have a camera with a fast lens (f/2 or faster) and use a high-speed film, such as High Speed EKTACHROME Film with ESP-1 Processing, you can handhold your camera when the lighting is sufficient.

ROD GRIMES

CAVE PICTURES

Illuminated caverns are among the many natural beauty spots found around the country where a photographer can find a wonderland of pictures. Taking pictures in caves is easier than it may seem because many of them are very artistically lighted. Because the light source is tungsten and the lighting is dim for photography, use a film such as KODAK High Speed EKTACHROME Film (Tungsten). Your exposures will be long—between 10 seconds and 1 minute at f/5.6—so take along your tripod when it's permitted.

If your camera has a very fast lens, such as f/2 or faster, you may be able to hand-hold your camera when you photograph the more brightly lighted formations in the cave. For this type of situation, you need the extra speed obtained by push-processing High Speed EKTACHROME Film. Try exposures of 1/30 second with your camera lens wide open.

Some caverns even sponsor special tours for photographers and have guides on hand to give helpful tips on exposure and choice vantage points.

KODAK High Speed EKTACHROME Film (Tungsten) with ESP-1 Processing— ASA 320, 1/30 sec at f/1.8.

ROD GRIMES

A tripod is necessary for making time exposures. Check at the visitor center to make sure tripods are allowed.

If the distance isn't too great, you can use flash. With flash, you have greater assurance of proper exposure and you don't need a fast lens or a high-speed film.

Existing light.

CREATIVE ADVENTURES

Now you've nearly finished the picture-taking part of this book and it's almost time for you to stop reading and continue these adventures in color-slide photography with your camera. Creating unusual slides is a never-ending challenge. There's always a new horizon just around the bend. A refreshing, change-of-pace scene may lead you on to new ideas on how to photograph it. You're the photographer who creates the picture; your camera is only your means of capturing what you visualize.

One way you can enter the world of creative photography is to capture abstractions in your slides. There are any number of techniques to produce photographic abstractions in color. Some methods are simple camera techniques, such as using color filters to give the slide an overall color cast or using multi-image lens attachments on your camera.

One creative method involves photographing familiar objects, such as candle flames and figurines, through materials that will distort the image. You can use glass building blocks, condenser lenses from an enlarger, and different kinds of fluted and pebble-grained glass to produce varying and interesting effects. It's important that the light fall only on the subject, not on the glass used to distort the image.

One of the easiest ways to make color abstractions is to use a swinging-pendulum light source to create a light-trace pattern.

To make some of these lovely patterns, place the camera on the floor with its lens pointing up toward a flashlight or a small light bulb suspended from the ceiling. Turn the room lights off, give the light source a push, and open the shutter. As the light moves back and forth, the pat-

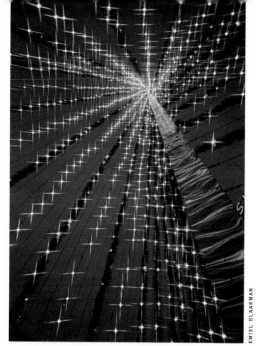

EMIEL BLAAKMAN

The photographer used a star-screen filter over his camera lens to photograph the interior of this modern sculpture by existing light.

BARBARA JEAN

Minimum exposure through an orange filter produced this effect.

A multi-image lens attachment was used to create these abstract images.
The picture of the Statue of Liberty was made with a small piece of
magenta, green, blue, and yellow CC filter over each of the lens facets,
respectively, except the center one. CC filters are KODAK Color
Compensating Filters and are sold by photo dealers.

This shows what you can do by making a double exposure.
Since two exposures were made, each was made at 1 stop less exposure
than normal. You need a rigid tripod for this technique
so that both images will be in perfect register.

GENE JOHNSON

terns it traces through the air will be recorded on your film. By using different colored filters over the lens, you can make multicolored designs.

For more elaborate patterns, attach strings to the main supporting string or wire so they form a V. Different arrangements of these strings will make different patterns.

Take two identical abstractions made in this way and superimpose the transparencies when they're returned from processing. You'll find that they create different designs as you move one over the other, just as a kaleidoscope does. If you find an especially pleasing combination, bind two or more slides together in the same mount for projection.

Other simple techniques you can use are throwing the image out of focus, using slow shutter speeds for moving subjects, moving your camera or changing a zoom lens adjustment while the shutter is open, panning your camera to blur the image, and double-exposing. With other methods, you photograph conventional subjects that form interesting patterns or reflections, or as mentioned before, you sandwich two or more slides together in the same mount to form a new picture called a montage.

Another abstract technique that's

You can use a setup such as that used for the glassware on page 231 to create unusual effects with other subjects, too. The flower arrangement was placed behind a sheet of hammered glass and one rose blossom was taped to the front of the glass so that one part of the subject would be in sharp contrast with the mottled tones of the rest of the subject.

LLOYD SWAN

IRMA VITALIS

This is a photograph of a frosted window with the setting sun in the background.

To make this unusual abstraction, a flashlight was hung from the ceiling by a string. The camera was focused on a large sheet of rippled glass suspended about 2 inches from the light source. During the long time exposure made while the flashlight was swinging, different-colored filters were held over the camera lens to create the multicolored effect.

NEIL MONTANUS

The rippled glass was not used for these two pictures. The camera was focused on the bulb of the flashlight.

For this picture, a
sparkler was moved
in a circle while the
shutter was held
open. Then an
electronic flash
was fired to record
the image of
the girl.

KODAK
EKTACHROME
Infrared Film with
a No. 15 (G) deep
yellow filter.

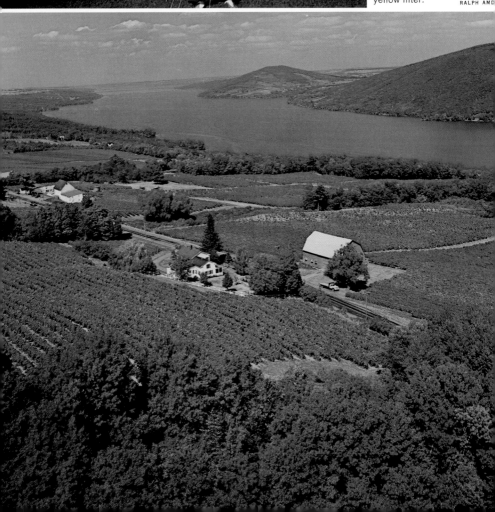

DON MC DILL

Eerie, unreal colors which turn ordinary pictures into abstractions are the results of using EKTACHROME Infrared Film with a No. 15 (G) deep yellow filter. Other filters can produce weird results too, so it pays to experiment.

DON MC DILL

Often you can photograph unusual patterns to produce creative images.

fun to experiment with, because the results are so bizarre, is to use KODAK EKTACHROME Infrared Film. This 35 mm film is a false-color film which produces some very unexpected colors. Unlike conventional films, EKTACHROME Infrared Film is sensitive to both infrared radiation and visible light. We can't see the infrared, but the film can. Infrared records on the film as red, and many of the other colors in the scene record as colors different from what we normally see. For example, green grass and trees become red, a red rose records as yellow, and black cloth may turn out red, but a blue sky is recorded normally as blue. This film is not for photographing people, though, unless you want an unreal look; flesh tones will have a greenish cast.

EKTACHROME Infrared Film is designed to be used with a No. 12 or No. 15 yellow filter. It has a speed of 100 with either filter. Use exposure meter readings only as a basis for trial since exposure meters are not intended for measuring infrared. A good trial exposure in bright sunlight with a No. 12 or No. 15 filter over the camera lens is 1/125 second at $f/16$. Bracket your estimated exposure by taking pictures at ½ stop and 1 stop under and over the estimated exposure.

These are just suggestions—merely the beginning. If you have—or develop —an interest in such offbeat things, more ideas will occur to you as you experiment.

In this section, we have presented some pictures that we hope will whet your creative appetite. These are only a few of the kinds of things you can create and capture in your color slides —merely the beginning. We hope that these pictures will set off a reaction in your imagination that will send you off on new adventures wtih your camera.

W. HAGEDORN

RALPH AMDURSKY

GARY ZACKOWITZ

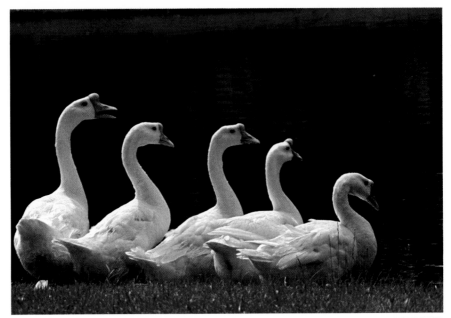

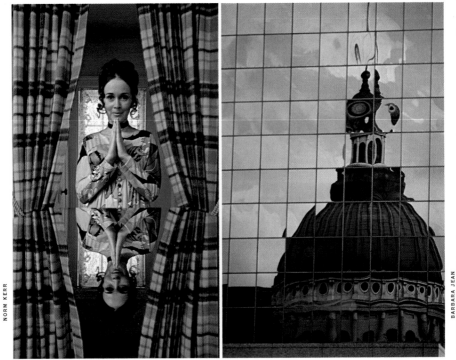

Look for fascinating reflections.

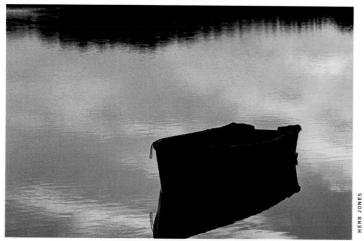

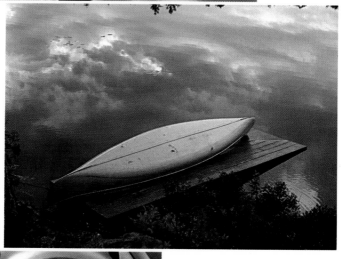

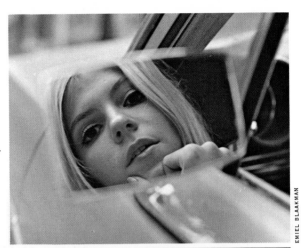

Reflections
are everywhere.

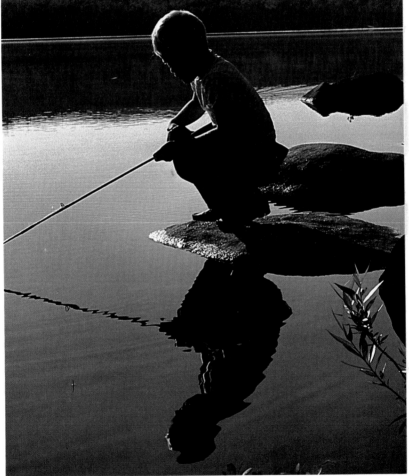

NEIL MONTANUS

KEITH BOAS

LEE HOWICK

HAROLD MANN

An easy way to make an abstraction is to photograph colored
lights with your camera lens out of focus.

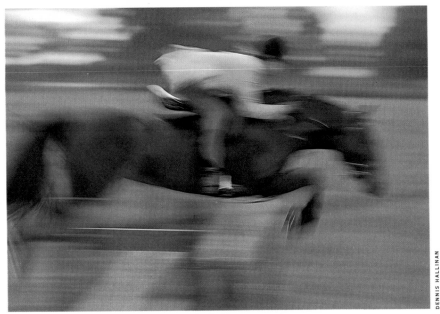

DENNIS HALLINAN

You can use blurred motion to create abstractions.

314

LEE HOWICK

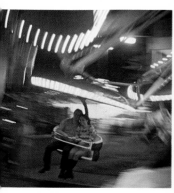

JIM DENNIS

JIM DENNIS

Exposure was ¼ second.

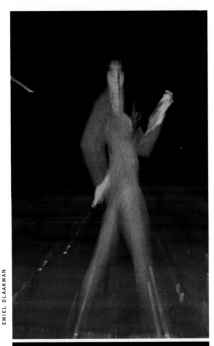

A zoom lens lets you create a special form of blurred motion by zooming the lens during the exposure. Use a slow shutter speed so that you'll have time to move the zoom control.

This picture of a dancer was made with a combination of electronic flash and photolamp illumination. One flash unit and one floodlight covered with green filters were on the left, and one flash unit and one floodlight with blue filters were on the right. An exposure was made with electronic flash at the short-focal-length setting of the zoom lens. Then during a 1-second exposure with the floodlights, the lens was zoomed to the telephoto position.

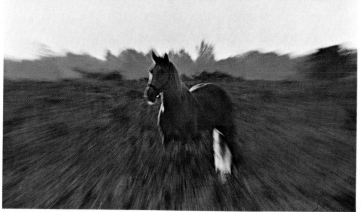

Combine two slides to create unusual effects.

You may find that you've made two otherwise ordinary slides into one prizewinner. Take the slides out of their cardboard mounts and mount them together in a glass mount. Some photographers enjoy experimenting with montages so much that they purposely overexpose certain scenes just so that they can make montages. Let your imagination run wild and see what kinds of unusual pictures you can create!

HERB JONES

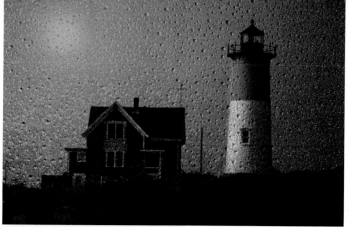

HERB JONES

Since the sky was white and uninteresting in the slide of the lighthouse, this slide was combined with a shot of the sun shining through frost on a window.

HERB JONES

The single slide of the rock formation had an uninteresting sky, so this image was combined with one of the sun to create a much better slide.

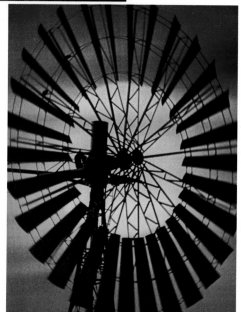

A telephoto shot of the setting sun and a slide of a windmill were combined to make an artistic montage.

WILLIAM EASTMAN III

ALBERT KLEIMAN

Always be on the lookout for interesting subjects or unusual viewpoints.
Since you never know when those once-in-a-lifetime opportunities for creative
pictures will occur, it's a good idea to have your camera with you.
A KODAK TRIMLITE INSTAMATIC Camera is just right for such opportunities
because it's so easy to slip into a pocket or purse.

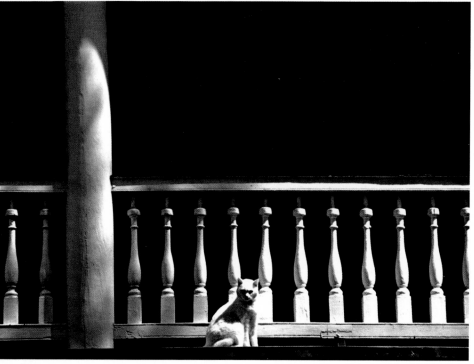

Opportunities for pictures present themselves at every turn, so keep an eye out for interesting patterns, textures, and lighting.

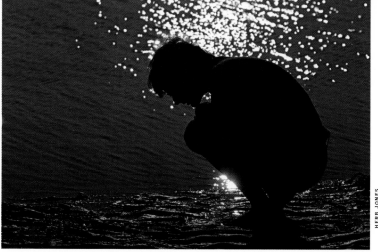

HERB JONES

BARBARA JEAN

NEIL MONTANUS

Showing Your Slides

Once you get your slides back from processing, you'll be anxious to project them to experience the rewards of your picture-taking efforts. Your color slides deserve the very best, so take care in showing them. With some helpful tips and a little planning, your friends and relatives will praise your slide show and you'll be proud of the pictures you've taken.

A wise photographer shows only his good pictures. Make sure the pictures you show are properly exposed and in sharp focus. Don't show a slide if you have to apologize for its poor quality or if it requires a lengthy explanation as to what the subject is. Your audience will prefer a few really good pictures to many mediocre ones. Arrange your slides in a logical sequence so that they tell a story, and be sure to include some appropriate title slides.

You'll want to keep the length of your shows to an hour or less. Even professional slide programs are usually not much longer than this. Here are some easy-to-follow tips that will make your slides even more enjoyable to view.

- Show your slides in a room large enough for everyone to be seated comfortably. All the people in the room should have a good view of the screen. Have enough chairs available and, if possible, arrange them ahead of time. For best viewing, arrange the seating so your audience is as close to the projector-to-screen axis as possible.

- Set up the screen and the projector, load it with slides, and focus the lens before your audience arrives. Select an electrical outlet for plugging in your projector where people won't trip over the cord. If the projector power cord runs across an open area of the floor, place throw rugs over it to prevent tripping.

- If the optical system of your projector needs cleaning, clean it according to the instructions in your projector manual.

- The projected image should fill the screen, if possible. If you have rectangular slides, check for proper positioning of the image on the screen for both horizontal and vertical slides.

- To avoid a distorted image, line up your projector with the center of the screen so that you don't have to tilt the front of the projector.

- Have the first slide in the projector gate so that as soon as you turn on the projector, your audience will see the start of your show rather than a glaring white screen. Similarly, end the show by leaving the last slide projected on the screen. Then turn on the room lights before you remove the last slide from the projector gate. Turn the projector lamp off before you remove the last slide in order to avoid a bright white screen.

- Make sure the room is dark enough for good viewing. Eliminate any stray light that illuminates the screen.

- Appropriate background music from a record or tape can add a pleasing touch to your slide show.

- Keep a spare projection lamp handy.

RALPH AMDURSKY

A slide illuminator, available from photo dealers, is very handy for sorting and arranging slides.

JOHN HOOD

A KODAK CAROUSEL Stack Loader lets you project and edit up to 40 slides without using a slide tray. With this beneficial accessory, you can preview your latest box of slides even when you may have forgotten to purchase a new slide tray.

You'll obtain optimum projection with slides from size 110 film when you use a projector for 110 slides, such as a KODAK Pocket CAROUSEL Projector. The optical system of the projector is designed to show the small pocket slides at their sharpest and brightest.

JOHN HOOD

KODAK 2 x 2 Adapter for 110 Slides. These adapters let you project 110 slides in projectors designed to accept 2 x 2-inch slides.

PROJECTING 110 SLIDES

For best results, we recommend that you project 110-size slides in a projector designed for that slide size, such as a KODAK Pocket CAROUSEL Projector. The Pocket CAROUSEL Projectors have extra-sharp KODAK EKTAR Lenses of short focal length, which are necessary for big, sharp images from the smaller slides and an efficient concentration of light through the small slide aperture.

Normally, 110 slides are returned in 30 x 30 mm mounts for use in 110 projectors. You can also project 110 slides in slide projectors that accept 2 x 2-inch slides if your slides are mounted in 2 x 2-inch mounts or have been put into 2 x 2-inch adapters. Kodak processing laboratories and some photofinishers will return 110 slides in 2 x 2-inch mounts if you request this service. When you want the 2 x 2-inch mounting service, be sure to include instructions with the film you are having processed. Without such instructions, Kodak laboratories will return the processed film in 30 x 30 mm mounts.

Kodak also makes KODAK 2 x 2 Adapters for 110 Slides, which adapt slides in 30 x 30 mm mounts for use in projectors for 2 x 2-inch slides. You need one adapter for each slide. The adapters are sold by photo dealers.

When you use 110 slides in a projector for 2 x 2-inch slides, the projected image size will be smaller, of course, than when you project larger slides with the same lens and at the same projector-to-screen distance. To obtain a larger image without having your projector too far away from the screen, you can use a short-focal-length projector lens, such as a 2½-inch lens.

PROJECTOR-TO-SCREEN DISTANCE AND IMAGE SIZE

The following table provides projector-to-screen distances and the corresponding image sizes for different combinations of slide sizes and projector lenses of varying focal lengths.

PROJECTOR-TO-SCREEN DISTANCE IN FEET

Long Dimension of Projected Image in Inches	110 Slides (13 x 17 mm)			
	2½-inch (64 mm) Lens	3-inch (76 mm) Lens	4-inch (102 mm) Lens	Zoom Lens 2 to 3-inch (51 to 76 mm)
20	7	8½	11½	5½ to 8½
30	10½	12½	17	8½ to 12½
40	14	16½	22	11 to 16½
50	17	20½	27½	13½ to 20½
60	20½	24½	33	16½ to 24½
70	24	28½	38	19 to 28½

Long Dimension	126 Slides (28 x 28 mm)				
	3-inch (76 mm) Lens	4-inch (102 mm) Lens	5-inch (127 mm) Lens	7-inch (178 mm) Lens	Zoom Lens 4 to 6-inch (102 to 152 mm)
40	10	13½	17	23½	13½ to 20
50	12½	16½	21	29	16½ to 25
60	15	20	25	34½	20 to 30
70	17½	23	29	40½	23 to 34½
84	20½	27½	34½	48	27½ to 41½

Long Dimension	135 Slides (24 x 36 mm)				
	3-inch (76 mm) Lens	4-inch (102 mm) Lens	5-inch (127 mm) Lens	7-inch (178 mm) Lens	Zoom Lens 4 to 6-inch (102 to 152 mm)
40	8	10½	13	18½	10½ to 16
50	10	13	16½	23	13 to 19½
60	11½	15½	19½	27	15½ to 23½
70	13½	18	22½	31½	18 to 27
84	16	21½	27	37½	21½ to 32

Long Dimension	828 Slides (28 x 40 mm) or 127 (1⅝-inch [41 mm] square) Super-Slides				
	3-inch (76 mm) Lens	4-inch (102 mm) Lens	5-inch (127 mm) Lens	7-inch (178 mm) Lens	Zoom Lens 4 to 6-inch (102 to 152 mm)
40	7	9½	12	17	9½ to 14½
50	9	12	15	20½	12 to 17½
60	10½	14	17½	24½	14 to 21
70	12	16½	20½	28½	16½ to 24½
84	14½	19½	24½	34	19½ to 29

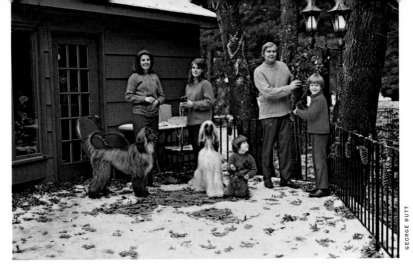

GEORGE BUTT

When you have a particularly appropriate slide, you can have photo-greeting cards made from it; just see your photo dealer. This slide was used for a Christmas card.

Prints and Duplicates from Your Slides

RALPH AMDURSKY

When you have some especially good slides, you'll enjoy having color prints or enlargements made from them. You might even like to try making some prints yourself. There also may be times when you need extra copies of your favorite slides to give to your relatives or friends. There are several ways to have color prints, enlargements, or duplicate slides made from your color slides. You can have such prints and duplicates made by Eastman Kodak Company or a number of independent color laboratories and photofinishers. The services offered by Kodak are described below.

KODAK COLOR PRINTS AND ENLARGEMENTS FROM SLIDES

KODAK Color Prints and Enlargements, made by Kodak laboratories, are full-color pictures on a paper base. They're available in sizes from 2½ x 3½ inches up to 11 x 14 inches. The originals can be transparencies of most sizes up to 2¼ x 2¼ inches, including stereo slides. To place orders for KODAK Color Prints and Enlargements, see your photo dealer.

SELECTING A SLIDE FOR PRINTING

No matter what process is used to make the print, the results will be better if the original slide is selected carefully. You'll obtain best results from original, rather than duplicate, transparencies. The picture should be sharp, well-exposed, and without excessive contrast. Any heavy shadow areas in the slide tend to block up and reproduce as blacks in the finished print. For this reason, pictures taken with even, flat frontlighting often make the best prints.

In checking print quality, it is important to view the transparency and print simultaneously by light of the same color quality. If the slide is viewed by strong daylight from a window, and the print by weak tungsten light, there will appear to be great differences in color rendition and brightness.

A simple and effective way to compare print and slide quality is to hold the print under a desk lamp and view the transparency by light reflected from a sheet of white paper on the table under the same lamp.

KODAK COLOR SLIDE DUPLICATES

Kodak Processing Laboratories will make KODAK Color Slide Duplicates from most sizes of original transparencies up to 8 x 10 inches. The duplicates are returned in 2 x 2-inch KODAK READY-MOUNTS; 110-size (13 x 17 mm) duplicates are supplied in 30 x 30 mm plastic mounts when the originals are in 30 x 30 mm mounts, or in 2 x 2-inch KODAK READYMOUNTS when the originals are in 2 x 2-inch mounts. The duplicates may differ slightly from the original transparencies, but they are satisfactory for most purposes. This service is available from photo dealers.

Slides from Your Color Negatives

As a color-photography enthusiast, you undoubtedly have some top-notch pictures made on color-negative film. Well, you can include these pictures in your slide collection, too, when you have slides made from the negatives. Kodak and other laboratories offer this service.

Kodak will make color slides from negatives from most popular sizes of KODACOLOR Film (not available from 110 negatives). These slides are supplied in 2 x 2-inch mounts and are called KODACOLOR Slides when they're made by Kodak. See your photo dealer.

More Information

If you have additional questions about taking color slides, write to Eastman Kodak Company, Photo Information, Department 841, 343 State Street, Rochester, New York 14650. This department has a staff of photo experts waiting to answer your questions.

A large selection of Kodak books and pamphlets which provide a wealth of information are usually stocked and sold by photo dealers. See your dealer for the publications you want. If he can't supply them, you can order by title and code number directly from Eastman Kodak Company, Department 454, Rochester, New York 14650. Please send your money order or check with the order, including your state and local sales taxes. *Prices are subject to change without notice.*

Index

Flash 60, 82, 204, 207
 Bounce flash 89
 Close-up flash 204, 207
 Electronic flash 87
 Exposure 83, 88, 91, 94, 207
 Multiple flash 94
 Off-camera flash 92
 Open flash 96
 Reflectorless flash 91

G

Glassware 225, 227, 230

H

Home interiors 113, 117, 245

I

Ice shows 127
Infrared pictures 302, 303, 304
Interiors 113, 117, 245, 247

L

Lenses
 Close-up 197, 198
 Telephoto 33, 161
 Wide-angle 33
 Zoom 37, 316, 317
Lighting
 Close-up 204, 243
 Flash 83, 89, 91, 92, 94, 96, 207
 Photolamps 99, 100, 101, 103
 Titles 243

M

Montages 141, 318, 319
Moonlight, pseudo 152
Multi-images 141, 298, 299
Multiple flash 94
Museums 251

N

Night pictures, outdoors 139

O

Off-camera flash 92
Open flash 96

P

Patterns 304, 305, 306, 307
People 17, 20, 98
Pets 180, 189
Photolamps 98, 243
 Exposure 99
 Lighting arrangements 99, 100, 101, 103
Polarizing screens 37
Prints from slides 332
Projecting slides 328
Projector-to-screen distances 331
Push-processing 110

R

Reflections 308, 309, 310, 311, 312, 313
Reflectorless flash 91
Reflectors 61, 62

S

Shade 53, 64
Showing slides 328
Sidelighting 50, 65
Silhouettes 261
Slides from color negatives 333
Stained-glass windows 258
Sunsets 270

T

Tabletops 214
Telephoto lenses 33, 161
Titles 238
Tripods 30, 145

U

Underwater pictures 275

W

Wide-angle lenses 33

Z

Zoom lenses 37, 316, 317

KODAK
Here's How
Books

The *Here's How* series is unique among KODAK Photo Books. Each book in the series consists of a group of articles written by photographic experts and specialists practicing in their fields. The subjects range from techniques for photographing insects to far-reaching methods of capturing the stars on film. The information in these articles can help you with projects already started and spark new interest in fields you've never considered.

Here's How (AE-81) $1.50

More Here's How (AE-83) $1.50

The Third and Fourth Here's How (AE-104) .. $3.50

The Fifth Here's How (AE-87) $1.50

The Sixth Here's How (AE-88) $1.00

The Seventh Here's How (AE-90) $1.50

The Eighth Here's How (AE-94) $1.40

The Ninth Here's How (AE-95) $3.50

The *Here's How* books are sold by photo dealers. However, if your dealer cannot supply the books you want, you can order by title and code number directly from Eastman Kodak Company. See page 333.

Consumer Markets Division
Adventures in Color-Slide Photography
KODAK Publication No. AE-8
CAT 179 8339

Rochester, New York 14650
New Publication 12-75-GE
Printed in U.S.A.